# Endorsements

*Evolution of Loving* is a magical tribute to long-lasting love. The brilliant Carl Studna magnificently captures the ups and downs, and ins and outs of intimate love with breathtaking beauty and a raw, searing honesty. Peer into these mesmerizing photos long enough and you'll start to see a blueprint to soulmate love.

*- Katherine Woodward Thomas*

NY Times Bestselling Author of *Calling in "The One" & Conscious Uncoupling*

*Evolution of Loving* is a powerful testimonial to the profound courage and power that arises in the vulnerability of human love and intimacy. With its beautiful images and the humbling stories of human love, this book opens the doors of our own hearts and beckons us to move beyond fear and into the deep waters of trust that heal the soul, and which can only be found in making ourselves truly transparent and vulnerable.

*- Sonia Choquette*

NY Times Bestselling Author, Spiritual Teacher, Six-Sensory Consultant, and Transformational Visionary Guide

*Evolution of Loving* brilliantly models the journey of eight couples down the path of evolving love. Their stories ignite in the reader a vision of what true love can be when we open our hearts fully. This book provides such a sweet blend of heartfelt photographs, in-depth stories and practical guides for cultivating successful, intimate partnership. You will love this book.

*- Mary Morrissey*

Author and Founder of *Life Mastery Institute*

With consummate spiritual sensitivity, connectivity, inspired creativity and eloquence, Carl Studna has captured the deepest intimacies of the eight couples in *Evolution of Loving,* evidencing the tender healing and evolutionary qualities of Love's divine essence.

*- Michael Bernard Beckwith*

Author of *Spiritual Liberation*

# EVOLUTION
*of Loving*

## BY CARL STUDNA

**MOtivational PRESS®**
LEADERS IN GLOBAL PUBLISHING

Published by Motivational Press, Inc.
1777 Aurora Road
Melbourne, Florida, 32935
www.MotivationalPress.com

Manufactured in the United States of America.

ISBN: 978-1-62865-488-2

# Contents

# Dedication

First and foremost, this book is dedicated to all eight couples who courageously chose to share their hearts and souls with me and with the world. Your demonstration of trust has forever raised my faith in knowing the unlimited richness that evolving love offers when we remain open, respectful, and awake.

Throughout the early stages of this project, there were several folks who truly caught the vision of the book's power and potency. These angels contributed greatly through offering various resources and holding the highest vision. A monumental thanks to Kenny Loggins, Arielle Ford, Charles Muir, Caroline Muir, Joe Marshalla, Rick Sands, Lori Grace, Kit Thomas, Cheri Clampett, Melanie Hutton, Michael Torphy, Georgina Lindsey, Julie Chertow and Hanah Lynn.

I'm sending mountains of gratitude to my brilliant editor, Danielle Dorman. Your vast experience and ingenuity brought grander dimensions of possibility to this project, and you always infused your warm heart into the book's highest vision.

My heart extends out to James and Debra Rouse, Stewart Emery, Cyndy Beardsley, and Lori Jensen. Your brilliant support throughout the book's final birthing stages has been instrumental.

To every individual on this planet who chooses to pick yourself up whenever you feel hurt, discouraged, betrayed, or misunderstood. Then allowing love's innate guidance to help you find your way back to the wellspring of your inner perfection.

Lastly, to my beloved wife, Cynthia: Your unwavering commitment to living a bold life that's dedicated to truth, expansion, service, and compassion continually raises the roof off of my self-imposed limits in this ever-changing world. We are truly blessed to be intimate partners on this most diverse path with its constant twists and turns, knowing that we are always perfectly guided by love's evolving wisdom.

# Foreword

WE LIVE IN A WORLD where we are brainwashed and spoon fed stories and movies and books telling us that LOVE is a feeling; it's that over-the-moon, socks knocked off, out of your mind, swept away tsunami of bliss…. But the truth is, love is much more than a feeling.

In the beginning of your relationship, when you were in the "in love" stage (also known as the socially acceptable form of insanity), your brain was cascading you in feel good chemicals which produced within you a high even stronger than cocaine. This is not – nor was it ever – real, adult, mature love. It is simply nature's way of tricking us into staying together long enough to procreate.

So what IS LOVE?

Author and motivational speaker Leo Buscaglia defines it as "the ability and willingness to allow those you care for to be what they choose for themselves without any insistence that they satisfy you." Jeremy Taylor says that, "Love is friendship set on fire." And then there's a little boy named Matthew, who's seven, who defines love in perhaps the most accurate way of all: "When you tell someone something bad about yourself and you're scared they won't love you anymore, but then you get surprised because not only do they still love you, but they love you even more. That's love." How precious is that?

Definitions aside, here's what I know for sure about love:
- » Love is a choice.
- » Love is connection.
- » Love is a behavior.
- » Love is the juiciest part of life.
- » Love opens our hearts, expands our world and brings a smile to our lips.
- » Love compels us to commit ourselves to share our life with another in both good times and in bad.

When we pledge our love to another we say to them:
- » I will love you on your good days and your bad days.

»     I will be your safe place to land.

»     I will share with you my attention, affection and appreciation.

»     With you I will become a better woman and with me you will become a better man.

»     I will be your best friend, lover, partner and protector (and if things don't work out, I won't sell you out).

Love is not all things shiny and sparkling. Although those are nice for a special day, they are not ultimately what love is all about. Love is as much about giving as it is about receiving. And, it's also about being willing to forgive. And let's not forget truth-telling.

Mature, adult love is active; it's about deliberately choosing to be present and kind and courteous to your partner. And perhaps most importantly, love is about being willing to understand that although you are not perfect and your spouse will never be perfect, you can choose to love an imperfect person, perfectly!

Carl Studna and Cynthia James are truly love masters who have explored the heights and depths of what a true soulmate relationship is made of. In this very unique book, they take us on both a visual and a narrative journey that provides a deep dive into the essence of soul-stirring, heart-opening lifelong love – as told by couples who have lived this path with great success.

In this book, you will find insights, sage advice, and practical exercises shared by couples who have mastered the art of love. From it, you will learn exactly what it takes for two souls to merge into a blissful and compatible love union. If you allow yourself to receive what is offered here, it will guide you along a well-lit path to uplift and transform your relationship to grander levels of satisfaction, contentment and joy.

*Arielle Ford*
*Spring, 2017*
*La Jolla, CA*

# Author's Preface

THE BOOK YOU ARE HOLDING in your hands has been in the process of ripening for over two decades, and the form in which it exists today is a living example of the ways in which love calls us to evolve. *Evolution of Loving*, which began as an idea to document in photographs the intimate moments shared between couples who had created extraordinary partnerships, has transformed and expanded many times over these many years.

This project was conceived under fascinating circumstances. In November of 1992, I had just completed a photo session with musician Kenny Loggins and his family in Southern California. At the end of the day, Kenny and I were sitting in his hot tub with the sun setting over the Pacific Ocean, when he shared with me an inspired idea. He and his wife Julia, who was three month's pregnant, were deeply in love. Kenny began the conversation by saying, "If I were a photographer, I'd want to capture the deep love, presence, passion, and trust that I see in Julia's eyes when we're in the midst of lovemaking." This sparked a rich conversation and inquiry focused on the raw truth of love's power and presence during this sacred act. What began as a seed birthed out of this couple's love blossomed into a twenty-five year journey that has expanded into an in-depth exploration of love's many dimensions, represented through the eight couples featured in this book.

Kenny's idea resonated with me not just from the perspective of being a photographer, but from a personal standpoint as well, for I was just ending a relationship at the time, and was in fact fearful of letting a genuine, fully loving and conscious partner into my life. Having been in and out of a few relationships in the past – including a girlfriend I lived with for two years straight out of college, several short term relationships in my thirties, and a seven-year marriage that ended badly – I was all too familiar with the illusions, projections, and habitual patterns of behavior that inevitably seemed to break apart even the strongest of partnerships.

Tired of living these myths and in search of a deeper connection, I began to contemplate how it would feel to trust another person completely, and to trust myself enough to be willing to be seen – both the full immensity of my light as well as what I judged to be the darker sides of my personality. I knew that a relationship could be consciously built on a foundation of transparency and authenticity rather than secrecy and defensiveness, but I hadn't been successful in consistently trusting and practicing this truth. I had no problem demonstrating this level

of transparency when working with my photography clients but day-in-day-out in an intimate relationship was a whole other ball of wax!

As a portrait photographer, my primary intent is to bring out my subject's inner light and genuine presence, and as such, the most essential aspect of my job involves creating a safe and inviting space for people to open up, to show up, and to simply relax into who they are. Having logged countless hours on the other side of a camera lens, I understood that the very best in people can only be brought forth in an environment of acceptance and trust. With hundreds of clients, I had experienced the genuine connection that is forged when people are willing to be authentically themselves, and I certainly witnessed this with Kenny and Julia. Still, this level of connection was noticeably lacking in my own intimate relationships. My heart yearned to bridge this gap.

I found myself searching for couples who could serve as role models of a healthy and integrated partnership that upheld the possibility for growth, rather than constraint. And as I put the word out, couples began to surface around me who related with one another in truthful and open-hearted ways. Being in the presence of these couples was the catalyst that first triggered within me the concept of *evolving* love.

My initial intention was to portray in images a series of successful and inspiring relationships, and to include insights from each couple that would illuminate what each had discovered to be the essential elements for building partnership upon a foundation of authenticity, vulnerability and trust. That intention – along with many, many others – has been fulfilled in the publishing of this book. The wisdom shared on these pages has not only been a catalyst for transforming the way that I personally relate to love, but in the twenty-five years that the vision of this book has been gestating, I have watched a similar transformation take root in the collective consciousness as well.

I believe one of the biggest strides we've made as a society is in our realization that because love always causes us to evolve, we must continually expand our previous notions of what it is, how it looks, and how many unique forms it can take. The images of the eight couples that I was blessed to photograph do indeed depict love's many facets, and their stories inspire us as to what becomes possible when we have the courage to fully open up to and grow in partnership alongside another human being. While my original vision of this book was long ago realized, an expanded vision has continued to grow over time.

A case in point occurred one evening as this book was nearing what I believed would be its final draft. Cynthia and I were dining at a romantic Italian restaurant celebrating the twenty-first anniversary of our first date when the tugging on my shirtsleeve could no longer be ignored. Ever since the book's inception, I had always considered

including same-sex couples, but continued to dismiss the idea. Throughout the nineties and into the first decade of our new millennium, it was hard enough finding a publisher that would consider publishing such an intimate glimpse into the relationships of heterosexual couples, let alone those of the same sex! I had always known that the inclusion of same sex couples would make the project complete, but until that moment sitting there with Cynthia, I never felt that the collective viewership would accept this addition. And now, after two decades of shirt tugging I had finally been given a clear and resounding, YES.

It became crystal clear that even though there was great diversity represented in the six couples whom I'd initially photographed and interviewed, and even though each relationship reflected a wide range of values, cultural influences, ages and circumstances, the picture I had painted was still incomplete, for it was missing the diversity and insights that only a same-sex couple would be in a position to provide. It may be difficult to acknowledge, but in the early1990s, when the seed of this book was first planted in my awareness, the United States actually banned the federal government from recognizing same-sex unions! For as many freedoms as our country had realized up to that point, our ideas about romantic love were still – relatively speaking – in the dark ages.

Reflecting back on the year this project began, and the misconceptions and superstitions about sexuality and love that were then rampant in our culture, I realized how far we've come in twenty-five years' time. Now, gratefully, a widespread recognition of, and respect for, devoted love between gay and lesbian couples is gradually becoming the New Normal. The more I contemplated this realization and the more I talked with Cynthia about it, I saw clearly that no story of evolving love could be complete without including the valuable perspective of at least one male and one female same-sex couple. And so, this was yet another evolution of *Evolution of Loving*.

I never could have predicted when this project began the way it would ultimately unfold. There was no way to foresee the path it would urge me to follow, or to anticipate that being with people so devoted to one another would open a clearing into which I would eventually manifest the love of my life. As fate would have it, my first "date" with Cynthia James, the beautiful, powerful, brilliant goddess who is now my wife, came about as a result of her stopping by my hillside cabin in Los Angeles one night to view the very first, roughly pieced-together mockup of this book. That was in 1995; exactly twenty-one years almost to the very day that I am now writing these words.

Because many of these first-person accounts, as well as the photos of the couples who shared them, were documented in the 1990s, naturally, the relationships today are not as they were back then. The couples have since experienced many of life's stages, challenges, and transitions – from the celebration of joyful milestones to

the reality of losses and empty nests. Some have lived through the physical death of their spouse, only to discover that the love between them continues from this world to the next. Others encountered tragedies, infidelities – even separations – that shook the partnership at its very roots. Some of the individuals who were coupled then are no longer together today; their stories serve to create the possibility not only of conscious partnership, but also of conscious "uncoupling."

This work reflects not only each couple's evolving journey, but my own journey as well. Photography will always be my first love and an important conduit through which I have the honor of being paid to share beauty, reflect light, and portray images which expand both perspective and consciousness. Looking back, however, there is no doubt that spirit has been crafting my life experiences to contribute these gifts through other mediums as well. As I continue to grow into this new role I've been called to play, I know this book is in alignment with that calling.

In many ways, the crafting of this project has felt a bit like creating a time capsule, except that the timing of its release was dictated by the vision itself; never by me. *Evolution of Loving* has been doing just that – evolving – for all these years, and yet its fruition has come at this perfect and particular moment in time.

The journey I have taken over the last twenty-five years was launched by my genuine desire to experience for myself – and later, to ignite in others – an awareness of the depth of love that is possible between human beings. This book represents the culmination of that desire, and reflects the most important lesson I have learned from spending countless hours behind a camera: When we create a safe space for others to be genuinely themselves, love rushes in to fill that space.

The depth of vulnerability demonstrated by each couple whose intimate life together I had the immense privilege of documenting has made me a much wiser individual. From their stories I learned that partnerships become infinitely more successful when we have the courage to walk a conscious path together. For Cynthia and myself, this path has been made much clearer from having received from each couple featured in this book a piece of what has now become a precise roadmap for nurturing the continual evolution of love.

It is my sincere wish that this wisdom will also light your path toward an experience of love that grows ever deeper, transparent, and trusting.

**Carl Studna, Pine, Colorado**

# Introduction

Evolving love is a practice, a conscious and deliberate choice. It's not an experience that just happens to us, but one that is nourished by our ongoing commitment and attention. We live in a culture that is saturated in romantic illusions about love. We're fed the notion that there exists that one special person who will fill our emptiness and make our lives complete. We're led to believe that falling in love should automatically equip us with the skills needed to create healthy, lasting partnerships. We easily confuse physical chemistry with long-term compatibility, and have a tendency to rely on attraction alone as a barometer of true intimacy.

Most of us have but scratched the surface of the depth of love that you will encounter on these pages. The eight couples whose stories you are about to read display a remarkable degree of mutual devotion and trust, but this did not happen by chance. Their experience was the natural consequence of incorporating into their relationships specific practices to nurture in one another a greater willingness to be fully open, and authentically themselves. The level of intimacy they created was in direct proportion to how much each was willing to give of themselves for the sake of their relationship – not only in happy times when giving comes easy, but at times when old wounds are triggered and our every survival instinct is screaming for us to build defensive walls and guard our hearts. The commitment to return to the practices that foster, maintain and restore connection – even in the midst of heartbreak, disillusionment or uncertainty – is what ultimately guided each couple to the other side.

Over the years we've been together, Cynthia and I have synthesized and applied in our own relationship what we have found to be the most refined and effective of these practices. And, thanks in large part to Cynthia, with whom I co-lead transformational couple's workshops, and who is the founder of a successful international coaching practice, we have developed a wide array of our own.

In the third and final section of this book, titled "Tools and Practices," Cynthia has organized an extensive menu of techniques – including meditations, communication exercises, daily and monthly rituals, and more – that are all designed to deepen intimacy and rebuild trust. Because they are so effective in guiding partners to release the fears, limiting beliefs and emotional wounds that constrict our experience of love, these processes have become an integral part of the workshops we co-facilitate with couples. And while I have to admit that sharing these techniques in-

person allows us to incorporate more experiential modalities such as movement, music, and even role play and art, Cynthia has done an excellent job of capturing the essence of our work and structuring each practice so it can easily be implemented at home.

Without exception, we routinely use or have used in the past every one of the techniques outlined in the final section of this book. They have served not only to strengthen our evolving partnership, but also fortified our mutual desire to pass along the insights which we feel so blessed to have received.

Few of us are skilled in the practice of love. But approaching it as a practice is precisely what is required, both for a relationship's longevity and for our ability to evolve within it. Just how completely can we love each other? Can we be each other's teachers, and guides; students and friends? Can we be the one person who is willing to open our hearts enough to provide for our partners the experience of being truly, completely heard? How transparent are we capable of being, and how free to be completely ourselves? What are love's limits, and what becomes available to us when we commit ourselves to transcending them? These are but some of the discoveries you will make for yourself as you walk with these eight extraordinary couples along their paths of evolving love.

# Chapter 1

## THE POWER OF GRATITUDE
*The Evolving Love of Walter and Carla*

.........................................................................................

M Y FIRST VISIT WITH CARLA AND WALTER took place at their home on Oahu, Hawaii. Immediately, I was struck by the fact that even after being together for over fifty years, both were still so devoted to their own growth and expansion. At first sight, Walter and Carla felt as if they could have been my grandparents in another life: they were German Jews who had escaped Nazi Germany, and given that my Jewish relatives had also migrated from Eastern Europe, I felt a sense of kinship with their ancestry, and certainly a great deal of compassion for their plight. I also sensed a solid bond in their family unit, and a shared devotion of their eight children. Undoubtedly, their past history of harrowing experiences had instilled within them a deep appreciation for the preciousness of life. I could see from the lively way the two communicated that they took nothing for granted.

I also witnessed a dynamic between them that gave me new insight into what it takes to create longevity in relationships. At certain moments, they'd exchange brief rounds of bickering; Carla getting impatient with Walter's "old fashioned" ways, while at times Walter considered Carla too unconventional and felt embarrassed by some of her actions. And yet, as the photos below beautifully illustrate, the differences between them clearly didn't get in the way of their connection, or the immense gratitude they felt toward one another. The level to which they opened their hearts – expressing rich, caring intimacy and love –impressed me deeply, particularly given that they grew up in a generation that lacked the tools or even a basic awareness of the principles of conscious communication. Together, they carved out their own path, and simply found their own way!

# Carla & Walter

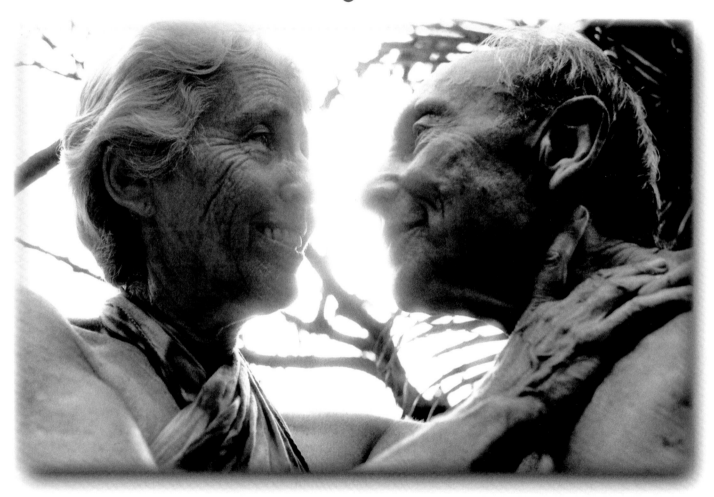

Walter is a treasure, totally giving, annoyingly self-denying.
"You don't need to give to me," he says. I say, "I love doing for you."

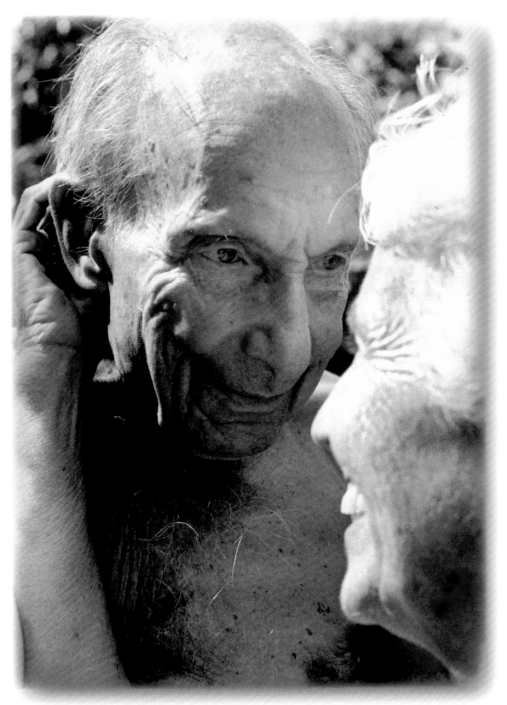

My love for Carla is the sun of my life, the sustenance of my soul. Her being fills me with everlasting gratitude and I cherish the air we are breathing together.

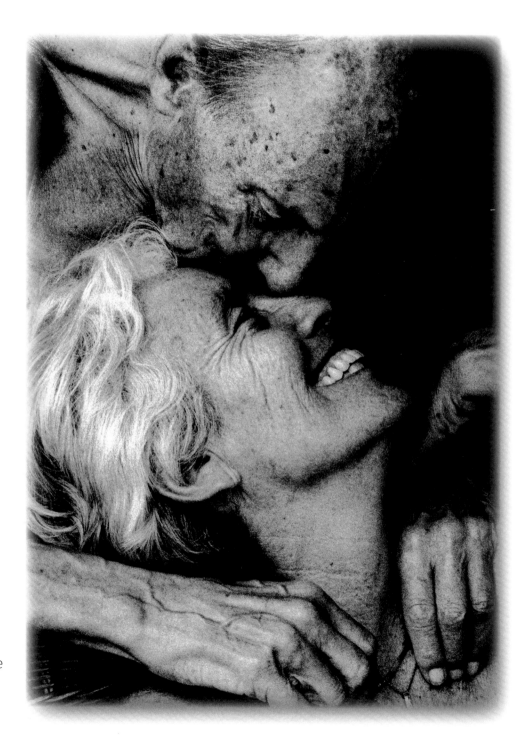

Somehow we blend in spirit
and in movement. Our dance
of joy sweeps other lovers of
life into our orbit.

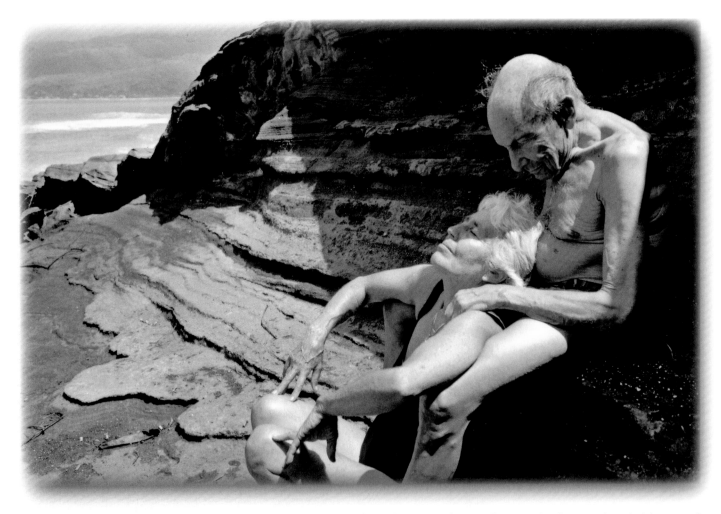

Your stability is something I lean on, and the qualities of our lasting relationship are built into the children and it will go on and on through their children.

After fifty years of marriage he still notices, "How trim you are – your baby breasts, how beautiful they are!" Now, fifty years later, Walter is still a most radiant being. Wrapped in golden satin skin, his limbs are lean and strong as they wrap around my body.

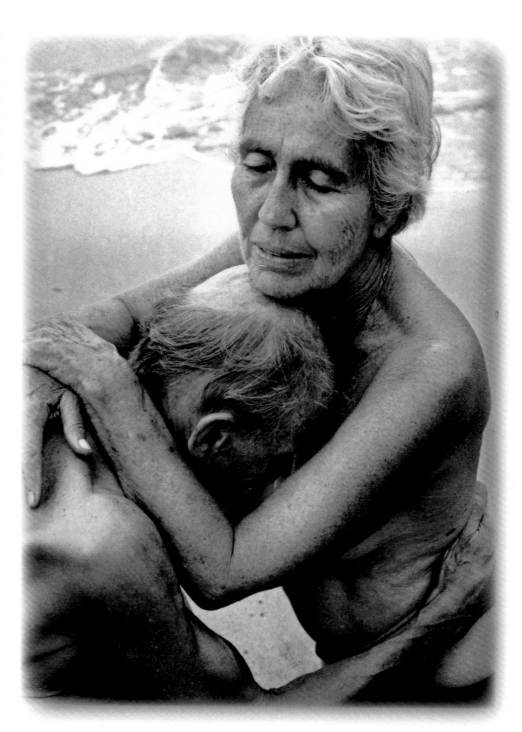

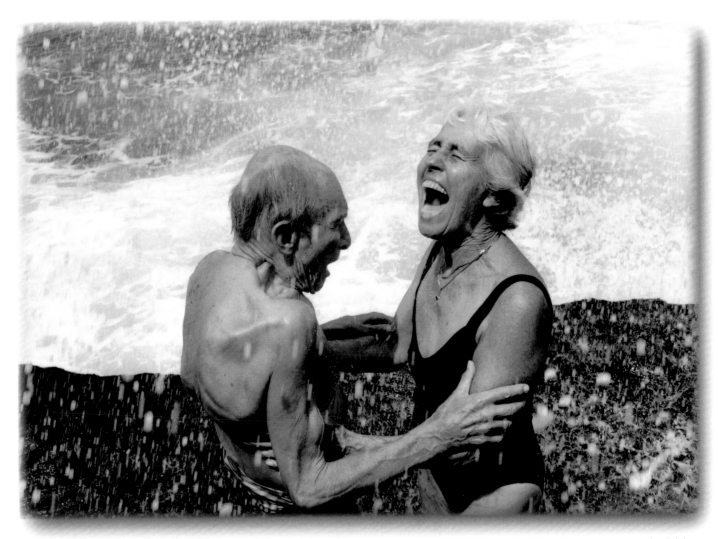

I'm a nature spirit, naked to the world. My daily renewal is a sunset swim in Hawaiian waters. My voice bubbles out, "Thank you God for all of these blessings!" Then I ride my old bike back to fresh friendship with my Walter-man.

The insights disclosed during the long conversations I shared with this couple - and years later, those I shared with Carla after Walter's body gave way to Parkinson's disease – have served as a lasting reminder of how powerfully gratitude can shift our perspective. By actively looking for the good in one another, even in the presence of petty annoyances, they were able to nurture and maintain a loving, growth-filled and inspired partnership that spanned an entire lifetime.  Here is Walter and Carla's story, in their own words:

# Interview #1

## What has been your secret in keeping the love fresh, new, growing and fulfilling over all these years?

**Walter:** Carla's integrity, her beauty, and her smile renew my faith in her and my love for her. Her presence inspires me, and awakens me to the joy of still being alive. My love for Carla is the sun of my life, the sustenance of my soul. Her being fills me with ever-lasting gratitude and I cherish the air we are breathing together.  We care for each other so much that her welfare is more important to me than my own. I believe that much of what we have is a blessing, and it's very hard to explain that. We receive the gifts that we've been given, while never taking them for granted.

**Carla:** If I were a flower, I would be constantly getting watered by Walter's love. It's very easy to love Walter, because he's very lovable. Each day is exciting. It's fun to watch Walter sleep; watch him wake up. When the children call, he's very present and receives each one like a deep, spacious ocean. Not a day goes by that I am not deeply grateful for being here; for being alive, and for being by his side.

When Walter was in the hospital recently in intensive care – even with all of the drugs being given to him – I was grateful that his clarity of mind never failed. I said, "If you want to go, you know I'm with you." Anyway, he decided to come back, and I'm happy about that. It was always a big celebration when Walter would come home from a business trip of two or three days across the mountains from Seattle. The children would be jumping for joy when

he would return. That sense of joyous receiving along with the deep gratitude for being together has carried us happily through our lives. I wonder whether some of our appreciation for one another has to do with being refugees from Hitler. Each of us escaped in different ways, but we both came out of the experience knowing that every day is a treasure. Every day we're grateful to be alive, to live in America, and to have each other.

**Over the years, when the two of you have been in conflict with each other, have you had a particular method for working through your challenges?**

*Walter:* There's no question that I've been angry many a time and that Carla has been angry many a time. I believe that my desire to have peace is so great that even if I'm angry, I'm willing to make a change in my behavior, knowing that the problem needs to be worked out or it's going to eat at me like a cancer. So if I feel like banging a few doors, I try to divert myself by reading or writing. Taking time by myself helps me to cool off and become more aware of the situation, so I can better understand her point of view. It doesn't take long to see a way of making the situation more peaceful. In hindsight, I might realize that I was being too rough, or that she was just angry or tired. It's a matter of yielding when it's appropriate to yield, and taking time to adjust my perspective to see the big picture, and all the ways that Carla adds richness to my life.

*Carla:* The one and only real challenge we ever had was when we lived in Seattle many years ago. I was very active in the Civil Rights Movement and helped sponsor a musical group's performance. I dropped by the house where they were staying, delivering a birthday cake. Three of the guys were gone at the time and the one who was there opened the door. I went in to deliver the cake, and he took me into the bedroom. This was a one-time occurrence, never to happen again, and of course it was very painful for Walter and painful for me. I knew it was a transgression. I didn't feel any love for this man, so there was nothing to undo except the disappointment of hurting Walter. I could have been silent, but chose to admit it to Walter. It's as if I could not keep it from him. We had never had any secrets between us – and in fact, not having any secrets has been one of our greatest secrets for happiness. Walter instinctively knew that something had happened, and my choosing to withhold the truth from him would have created an unnecessary rift between us. Still, it was very painful, naturally. Walter initially said, "I'm going to have to get a divorce."

*Walter:* She thought she was pregnant and I imagined myself having a black child and being judged by all my middle class friends. A whole part of my life felt destroyed. It was initially very devastating to my ego, but through time I gained wisdom that led me to a certain level of peace, acceptance and forgiveness.

*Carla:* We're very divergent in that way. I'm not concerned about what others think. The challenge was to love Walter and let it blow over, because naturally he was very upset as was I.

**In all the years you've been together as a couple, what is the greatest lesson you've been working through that this relationship has continually brought up to heal?**

*Walter:* For all our shared history, Carla and I are very different in how we approach some aspects of life. And although I've accepted a lot of her ways, there is still a level of criticism that I hold on to with Carla related to her nudism. I don't say anything when you *(talking to Carla)* walk around naked. I don't mention the fact that you're totally nude when customers come in. Instead, I focus on the ways our differences have forced me to grow. You have put me on a broad twig of openness. It's caused me to broaden my outlook on what other people think; my viewpoint is far less strident than what it used to be.

*Carla:* I would think that certain stumbling blocks like the one just mentioned— traits that are hard to accept— don't really have to be accepted as long as we can co-exist with them. Walter doesn't have to run around naked if he doesn't want to. The main thing is that he shouldn't be bothered by it. I don't deliberately run around naked in front of customers. If somebody's coming in, I'll go and wrap something around myself, but I don't feel embarrassed about it. It's not true that I'm naked around customers. I am a nature spirit, naked to the world. My daily renewal is a sunset swim in Hawaiian waters. My voice bubbles out, "Thank you God for all these blessings!"

The main criticism I've had to work through regarding Walter is that he cares too much about what other people think. I care about what others think as well, but not to the extent of propriety or morality. I've learned to live with that quality in Walter and he's learned to live with mine. We've learned to co-exist and to know that we don't always have to agree. I think that fundamentally we have strong enough congruence that we don't have to agree on every

last detail. It's just that on this one particular detail, we're at opposite ends, but that's okay…..let him be dressed and let me be naked (*laughing*).

*Walter:* When my concern about "What the neighbors think" pops up, it causes strife.

*Carla:* When I have judgments and I just blurt things out, they can be a thorn in Walter's side. *(Turning to Walter)* Have you had to develop a tough skin to resist my little jabs?

*Walter:* Certain jabs, yes….little rough stuff that reminds us of more serious infractions.

*Carla:* Little pin pricks.

*Walter:* We're both very critical about being criticized! (*Laughing*) Carla doesn't like me to tell her how to do something that she's really involved with. At the same time, I feel that she is unwavering regarding particular maneuvers or activities. She needs to do them in an exacting way with no room for deviation, and this can create some discomfort. For example, somebody recently told her that for my health, I daily need to drink eight glasses of water and she quite religiously serves them to me every day – whether I'm thirsty or not!

**How do you deal with those moments when your feathers feel ruffled and your judgments come up?**

*Walter:* In most situations, I feel it is better to be quiet, to not say anything so it can wear off in time. Of course, there are things that are said and done that I don't like; that grab me for a moment. But when I look at it in a broader way, it's easy to say, "forget about it," because I know that if I make an issue about it, it's going to be mightily blown up.

*Carla:* I probably slither the other direction or go jump in the lake *(laughing)*. We do have judgments about each other's ways, but they're not crucial to our mutual well-being. We are very different on the surface, but I don't think that has interfered with the deeper ties beneath and above.

*Walter:* I might be annoyed about something, and then I think, "Just look at the good side of Carla. Don't latch onto her little outbursts of comic or strange behavior." As we age, the love I feel for Carla goes deeper and outweighs her nutty behavior. *(laughing)*.

## How would you describe your commitment to each other?

*Walter:* *(Turning to Carla)* It is a joy and a privilege to support you in whatever is meaningful to you. I know that everything that comes from you will benefit me and will never hurt me. I'm most grateful for your existence. I'm sure that without your love, care, and interest in my welfare I would have turned out a different person…less attractive, less unified with the Universe. For this, I bless you and thank you beyond words.

*Carla:* In response, my dear husband, I also feel that we've brought out the very best qualities in each other. Your stability is something I lean on, and the qualities of our lasting relationship are built into the children and it will go on and on through their children. There are already thirteen grandchildren, who will each make a mark in the world that will have a little stamp of you and me on it *(laughing)*! Ours is a case of "Until death do us part and beyond." You have been gentle and loving and understanding….most of the time. So stick around for a while…we all need you *(tearfully)*. I must say that the angels will have a wonderful companion when Walter gets up there! He's going to be a super angel *(laughing and crying)*. So you will have lots of fun wherever you go. You'll be appreciated.

## What is it about the way the two of you relate that allows conflicts to blow over so easily?

*Walter:* It isn't talked about, but there is an unspoken awareness between us. We are both deeply grateful for having found one another, and for the life we've built together. There's peace in the relationship.

**Carla:** Our arguments are always superficial, not deep disagreements. If Walter is unhappy on my account, I assure him that I love him. We give each other back rubs, head rubs, fingers and toes. We'll make a good meal, or go dancing….we like to dance. Even when the children were little, we would take an occasional weekend off. I think it's important to love the family and also have separation a couple of times a year, even for a matter of hours. Just doing something away from home together has been important.

The German phrase *ganz geben* refers to a simple way of life where everything is shared and no secrets are kept. This is what we strive for. Secrets are so painful. They take a lot of work to emotionally maintain, which is why I don't believe in them. I suppose that withholding my brief infidelity all those years ago might have caused Walter less pain, but I just was not able to hold it back. Ultimately, I am grateful for this as well.

**Walter:** I don't want there to be any falsehood between Carla and me, and withholding that from me would have been a falsehood. Falsehoods bring a sense of disloyalty and superficiality. I like to be able to look into Carla's eyes and know that I'm clean and I wish the same of her.

**If there was one message that you would want the world to know about how you've maintained a growing, successful relationship for fifty-four years, what would that be?**

**Walter:** You need to be really willing to give of yourself. Your giving is going to open up all doors. It's infectious. And the most valuable thing you can give to another person is your appreciation for their rich presence in your life, and your acknowledgment of the ways they enrich your life.

**Carla:** I go with the path of least resistance and make things as effortless as possible. We might become mildly annoyed with one another twelve, even fifty times a day…but it's no big deal. I simply remember the deep alliance that underlies any superficial scuffle we might be having. If I were fighting over each one, resentment would build. We just go with the flow and accept "what is." And we take time to count our blessings.

**What does trust mean to you?**

*Walter:* Letting be and letting go, leaving to the Universe the major decisions of my life. In letting go, I let trust work it out for me. I have faith that I'll be treated well.

*Carla:* I have thankfulness when I go into the ocean at six in the morning. I say, "Thank you God for all of this beauty." Thank you for the beauty in our relationship and for our wonderful eight children. I say the words "thank you" a lot throughout each and every day.

**Walter, through your love for Carla, how has this relationship been a catalyst for opening and growing in ways that you would likely not on your own?**

*Walter:* My desire to share deeply with Carla, has brought about deeper insights about love, about the universe, and about my place in it.

*Carla:* Making love on the slopes of Mt. Rainier in the meadows with all of the wildflowers….you couldn't have done that without me (*Laughing*)!

*Walter:* Very good! Carla has certainly encouraged me to be more adventurous, and to keep an open mind. Recently, she's supported me in doing Yoga. She is very adamant that I do it – even when I don't feel like leaving home. She feels very strongly that it will be beneficial.

**Over the years when Carla has needed support or in crisis, how have you been there for her?**

*Walter:* By assuring her that whatever happens is accepted as part of the need to grow and form a better union than we have previously had.

**How do you keep the joy, playfulness and spontaneity alive with each other?**

*Carla:* By playing and being joyful! (*laughing*). It's sort of redundant. I'm nothing but spontaneity – sometimes more than Walter would like. I couldn't help myself from being spontaneous even if I tried.

*Walter:* And she drags me along!

*Carla:* And he always has such a good time! We took a big band cruise and there was a band on every floor and we danced on all of them….and that was only five years ago. We have a lot of fun. I don't easily get into a rut or routine. Every moment is new.

*Walter:* As we get away from routine, there's a certain amount of release that makes me spark and brings the marriage closer. It's not hard to do. I feel a great deal of gratitude as I see how far I've come because Carla has taken me with her to places I would not have gone on my own. Overall, being with Carla has been extremely beneficial to my development. She makes my old age livable; even joyful at times.

# *Interview #2*

SEVERAL YEARS AFTER MY FIRST MEETING with Walter and Carla, I visited with Carla again – nearly two years after Walter's passing – and it was particularly poignant that Cynthia joined me. I had long wanted for these two strong, independent women to meet, especially because I was still a single guy during my first visit with Walter and Carla, and each had given me valuable insights into bringing in the right woman. Not surprisingly, Carla and Cynthia hit it off immediately, and the conversation the three of us shared was every bit as intimate as any that had come before:

**It's been close to two years since Walter passed. Would you talk a little bit about the transition time and how it's been for you since then?**

*Carla:* Well, it was a busy time because we have eight children and everybody came. We had an open house during the time Walter was dying and after his passing. He was covered with tons of plumeria blossoms. I told people "Tonight at eight, if you'd like to say goodbye to Walter, please come." There were seventy-five people that crowded into the room. Walter, in certain ways, served as the guru of his men's group and many of them attended. He was very much loved by the whole community in Honolulu, and by the children and thirteen grandchildren, of course. Anyway, it's a blessing that he left when he needed to.

**In our last interview, about two months before Walter passed, he was sharing that he was ready to go but he was holding on because he knew that you and some other family members weren't quite ready.**

*Carla:* I'm still not ready *(laughs)*, but I think he's in a good place and we still communicate a lot – only now, instead of in person, it's outdoors, through the wind rustling in the monkey pod tree; on mountaintops, and through the waves in the evening at sunset.

**So after spending fifty-plus years together, it has to be a significant change in your life to not have Walter physically with you any longer. Would you share about your current lifestyle?**

*Carla:* Well, this week I have tennis on Monday, Wednesday, Thursday and Saturday at six in the morning. So I'm back and ready to start the day at about nine a.m. And I still work occasionally as a photographer, so I have pictures to take – mainly of children. That's a very pleasant continuation of my professional life because people are very appreciative and loving. So I get a lot of love wherever I go. I don't like to have people feel sorry for me and generally they don't because they know I've had a wonderful life. I stopped at a garage sale last night on the way back from my walk and the woman there was so kind and open-hearted. She drove me home and I ended up taking pictures of one of her grandkids. Everything seems to evolve out of loving.

**Carla, I know this is bringing up a lot of emotions to talk about the changes and I can feel your tremendous sadness in missing Walter. Would you talk a little bit about being on your own after fifty-five years of being together?**

*Carla:* Well, *(sighs)* there's no one to come home to *(crying)*. It used to annoy me a bit that he'd always be waiting like a puppy dog at the door, and every time I left the house and would come back, he was always ready for hugs…. Now I miss that more than anything, and am able to see it as a touching way that he expressed his devotion to me. He would fix meals that I would snack on. He did a lot of little things that showed his love for me.

He was really beloved in the entire Honolulu community. He did a lot of things that I didn't feel like doing, like going to meetings for the Honolulu Women's Symphony Society and other affairs like mediations for the justice center. I used to go with him, but after a while I just decided it's not my thing. I would rather be in nature doing my two ocean swims a day and not be inside a building with people talking about things that are not essential to my life.

**I get the feeling that part of the way that you are making this change and feeding yourself is largely by being in nature in one form or another. Is that right?**

*Carla:* Yes, increasingly. And evening walks. I didn't do that when Walter was here, because I wanted to be with him. Now I go for walks up the mountain every night with our two neighbors. And, I've begun enjoying my body in other ways. I can't make love so I use that energy to appreciate nature. I swim half an hour twice a day in the ocean and walk up the mountain once or twice a day above Hanauma Bay. That's about an hour-and-a-half walk and that takes up some of the energy that would have otherwise been devoted to Walter. Although, he always encouraged me to do my thing, regardless of whether he could join me, which was his way of being a good person.

**It seems like it's simply your nature to open up and reach out to people everywhere you go, and they in turn feel a corresponding connection with you.**

*Carla:* Yes. I think that right beneath the surface people are really wonderful, and you don't have to scratch very deeply. Just showing interest is enough to get them to feel their feelings and express their innate love. It's easy. Also, our house has always been open to all our friends. It's delightful, people knowing that they can have a home for a night, a week, or whatever they need. If it's too crowded inside, they can spread out in the garden. But anyway, there's never too many people seeking refuge on the island where we live. They're always welcome. I continue my life and they just do their thing and we do some things together.

**Please share your vision for moving forward.**

*Carla:* Well, I don't know if I'm moving forward or standing still or just enjoying breathing the atmosphere. I'm not looking for any great accomplishments. My life has always been rich and full and I think that it's going to continue to be. I'm very fortunate to be in good health. And it's so obvious to me that there's love everywhere. I just tap into it and it flows like a faucet. And Walter is the silent presence throughout all of this….a very outrageously beautiful presence. He continues to be there. Wherever it's beautiful I talk to him, out on the mountain, or in the ocean. And his dog Duke is my constant companion. He watches over me and sleeps right in front of my bed.

**When you speak with Walter do you hear responses from him? Does he offer you guidance?**

*Carla:* I feel him sparkling. Whether it's guidance… that's a nice thought. I probably should ask for guidance. I'm sure it would be there. I feel that he's not far away or maybe he's over the next horizon.

**With Walter's passing, has that strengthened or deepened your relationship with your children in any way?**

*Carla:* Definitely. Walter was such a wonderful father to each of them that I'm sure that they're very intertwined with him as well. It's a great joy to see them reproduce and celebrate him all the time. It's a Hawaiian custom to spread the body's ashes on the ocean and in the garden. In honor of this beautiful custom, we're waiting until all thirteen grandchildren and eight children can get together and take the canoe out, allowing all of us to take part in sprinkling Walter's ashes. And he'll still be around even after that! We retrieved the ashes from the medical school after he donated his body for research. They were very grateful. Even before he passed, there were several visits from medical students coming to talk to Walter, telling him how grateful they were that this was his decision. Isn't that a nice way to part?

**So in closing, what in this moment would you like to say to Walter?**

*Carla:* (*Crying*) Well, you've taken wonderful care of me all your life and the monkey pod is waving above the apartment where Carl and I are now sitting. You had that built so I would have some source of support, and so… I couldn't be living a better life (*pause*). Some of the things that we did together, like our yearly symphony subscription, are not enticing to me without you, because for years, part of what made it special was the snuggling up, the squeezing of hands, and the walking and rushing to get there… thanks to me! Even the outdoors is not as exciting when I go walking now, but I actively look and listen for your presence, and that makes it exciting. And I have your dog Duke.

When I used to work occasionally at night in my darkroom, you would reach over and welcome me back. When I'd rush out to tennis, you would eagerly receive me back with such joy, and there's nobody to do that any longer. When I go up the mountain in the evenings, I always reach you in different places and I always tell you I know you're in the right place and having a good time. You know that you are where you need to be…. and I am where I need to be… and I love you.

Near the closing of this heartfelt day together, Carla – being a photographer herself – expressed a deep desire to take some portraits of Cynthia and me, and of course we said yes. My favorite photograph from that session graces the closing of this book. It felt so enriching to be on the other side of the camera and switch roles with this wise and generous woman. Looking back years later, these beautiful black and white images are so precious; reflecting the blossoming of my relatively new love with Cynthia. Clearly, Carla wanted to give back to us a visual testimony of our love, as I had given to them.

At the end of the evening while saying our goodbyes outside their Hawaiian home, the warm trade winds swept through our souls, stirring a bittersweet blend of feelings. We knew this would be the last time our paths would cross (*in this lifetime*), and yet we were completely fulfilled by the unique gifts that we had brought to one other. Indeed, the message that Carla and Walter shared all those years ago have proved profound and everlasting.

Carla and Walter's relationship is a true demonstration of evolving love: Their individual differences, which could have become a cause for contention or even separation, were instead a source of variety and expansion, for the simple reason that each viewed the other through a lens of gratitude.

In my work as a photographer, my overarching intention is to attune myself to notice, appreciate, and encourage the beauty that is all around us. Carla and Walter applied this same principle to their relationship, and their daily practice of gratitude became a kind of living art form. In the same way we can change the scope of a camera to zoom in on the smallest detail or to take in an entire horizon, our experience of life is filtered through our perspective. Our partner's individual differences or quirks can be a source of irritation, but only spiral down into criticism or mean-spiritedness if we allow ourselves to dwell on them; to focus on them to the exclusion of the big picture. And

likewise, when we give our attention to the positive aspects of our partners – when we seek them out, appreciate them and allow ourselves to feel genuine gratitude for the contributions they make to us – we are using the power of our attention to nourish the things about them that we love the most.

It's been said that love brings up everything that is unlike itself. In the intimacy shared between partners, we will of course come face to face with one another's imperfections. But how we focus our gaze in those times is of vital importance, because what we look for, we tend to find. When we become willing to view minor irritations and misunderstandings from a broader perspective, our differences can actually make us stronger.

My rich and intimate time with Carla and Walter served as a potent reminder that it's perfectly natural to experience moments throughout each day when our partner's words or actions rub us the wrong way. Cynthia and I are by no means enlightened when it comes to maintaining constant harmonious communication. Even though we share similar foundational values, our ways of processing information can vastly vary. This can show up in how we hear each other's communications, or sometimes, don't hear them!

Recently, we were completing a walk in our beautifully pristine mountain community on a warm, spring day. At the end of our walk as we were nearing our driveway, I let Cynthia know that I'd be on a phone call from 11am-12pm discussing a book project with some dear friends. Following this comment, Cynthia turned to me and said, "Speaking of Michael, he's scheduled to have a hernia operation today." In surprise, I responded with certainty, "I didn't say anything about Michael." Cynthia then insisted that I had just mentioned a planned phone call with him following my first call.

This incident initially placed each of us in a reactive state. I was one hundred percent certain of what I said and didn't say, and Cynthia was equally certain about what she had heard. So, who is right? I was clear that it would not serve either of us to hold on to my position of being right, so I shifted my perspective and decided to be in the mystery rather than in my certainty. For all I know, she very well might have heard me mention Michael's name, even though (in my reality) I didn't verbally discuss him. After all, Cynthia is extremely intuitive, and often demonstrates an ability to "hear" communications that are offered on many levels of consciousness. Rather than clinging to the limited perspective that one of us had to be right and the other wrong about what had been said, I chose to view the experience as fascinating.

Ten minutes later, I received an email from Michael asking that I hold him in prayer throughout his surgery. He prefaced this request by saying, "I don't know if Cynthia told you, but I'm having hernia surgery today." My immediate thought after reading this was, "Yes, she did tell me – and her way of remembering to do so was through *hearing* me make mention of him!" From this experience and countless others, I continue to learn that communications can be delivered and received in such vast and diverse ways, and it's essential at times to release my linear mind's rigidity about how information "should" be shared.

One of the most valuable messages that has remained with me over the past twenty years after receiving my master's degree in Spiritual Psychology from the University of Santa Monica is the idea that "how we deal with the issue *is* the issue." So, when I'm feeling irritated or righteous, I now practice placing more of my attention on *how* I'm relating to the issue at hand. I'm continually learning that whenever I hold on to a position of being right, or of seeing Cynthia as being wrong, I'm actually placing a shield over my heart that prevents love from having a chance to take precedence. Bottom line, I've decided – as did Walter and Carla – that I'd rather spend my energy being *in the loving* than proving that I'm right.

Even though Carla and Walter displayed moments of frustration or nitpicking, I never saw them close their hearts to one another. Instead, they projected an unwavering certainty of being fully there for each other. Their differences didn't cause them to distrust or question the other's love, respect, or admiration. They had learned to genuinely accept each other's opposing views and trust that at the very heart of these differences lay the opportunity for rich growth and expansion that would take them far beyond their previously set ways. Their example continues to reassure me that it is in our diversity that we can transcend what we have known and open to wider dimensions of wisdom, compassion, and love's evolving nature.

# Chapter 2

## THE MIRROR OF RELATIONSHIPS: REVEALING AND HEALING CORE FEARS

*The Evolving Love of Ron and Priska*

...........................................................................

I AM DEEPLY HONORED to have been a loving witness throughout many different chapters of Ron and Priska's life. At the time of our first meeting, they were already well known as teachers of Tantra who embodied deep passion, sincere vulnerability and inspired creativity.

Our underwater photo session brought forth inspired and truly timeless images that exceeded my wildest imaginings. We had the opportunity to shoot in Santa Barbara at Kenny Loggins' pool that featured a beautiful waterfall and produced bubbles that encircled the couple while underwater. This was my first time shooting underwater and – given that this was during the days of film – I really wasn't sure of my results until I received the contact sheets from my photo lab.

When I first viewed the images, particularly the full-length image included in this chapter, I had the most insightful revelation related to my craft that I'd had up to that point in my life. I thought, "I didn't DO this. A much greater force beyond myself was at play here, and I was simply showing up and being the vehicle to bring it into form." To this day, I'm absolutely clear that there is no way that "I" could have set this image up in the perfect way that it came together. From that day forward, I've used my experience with Ron and Priska as a touchstone for remembering that the greatest of creative achievements take form when I listen, honor, and am guided by the greater Universal Intelligence.

Needless to say, my first experience with this couple anchored a deep bond between us. When I heard the news of Priska's pregnancy, we waited until her eighth month to produce a series of images reflecting this sacred time for her and Ron. As I walked in their front door that morning, a very different looking Priska greeted me. Gone was the classical looking Goddess I had previously photographed and here before me was a stunning expectant mother, hair cut short and graying. She had chosen to discontinue dying her hair containing potentially harmful dyes throughout her pregnancy. As I looked into her eyes, I witnessed peaceful, aqua blue pools of pure presence and harmony. It was clear that she was taking this sacred time to be still and prepare for their most blessed daughter to arrive. Both she and Ron had clearly moved into a new, sweet and tender chapter of preparing their nest, steeped in love.

A few weeks later, when I received Ron's call that their daughter was close to birthing into this world, I made a beeline to Saint John's hospital in Santa Monica to witness and photograph her arrival. It was personally significant that Cambria was being born at this particular hospital, as my mother made her painful transition there over a decade earlier.

I was reminded that a specific location can hold two diametrically opposed memories and feelings; the first being one of the most painful memories of my life and the second being one of the most beautiful and loving. At less than an hour old, my camera had the honor of documenting this soul so pure, clear and powerful, as she entered this world. Once again, a "first" had taken place in my life as a direct result of my craft.

My third experience with this couple, now a family, took place at a local park near to their Santa Monica home. As we sat in swings and rocked in a gentle rhythm as Cambria nestled snugly in Priska's baby pouch, the two began to reflect on the various chapters of their rich life together and acknowledge the choices that had brought them to this precious moment in time.

# Ron & Priska

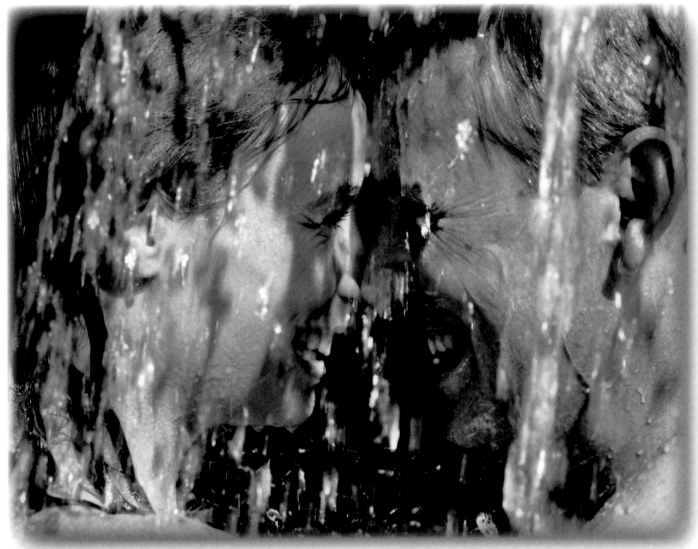

What I love about Ron is his positive outlook. He's always reassuring me that whatever I do or whatever decision I make is going to be fine.

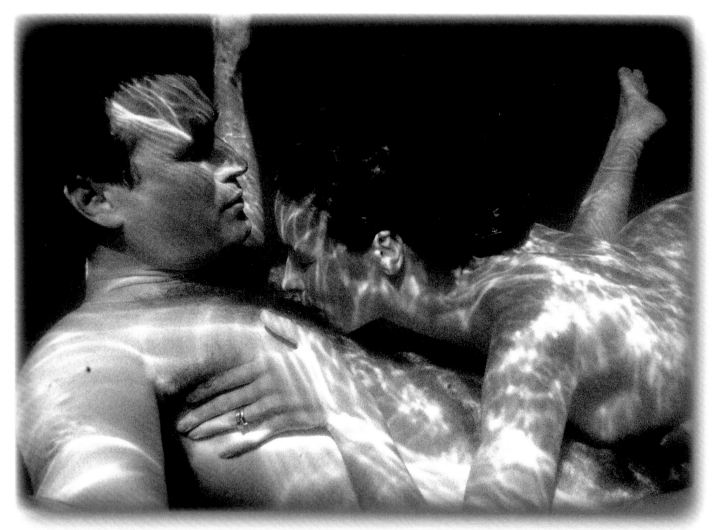

Priska and I are learning how to fall down in front of each other and make mistakes. When I'm down on my face and feeling vulnerable, I can look up at Priska and still know that she is here for me and she loves me.

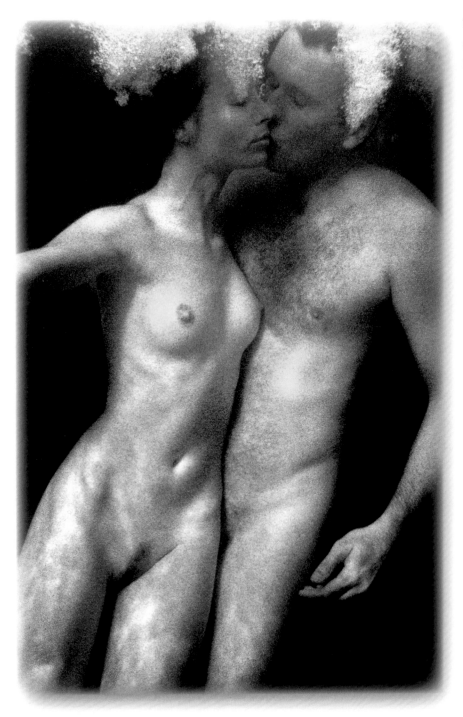

We met and it felt like all of the pieces of the puzzle had come together to make one complete whole.

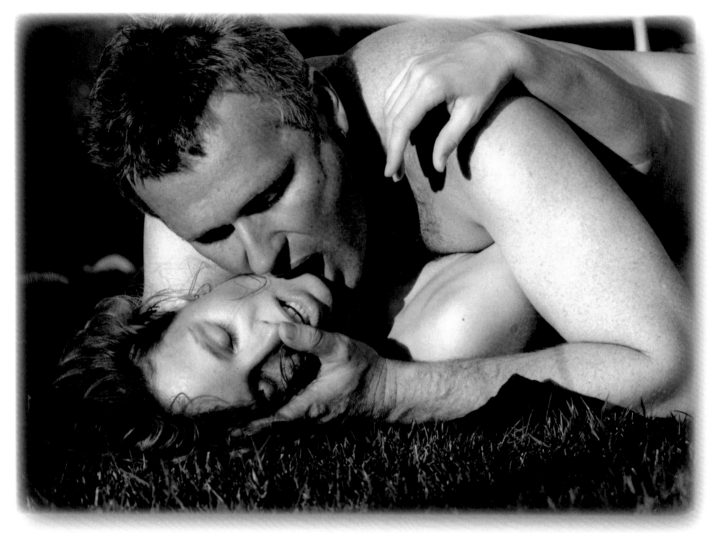

Being with Priska, my soul mate, I am open and willing to go deeper than I've ever gone in my own healing and strengthening of trust. Our marriage is such a wonderful path of growth.

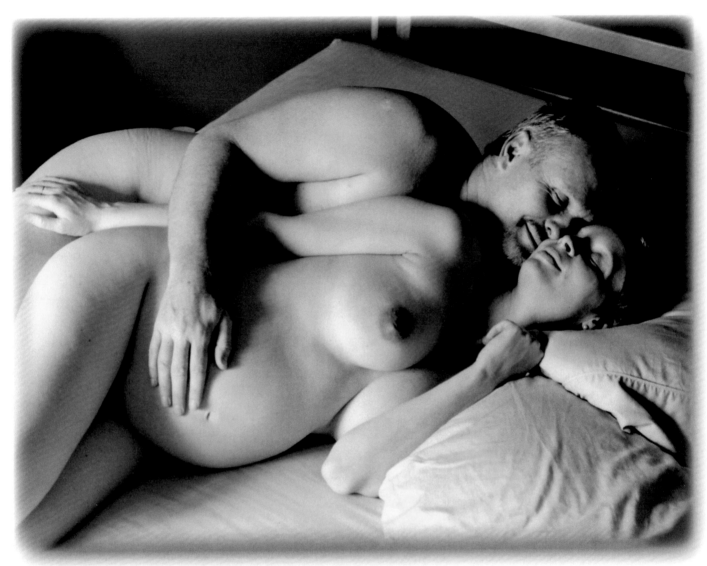

Over the years, I've watched Ron grow through various stages of life with me, beginning as my love, recognizing each other as soul mates, my beloved partner, my husband and now father of my child.

Now that we've birthed this little blessing (Cambria), it's as if a broader spectrum of color has been added to my life. I thank God every day for simply being alive, taking a breath and having the joy of creating our nuclear family.

What moves me most about Ron and Priska is their willingness to continually confront – rather than avoid – the fears and areas of discomfort within themselves that surfaced at various times throughout their relationship (and were often mirrored back to them through their partner). The spaciousness and acceptance each offered the other not only promoted the healing of decades-old wounds; it also opened the door to a richer and more authentic love than either of them had ever known. Here are the insights they shared with me about their experience of evolving love.

# Ron and Priska: In Their Own Words...

### How did you first meet and fall in love?

*Ron:* I got a message out of the blue from a stranger who said, "Hello, this is Kriska." (I continued calling her "Kriska" until she corrected me.) She said that she was here from Germany and would be visiting in LA for another week. A mutual friend thought that we should connect and gave her my number. Since I didn't know who she was I just put it off to the side. Then four or five days later I got another message that said, "Your friend speaks so glowingly of you and I'd love to meet you before I leave. If you're free, please come up to the Hollywood Hills where I'm staying since I don't have a car to meet you." So, I called her back and we made a date to meet. As I drove into the hills I began feeling butterflies in my stomach and I couldn't quite understand why. As I got out of the car, and walked up the long steps to the house, my legs got heavier and my heart raced. I thought, "What is going on here?" I arrived at the door with sweating palms, completely mystified by my reactions. I rang the buzzer and waited and waited. All of a sudden the door opened and there was my soul mate... instant recognition. We didn't even say two words, we just looked at each other.

*Priska:* When I opened the door, I couldn't even say hello. I just stared into his eyes. Then in the background my friend Lynn said, "Don't you want to ask him in?" I said, "Oh, of course. Come on in!" I remember how nervous and astonished I was. Inside I was thinking, "This is incredible. This can't be." So many emotions were stirred up as I wondered, "Gee, does he feel the same?" I actually had to disappear into the bathroom to collect myself. I don't know how long I was gone, but it seemed like forever. I looked into the mirror and said, "That man out there feels like my soul mate." It was an incredible experience.

*Ron:* Until that moment, I never believed in love at first sight. In my past relationships, I had been fear-based, always entertaining the thought, "I don't know if we're supposed to be together," and many other excuses that human beings come up with. This was the first time I didn't feel any fear, just excitement. Priska felt so comfortable and familiar, like an old shoe *(pardon the expression)*, as if I had known her for many years and even many lifetimes. She spoke very little English but it didn't matter because we shared such deep loving feelings and warmth.

 While Priska was in the bathroom, I sat with two total strangers as they both drilled me with questions like, "Who are you?" "Why are you here?" and "What do you do?" Most likely they were thinking, "Who is this man who has had such a strong effect on our friend?" I cannot tell you to this day what I said. I was completely in a surreal state, not remembering what time it was and feeling like past, present and future were happening simultaneously. I know they were very good friends of Priska's and they were being very protective.

*Priska:* Ron and I had dinner plans that evening but we never made it to dinner. We ended up going back to Ron's house and the evening unfolded into an intimate spiritual journey. We did hands-on healing with each other, and even though we couldn't verbally communicate very well, there was an in-depth exchange going on. We never did end up eating. Instead, we filled ourselves emotionally.

*Ron:* That night reminded me of what the gurus always say about living off pure energy and air. The atmosphere was completely kinetic, as if it was sizzling. This level of connection went on for days. We were completely present and totally focused in asking, "What is this and what does it mean?"

At the same time I was thinking that I had already gone through a divorce and I definitely didn't see myself settling down and getting married again. My whole focus was on my career and on teaching the messages of Tantra. Yet, when I met this woman it felt like all the pieces of the puzzle had come together to make one complete picture. She understood everything that I was talking about. Even though we didn't speak the same language, we just knew. There was a familiarity and a deep respect and love for one another. It was as if it hit us both on the side of the head, beyond our rational way of thinking.

*Priska:* In a relaxing way.

*Ron:* Yes, very relaxing. She had just come out of a relationship that had been very caustic and unhealthy. In the first three months together we did a lot of healing, loving and bonding to heal that relationship as much as we could.

*Priska:* Getting back to our first night together, by about 1:00 a.m. I was thinking, "Well, I need to go home at some point and get some sleep." We were sitting on the floor looking at each other and I just began giggling. It was so embarrassing because I couldn't stop, and pretty soon we both were laughing out of control. It was so silly and I remember thinking, "Gee, I've got to stop this." But it continued beyond my will. It was so intense that we both had to do something to calm ourselves down. The most logical thing was to simply hug each other. First we hugged and then we kissed... and we both knew this was it. From that night on I actually never left. I called my friends the next day and told them that I'd come by to pick up my two suitcases.

*Ron:* They were very worried. I'm sure they were thinking, "This is not good. What has he done to her?"

*Priska:* Actually they said, "What a wonderful man. Go for it. It couldn't be any better." That moment was an incredible turning point. We never had to ask the question, "When will we see each other again?"

*Ron:* It was clear.

*Priska:* It was a done deal right there and then.

*Ron:* I think that our immediate union also had to do with sharing the same spiritual path. When Priska first walked in the house she said, "This feels like my home. This is my temple." She had been studying self-realization in Germany and I was studying it here.

**When you say "Self-realization," do you mean Paramahansa Yogananda's Centers?**

*Ron:* Yes. Paramahansa Yogananda was part of the lineage and he brought "Self-realization" to the United States. When I look back at that time, I was coming from Germany, having practically no baggage, no apartment, no material things, and really no roots to tend to of any kind. And here was Ron who had just bought this house, and was wondering, "What did I get all of this for?" He didn't realize it at the time, but he was getting the nest ready for me to come into his life.

*Ron:* This was the first time that I had gone into a relationship without feelings of fear or concern. It was amazing, almost as if I was a third party watching this incredible union coming together. I was an observer and a witness to this special, special union. Even though we're dealing with life every day and all the challenges that come with it, I'm always reminding myself how blessed we are. We have many, many blessings.

**What qualities do you honor the most about each other?**

*Ron:* I honor Priska's honesty and her simplicity. She really has no facade. Perhaps it has to do with her being raised European. There is something very special about her unpretentiousness. What you see is what you get. She has a child-like quality that I cherish, and her smile brings me so much joy. Being with her each day allows me to get out of my own limiting thoughts, for as I look into her eyes, I see a light that is always shining. I feel so warm and blessed to always have her with me. It's just wonderful.

*Priska:* What I love about Ron is his positive outlook. At times, I beat myself up for decisions I've made in life that I feel I have to live with. Ron always sees the positive, reassuring me that whatever I do or whatever decision I make is going to be fine. This serves as an incredible relief for me.

**It sounds to me like he reassures a certain level of trust. Is that right?**

*Priska:* Yes, it's so nurturing and reaffirming. I do love Ron's strength. I know that in bad times I can lean against his shoulder and he'll simply hold me. He's not afraid to embrace me when I'm down or in pain. He'll really be there for me and I am so grateful for this. I also love Ron's smile, his childlike playfulness, and the degree of fun we share together. We giggle a lot and this really helps to lighten our outlook. Even when we're in the midst of an argument, we can often turn it around by suddenly starting to giggle. Feeling lighter, we might ask ourselves, "What are we doing here? This is not that serious. What were we fighting about? I don't know." It no longer seems important.

**Through your life experiences, what has been your path, and how have each of you learned to anchor a deeper trust with each other?**

*Ron:* Four years after we were married, Priska and I were involved in a significant accident. Out of the blue we were both hit in a crosswalk and thrown ten feet in the air, landing on the hood of a car that had been traveling at about thirty-five miles an hour. The impact broke Priska's pelvis and tore most of the ligaments in my ankle. Consequently, we literally were laid up for three months in our house.

*Priska:* It was the best thing to ever happen.

*Ron:* Before the accident occurred, it was clear to both of us that we had entered a rut with each other, being very busy in our lives and not really paying attention to each other and our needs. Suddenly here we were in the same room with each other every day, facing our fears for the first time.

*Priska:* Ron was on the one couch and I was on the other.

*Ron:* Right, and we really had very little help. Friends would come over and grandma was there which was great, but for the most part, we were simply stuck in one place together having to look under a microscope at all the things in our four years of marriage that we had buried and chosen not to look at. Everything rose to the surface and that mirror image was amazing.

Just before the accident, we had been discussing the possibility of separating because we'd been feeling so stuck in our old ways. Then suddenly we were given a three sixty view of our lives which really made us look at both our own and each other's wounds and fears. For the first time in our relationship, we started talking about them and for two or three months it was literally as if we were in therapy together.

*Priska:* Neither of us were able to run out or run away, literally.

*Ron:* In the past, we could always run away, block it out and be in denial about it.

*Priska:* I would go for walks to get away.

*Ron:* Our friends would come over during this period to visit and they were in shock because we were at the lowest point in our relationship.

*Priska:* There was one dear friend of ours; he was the best man at our wedding, a true brother, and one evening he sat with us and listened to everything. We couldn't have asked for a better friend to be there because he was so non-judgmental and supportive. It wasn't very pretty. We were really blessed that the clarity and love stayed right in that room and wasn't carried away.

*Ron:* There was a love touching us all.

**Priska:** Yes, it was a true blessing.

**What I'm hearing is that this was a time of anchoring into a deeper level of consciousness and commitment in your communication with each other and your willingness to be open?**

**Priska:** Right.

**Ron:** We had been very busy. We were teaching Tantra all over the United States, always on the go, being present on the outside for the public but often forgetting who we were to each other and why we came together. We had forgotten that we needed to do work on ourselves in order to bring the best of ourselves to the relationship. We were really far, far, away from this inner work and we were very unhappy.

That's when the accident came along and really woke us up. It hit us over the head, as if some spiritual force was saying, "Okay, I can't get your attention any other way, so it's going to be tough love," and I'm telling you, it was. It was tough. Priska almost lost her life. Within ten minutes she was having microscopic bleeding and she could have bled to death in that amount of time.

So we look at this experience as really being a blessing. It brought us closer together and it anchored us in a deep foundation of trust. I finally felt like I could say anything, be anything, do anything and be down in the deepest bottom of the barrel with the darkness and she would still love me, despite my fears of abandonment.

**Priska:** The love really deepened. It grew into something much greater than it previously had been. I'm actually so thankful that the accident happened because if it hadn't, I don't know if we would still be together. It would have been so much easier to just run out and be on my own instead of looking at Ron, looking into my own fears and actually saying, "You're right; I could improve there. You're right I wasn't fair there. I'm sorry." To actually say, "You know, I'm sorry. Can we start all over again and acknowledge each other's fears and needs and concerns?"

We needed a new perspective, because by this length of time together, we were very familiar with each other's fears and hang ups and we would usually take them personally and fight. The most important question we asked each other was, "Do we want to be in an evolving relationship or do we want to be by ourselves?" I always said to Ron,

"I know I want to grow old in a relationship. I don't want to grow old by myself. This is as about as good as it gets so why would I throw this away? Why would I want to meet somebody new?" I've never had that desire. I always knew that we were supposed to be together. So we mutually said, "Let's work on this. We can make it work. We can overcome all these things, wherever they come from, childhood, growing up, past relationships, whatever." I always felt clear in this way, and so the commitment was strengthened on both sides by us saying, "Let's work on it."

I am so grateful that we literally couldn't run away, because we really had found something that was so precious and so incredible. We were blessed to find one another. How could we throw it away like so many couples do?

*Priska:* I knew that this offered such a unique chance for me to overcome many of the challenges that surface in a relationship. I was clear that I was in the right relationship and I didn't want to walk away from it, even though it was causing me to confront some difficult things.

## What was your greatest fear entering into the relationship and how did you overcome it?

*Ron:* For me it was the fear of opening up. Through the years, my heart at times would close and I would not feel trusting. Old issues would surface; usually parent related, like the fear of abandonment. When I first met Priska, my heart was suddenly bursting open and there I was in the depth of something so immense.

Suddenly, in this raw and vulnerable state, all of my past hurts and betrayals began to surface and my heart began to close to protect itself. I found it really scary and difficult to allow my heart to open once it was hurt. Being male, I always find myself to be more in the mental state, trying to come up with a reason and then a result so that I can open my heart and be in the present moment. But I know that when I am able to create more love for myself, I can fully love Priska, Cambria, and everyone in the world. I think this is my greatest lesson here on Earth.

Before this accident I was really on a one-way path. Meditation is easy for me. I'm able to "go within" and block out many of the unsettling or upsetting things that are going on around me. It's a wonderful way of gaining clarity, but at the same time, I have also used it as a form of denial. For many years, there were times that I would use meditation as a way of not dealing with issues that were in front of me. Priska would have something to talk about that might be bothering her and instead of hearing her out, I would choose to go off and meditate. There have been

many instances when meditation has served as a great tool for tapping into a clearer knowing and understanding of the challenge in front of me, but I now see that part of my motivation for going off to meditate was to avoid dealing with my own pain.

Priska and I have now learned how to fall down in front of each other and give each other permission to make mistakes. When I'm down on my face and feeling vulnerable, I can look up at Priska and know that she is still here for me and she loves me. We're not acting out of abandonment as we did in the past, thinking, "Well, I'm getting out of here now." In our first two or three years together I was constantly saying to Priska, "You know what? Let's just walk away. If you don't like what I'm doing, there's the door." This response was my form of protection because I didn't want to be hurt. I'm so grateful that this way of thinking no longer rules my realm of operating.

Before I met Priska, I had not been in a relationship of any depth for six years. I had reached a point where I felt like I didn't necessarily have to be with another person. I could do this on my own. Being with Priska, my soul mate, I am open and willing to go deeper than I've ever gone in my own healing and strengthening of trust. Our marriage is such a wonderful path of growth.

**Priska, what would you say was your greatest fear in entering into this relationship, and how did you overcome it?**

*Priska:* I was far away from home and I hardly spoke the language. The trip was a vacation for me and I had no plans to stay here prior to meeting Ron. So, my first concern was, "Gee, if I marry this man I'm going to be living here and my family is in Germany." Knowing that I would be so far away from family and friends also triggered a deeper fear related to abandonment. In the past, my consistent pattern was to walk out of relationships. I would think, "I better leave before they leave me."

Committing to Ron and to living in a new country forced me to ask myself, "Why am I always running away? Why do I keep hurting myself?" This is why our accident was such an incredible eye opener for me because for the first time I couldn't walk out physically. I was literally confined to the bed.

**So what happens when you're in the midst of an argument with each other and anger and blame are coming up? Do you use a particular method that you're learning that supports you in being responsible with yourselves and working through it?**

*Priska:* We used to have this pattern where Ron would want to sit down in a very intense way and talk about what was going on, and I would always like to go for a walk, think about it, come back and talk about it.

*Ron:* By the time she would come back, I really didn't want to talk about it any longer, yet we really needed to come to a resolve.

*Priska:* Because of our history together, we now know each other's individual needs to resolve a problem, and we've developed a certain pattern of resolution that is much healthier. I now know that it's a wiser choice to not go out for a walk. Instead I'll choose to sit down and talk with Ron about our disagreement. By making this choice, Ron will be calmer and more receptive. I'm so grateful that we've grown quite a bit in this area because I'm realizing that life is hard enough as it is. We've agreed to make it easier on ourselves— in our own home and in our own relationship— by resolving our conflicts more quickly.

**What I'm hearing is that you could be in the midst of feeling angry and reactive but the two of you are learning how to put your egos aside in order to hear what the other's needs are in that moment. It sounds like you're developing a willingness to really listen so that you can set a foundation of trust and alignment.**

*Ron:* Trigger words like, "You did this," or "You made me do that," have always been difficult for me because I grew up hearing these kinds of words from my father and they would make me very angry. Most of the time when Priska and I argue, it's because we're reacting over trigger words that we're using. This gets us into a state where we both want to be right.

I am now aware of how important that it is to speak from a personal point of view, expressing how I feel, such as, "I

feel this" or "I feel that." When we both speak in this way, it supports us in getting past our need to defend ourselves, making it easier to hear each other's needs and our different perspectives. When we're able to get past this block, we can then work through anything. Therapy has also assisted us in peeling away layer after layer of our defenses and our fears, and I'm really seeing that this process is never-ending. I hope that when we're in our eighties, we're still in therapy peeling away those layers and remaining dedicated to our growth because I see that it's an ongoing process.

**One of the key elements that I hear from both of you is that you've made a commitment to voice anything that's uncomfortable so that it doesn't linger, grow and create walls between you.**

*Ron:* We've become much more sacred in our feelings for each other and in the way we respect each other around other people. We don't embarrass each other when we see things differently. We now wait until we're alone to discuss our differences – and this includes not arguing with each other in the presence of our daughter.

**So these days, when you find yourself in the midst of any kind of challenge with each other, whatever it might be, how do you work through the challenge? How do you reach that level of trust and safety in order to be present and available in order to get to the other side?**

*Ron:* Both Priska and I are firm believers in the benefits of therapy, so we're currently going and we're learning a lot. We're recognizing that we are not perfect and we're learning deeper communication skills that provide us with a safe space to deal with issues that are really bothering us. We're able to express what we're feeling in a very loving and very trusting environment instead of operating in the old fashioned way through judgment, fear and blame. It's an ongoing process. I'm finding that to communicate well requires constant attention. If something comes up for us to deal with, we do our best to stay out of denial and really go to the root of the problem so that we can clear it and move on. It's hard at times, but I try to be as present as possible as often as possible.

**When you say "present," part of what I'm hearing is that you are learning more and more how to communicate in a responsible way.**

*Ron:* Very much so. I can go weeks without expressing something that's bothering me, but when I do that, the emotions build up. Like my father, I haven't been the greatest communicator. Growing up in my family we were all very quiet, keeping our feelings inside to build and fester. It's no wonder that today I find myself exploding sometimes like my father did. His way of communicating was through anger. It was only recently that I made a true commitment and a conscious effort to catch myself from unloading all of my old unresolved issues on to Priska. It's not easy because these emotions and beliefs feel as if they've been impregnated inside me, making it extremely difficult to break through. So my attention is now strongly focused on how I communicate without judgment and be in the present moment with Priska as often as possible. Days can go by before we have a chance to talk things over and this can get a little challenging because issues build up.

*Priska:* We now have a commitment to clear up misunderstandings so that they don't linger on for weeks, allowing our mood to worsen. We've agreed to give a voice to the initial difficulty that's present. Over the passing years we've been through so many experiences – both wonderful and challenging – together, and we have always helped each other out of them. We've developed a trust in communicating our greatest dislikes by voicing what's present and **choosing** to grow from the experience. This trust exists because we share a mutual priority to see the relationship continue.

I am beginning to see many of Ron's grievances with me as valuable and interesting. When he says, "I don't like this and I don't like that," I can turn that around and actually use it to my benefit. When I don't like Ron's behavior because I feel he's expressing his opinion too much, he might be simply trying to help me out. It's easy to interpret criticism as negative, but I'm finding value in being open and learning from his point of view. Seeing in a different perspective suddenly turns out to be an incredibly helpful and insightful process for my own growth and for the development of the relationship.

*Priska:* One of the biggest lessons I've learned in this relationship is remembering that there is no right and wrong. Sometimes we just have two different opinions that we need to respect. There are times when we're seeing

things differently and an agreement just can't be found, but I'm seeing that I can still be with Ron and love him even though we're not seeing things in the same way. For me, this a big key in keeping the relationship going; remembering that he's an individual and I am no longer going to try and change him. With this outlook, the relationship just continues to get better and better.

**Let's talk for a moment about this beautiful little being here in the swing. How has the pregnancy and birth of Cambria altered or deepened your relationship?**

*Priska:* I intuitively knew when Cambria was conceived. It was a beautiful moment in Mexico on the Isle of Mujeras while we were on a vacation.

*Ron:* The Isle of Mujeras (The Isle of Women) is where the Mayan women would go to conceive. It's a very beautiful place and its history was devoted to fertility. Cambria was conceived on the fertility island.

Several months before Cambria was conceived, I actually had a miscarriage. As painful as it was, that experience was a blessing for me, because I was able to recognize how deeply I wished for a child. In the first pregnancy I didn't have that strong of a calling. My deep wish for a child really grew out of the experience of having a miscarriage. When I learned that I was pregnant with Cambria, I was ecstatic, and it was such a conscious conception. We really embraced the news. Everything went well the second time around, which was such a blessing.

*Ron:* Now that we've birthed this little blessing, it's as if a broader spectrum of color has been added to my life, and it's full of excitement, pure joy and renewal. It's quite wonderful and it's something that I've dreamed about, but never felt I wanted until I met my soul mate Priska to share in this dream together. Priska is such an incredibly loving and wonderful mother, and Cambria is nothing but pure joy. I'm finding that my priorities have completely changed. When I wake up each morning it's not just about me any longer; it's also about making sure my daughter is safe and free in this world.

*Priska:* Ron and I have come to accept that during this early stage of Cambria's life, we're not going to have much time for ourselves or for nurturing our relationship. Parenthood is taking a tremendous amount of attention, but we are treating the whole situation with such joy. There are times when certain things fall short, but it's all worth it when we see her smile. Ron and I look at each other and say, "That's all right. We didn't have much time for each other today but let's take a moment right now." We can forget about a romantic night of being loud and crazy. We're simply in a different life stage right now and we knew this ahead of time. Over the years, I've watched Ron grow through various stages of life with me, beginning as my lover, recognizing each other as soul mates, my devoted partner, my husband, and now father of my child. I just love him in all those roles. He's an incredible dad. I wish that I had had as loving and attentive a father. He's physical, he's fun and it's just wonderful to watch him grow.

*Ron:* Sometimes I have fears of being able to be both a good father and a good provider. It's very important that I give my daughter enough consistent quality time for her to experience who I am. I grew up with a dad that was constantly working so I didn't have that sense of bonding I think a child needs. Of course my career and business are important so that I can financially provide for us, but the most important thing in my life is my family and the ability to be present with them. My greatest wish is to make it as safe as possible in this world for this precious little child that's come into our lives. As she grows, I wish to honor her freedom to choose who she is and who she wants to be, encouraging her devotion to knowing herself and making her own wise choices. It's important that I get out of the way of her development and simply provide a safe and loving space for her.

As long as we stay true to ourselves and true to being joyful and in grace, there's really not a lot more to ask for. I thank God every day for simply being alive, taking a breath and having the joy of creating our nuclear family. Priska, even now I look at you in a different light. You're holding our daughter so tenderly and it's a blessing to watch the expression of this love unfold, to be a witness. This is one of my greatest wishes, to always be a witness in life. I don't pretend to know anything or be anything. I'm learning that I'm a student and I always will be. I'm witnessing incredible magic and blessing in just being with Cambria each day and in witnessing the glory of her birth. Simply being a witness to life. It's truly amazing.

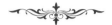

Thanks in part to an accident that left them nowhere to run, Ron and Priska's relationship continues to be enhanced by the reflections that each offers the other. Their evolving and rewarding journey is the result of a mutual decision to embrace the value of honest feedback and use it as an opportunity to evolve, rather than as an excuse to contract.

Several years into our marriage, Cynthia initiated one of *those* fiercely honest conversations that – depending on the spirit in which it is both shared and received – can either make or break a relationship. We were out for dinner at a local fish restaurant and I could tell that something critically important was weighing on her mind. Courageously, she let me in on the issue that was bothering her, sharing that if I didn't become more consistent and reliable in bringing in a higher level of monthly income, she could no longer stay in the relationship.

Her concerns were of no surprise given that throughout our entire time together, and long before, I lived the archetypal life of an artist living hand to mouth, never knowing when my next job or check would show up – and in many ways, enjoying the freedom and variety that comes with that type of uncertainty. Even so, as Cynthia spoke these words, I felt as if I were shrinking into the seat of our leather booth. Immediately, memories surfaced of being with my first wife twenty-five years earlier, also at a restaurant and witnessing her outstretched arm reaching across the table while handing back to me her wedding ring.

Fortunately, I had the presence of mind to remind myself of the tremendous lessons I had learned in my first marriage and that I didn't need to continue repeating *this* pattern any longer in my present relationship. In that moment, I chose to bring my full-size self back to the table and decided to use this opportunity to shift the way I related to money. This would require me to take a greater level of responsibility for how I managed my finances and structured my business. I had known for years that one necessary ingredient entailed acquiring a few ongoing clients who would provide consistent and reliable income. Up to this point, I thought I'd been placing a lot of intention on this goal, but the facts reflected the truth of the situation: I'd made very little progress.

I knew it would not be an easy process – as most lifelong engrained patterns tend to hang on for dear life – but the stakes were high enough to allow Cynthia's honest feedback to serve as a catalyst for forging a deeper level of commitment in our relationship, and in my relationship to my finances.

Once I released all traces of victimhood, my wiser, adult self was able to show up at the table and truly understand why this issue would be a deal-breaker for Cynthia. The truth is that I was also sick and tired of repeating this pattern that usually brought me grief and stress, and I could see how it would inevitably have ill effects on my partner. While sitting at that dinner table, I agreed to take some immediate action steps. In the next week, I would do a *reality check* and write up a list of average monthly expenses and income. We would then meet to review this list. Next, I would research potential clients that could be a good fit for my photography niche. I was also willing to consider part time teaching as an additional option, something that my ego would have never allowed me to consider in the past!

I began taking these bolder steps and my circumstances started to gradually shift. A dear friend introduced me to an educational tour company and that launched the birth of a fruitful working relationship that became a perfect fit in providing a more stable and ongoing income while learning, traveling and doing what I love via advertising photography. Other ongoing photo jobs began to surface and a sweet exhale of relief and rising trust and respect began to surface in our marriage.

Like the candid sharing that took place between Ron and Priska, this bold conversation was clearly necessary for me to make it a strong enough priority to shift a lifelong, encrusted pattern that I likely would not have taken the initiative to shift on my own. To this day, I honor Cynthia for having the integrity to listen to herself, and the courage to voice her concerns rather than bury them. And I also honor myself for making the choice to rise to the occasion she presented to me.

The "easy" road is to recoil from any feedback we receive from our partners that could be construed as criticism, but if we take this path, we rob ourselves of the expansion that is ours when we embrace rather than deflect the reflections offered to us by the mirror of our relationships. Accidents, confrontations and ultimatums can actually serve as powerful wake-up calls for both partners to commit more fully to telling the truth, to being more vulnerable, and to more courageously asking for what we need.

# Chapter 3

## LOVING BEYOND LABELS
*The Evolving Love of Sunshine and Sunny*

Shortly after having the realization that the exploration of the evolution of love would not be complete without including perspectives and insights from same-sex couples who have created successful, long-term relationships, I set an intention that I would be led to the perfect couples, both male and female.

One of the first female couples that came to mind was Sunshine and Sunny. Because we share the same spiritual community, *Centers for Spiritual Living*, they have been in my peripheral for several years. I recalled seeing them at past retreats and at various services at the *Agape International Spiritual Center*. Each time I've been around them, they've impressed me with their openness, their sense of giving, and their deep love for one another. I was deeply grateful that they "caught the vision" of this project and were courageous enough to say *Yes!*

One profound quality that was consistently present during my time with this couple is their innate ability to speak and lead from a place of honesty, clarity and conviction. Throughout our interview, I witnessed such a natural flow of exchange in the way they shared their story; each trading off and adding nuances to the other's perspective, as fluid and natural as two rivers that join together at the perfect moment.

# Sunshine & Sunny

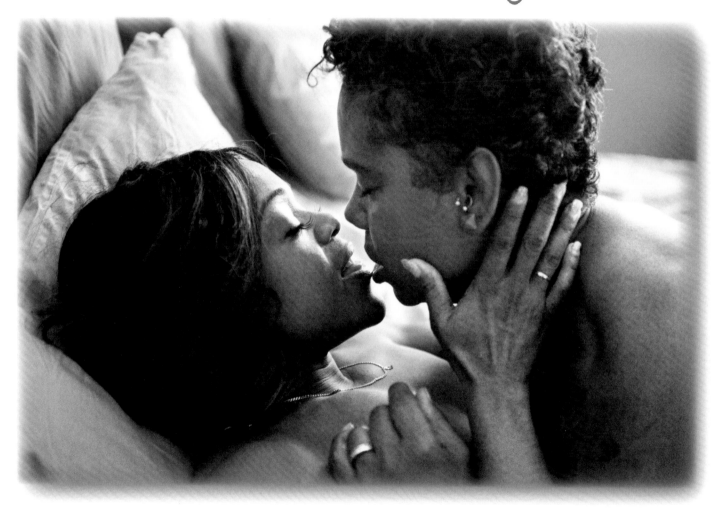

There's an agreement that we made early on, a soul agreement that love wins. When I met Sunshine, love took me over. I'd never been taken over by love to the point where anything that seemed to be against it just disappeared. Anything that could be contrary to it couldn't exist in the face of our love.

It was an internal job for me to learn to trust, a process of letting go. I had to consciously tell myself, "I have an opportunity to enjoy and partake in this rich exchange of love." It was about resting in the knowing that Sunny and I were exclusive, even if she was traveling for work for three months.

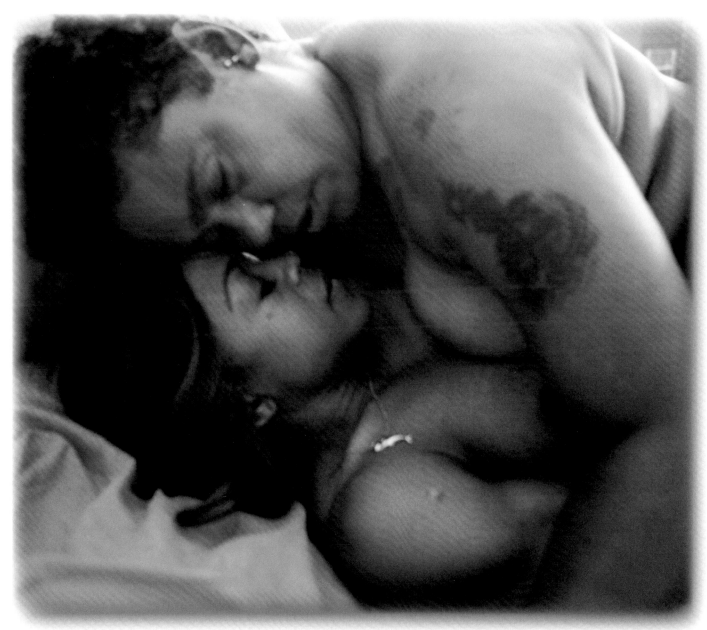

Sunshine had all the qualities that I knew I wanted but had never found in one person. How could one person express such kindness, openness and generosity towards so many people and yet give you the feeling like you're the most important person in the room?

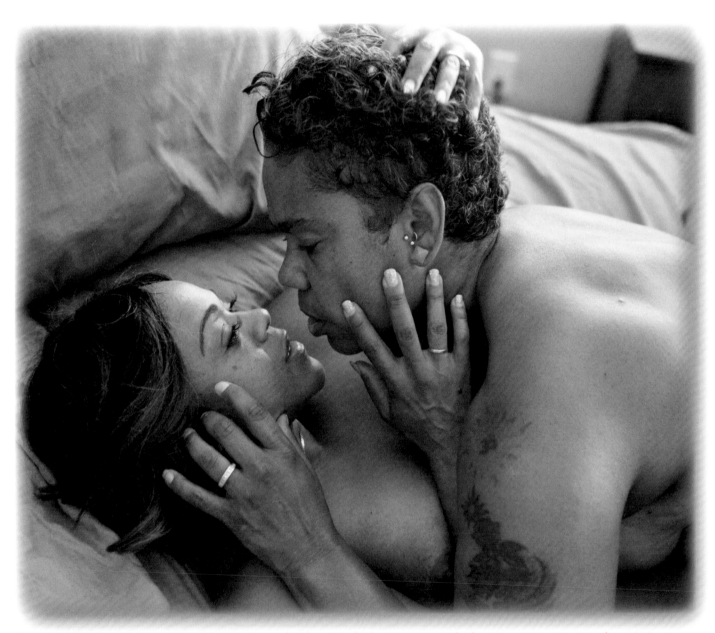

Sunny's love for me is not conditional on whether I'm behaving or misbehaving. It just is. Our love is just our love and we get to share it and express it. We're still growing in our love together because we have a strong foundation that we've built upon.

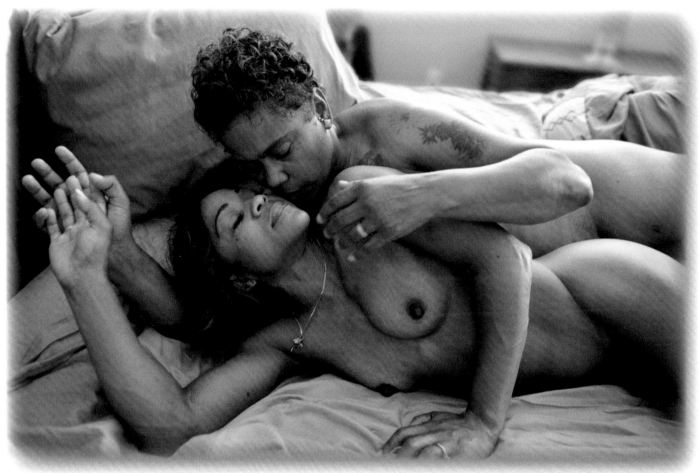

I think about our lives and how great we are together. It always comes back to our original agreement, which is how each of us is honoring what the other is committed to go out in the world and be and do.

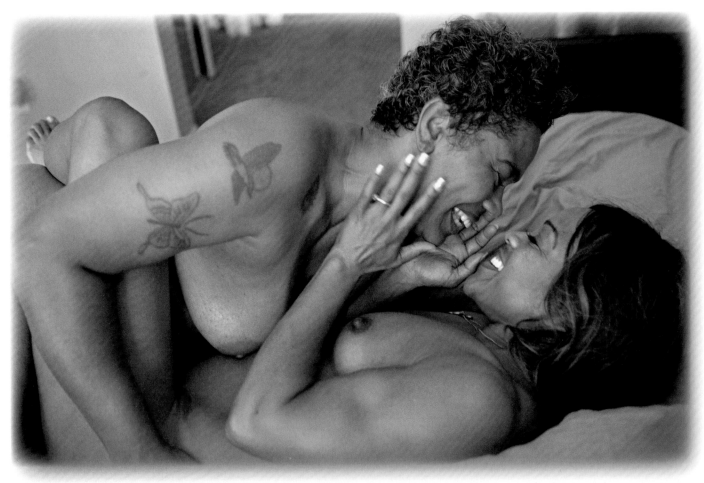

I decided that I was willing to turn my heart over to Sunny and show her the best of who I am because I was loving the experience of being with her so much. It was unlike any other relationship I'd had.

Both Sunny and Sunshine share a deeply rooted spiritual practice that I believe supports them in standing strong, both together and as individuals in the world. There's a strength of trust that you feel while in their presence, an unwavering purity of honesty. I was sincerely moved by their story of uniting as a couple, because it exemplifies a deep clarity and courage to follow their hearts, not letting limiting labels, conditions or past experiences define them. They truly live life led by love's wisdom and its innate direction, beyond the confines of conventionality. I witnessed the deep respect they share with one another and the commitment to support each other in living the most expansive and purposeful life imaginable.

# Sunshine and Sunny: In Their Own Words...

**Let's start by the two of you sharing how you met and how your love story has evolved.**

*Sunny:* It was years ago. I was twenty-something; just a child. My mom was performing in this show, Jezebel, in Los Angeles, and Sunshine was the stage manager. I had never met her, but my mom raved about Sunshine. One day, I went down to watch a rehearsal and was abruptly stopped at the door and told that it was a closed rehearsal. Sunshine is the woman who stopped me.

When I say abrupt, I mean she wouldn't even let me get in the door. I told her that my mom is the star of the show, and she said, "Oh, you're Wendy's daughter. Okay." Then she let me in. It was not a love at first sight but there was a knowing, definitely a knowing, between us.

Her looks really caught my attention. She was so pretty and so butch at the same time; I'd never seen anyone like her. She was like a creature from outer space and she stirred my interest in an instant. As the rehearsal went on, I was standing behind her in the lighting booth, and even though we hadn't yet connected, I sensed a very strong vibration that told me that something important was going to happen between the two of us. I didn't know when and I didn't know what, but from the first moment we met, that knowing was established.

**Sunshine:** Yeah. It was. I was in the lighting booth, calling the show. I'd just come on board as the new stage manager, and was really focused on making sure that I was doing my job correctly – that the lights, the sound, that everything was as it should be. All of a sudden, I felt this strong energy behind me that just stopped me in my tracks. When I turned around, there was Sunny, watching the show, noticing me, and just being present. I remember thinking to myself, "Wow. This is powerful." I knew I had to get back to calling the show, but it was like something was taking me over – like a spell.

**Sunny:** The show had to do with spells and high sexual energy, and my mom was playing Jezebel. So our very first meeting was infused with this electric energy. It was pretty deep.

**Sunshine:** We both felt that knowing between us, but the time was not right to pursue it. I was in a relationship, and I later found out she was in a relationship, also. Then about a year and a half after the show had ended, the director of Jezebel called to tell me he was directing another show, and asked me if I wanted to stage manage. I said yes, and then he goes, "Okay. I need you to call Wendy. This time I want her daughter to be in the show." I remembered Sunny immediately and the incredible energetic connection that we shared the day we met. I was excited that we'd get to spend time together during rehearsals getting to know one another.

**Sunny:** How perfect is that?

**Sunshine:** A lot of folks in the theater world want to experiment, especially sexually, because we're always working in that environment of creativity and adventure. Sunny kept telling me, "You know, we should do something together." I kept putting it off and putting it off and finally one day, she said it again, so I said, "Well, do you want to get a room?" She paused, tilted her head and then said, "No. That would just cheapen the experience." From her answer I knew that she wasn't just looking for a one-time adventure with a woman. She actually wanted to get to know who I am. I was impressed by that.

**Sunny, what was going through your mind when Sunshine asked you if you want to get a room?**

*Sunny:* I probably blushed from head to toe. I've never been a big dater, and her question told me that this was going to be a really on-the-edge encounter. I was like, "Whoa, get a room? The whole 9!" The idea of that was just a bit much for me.

**Previous to that meeting, had you had any sexual relationships with women?**

*Sunny:* I had, but they were all just casual flirting under the influence of a lot of beers and wine. Otherwise, I'd never had any willingness or interest. To be clear, lucid, sober, was something totally different. I had no intention of having a few drinks and then getting a room. It never crossed my mind.

**You were clear that you were interested in getting to know her.**

*Sunny:* Yes. I was very interested. She was, and is, very interesting. She did a lot of things that stirred excitement in my belly. She'd go in the sink and splash water on her face and hair, then throw her hair back like Fonzie. I was thinking, "Oh, my God. This is awesome. She is so cool."

**I can see it!**

*Sunny:* I just thought she was super cool; superhero cool.

We started passing romantic notes back and forth like, "What are you doing today?" through the fax computer. Do you remember those? Whatever you were doing, you'd have to wait to get the response. We talked on the phone a lot. I remember thinking that the way things were unfolding seemed really familiar. Being on the phone for hours when you've got only one in the house, stretching the cord so you can sit on the steps. Those conversations started happening more and more frequently, and soon I was spending time at her house. One time when she was asleep, I actually looked behind her head and behind her neck to see if there was a switch. I really thought this being must

be from another planet. I'd never met anyone so genuine and so open-hearted and kind and sweet. She had all the qualities that I knew I wanted but had never found in one person. How could one person express such kindness, openness and generosity towards so many people and yet give you the feeling like you're the most important person in the room? That's a really special quality. I was under the spell of that, and it was infectious.

**That's beautiful. Sunshine, what was your experience of that time in your relationship?**

*Sunshine:* She was the most attractive woman I'd ever been with. From the first day when she walked into the theater, I was like, "Oh, my gosh. She's so adorable. She's so pretty. She's so sweet." Every time we were together I felt that same electric energy that I'd felt in the lighting booth. It was so powerful. And when she replied to my offer to get a room with, "No, that would just cheapen the experience," I was thrilled, because at that moment I knew that something bigger was going to happen between us. The more time we spent together, talking on the phone together, the more interested I became. I was deeply curious as to what made her tick and to learn what she wanted to do in life. And at the same time I was also a little afraid because I really liked her, and since this was her first time being with a woman, I was scared that it might just be a phase.

I decided that I was willing to turn my heart over to her and show her the best of who I am because I was loving the experience of being with her so much. It was unlike any other relationship I'd had. In the early days, when we'd see each other at rehearsal, we had plenty of opportunities to make love, but we chose not to. We'd simply say, "See you tomorrow. Good night." Leaving rehearsals, we would drive along the same freeways together, and when the 110 and the 91 split, we'd wave to each other like, "Bye." The connection between us was already so strong.

**Sunny, how did your mother react to you being with a woman?**

*Sunny:* In the beginning, not well. In fact, she actually organized an intervention to make sure I knew what I was getting into. In hindsight, it was really hysterical, because my mom's friend Steve, the director of the show, is a gay man, and her other BFF at that time is also a gay man. Also, Steve was a longtime friend of Sunshine, so he already adored her, adored my mom, and adored me. So really, my mom was outnumbered at her own intervention!

Those who were present were not really on her side, but they showed up out of friendship, and ultimately, they helped her come to terms with the situation.

*Sunshine:* I think your mom's intervention was just her way of finding out what my intentions were with her daughter, because back then, being gay and being out wasn't this fabulous thing. The pressures back in the day of being an open gay person, whether you were male or a female, wasn't always very pretty. It wasn't very sexy, because it was far from being understood. It's a very hard life to hide your true feelings and not be able to openly express your love.

*Sunny:* After the intervention, my mom understood that I'd prayed for this person to come into my life, and I can't help that she happened to be a woman. I told her, "This is what that looks like for me." I was really clear. It's just about love. That's all I can say. I don't know any more than you know at this point but I know that it's pure. It's clear and it's love. That's all I know.

My mom came away from that experience without a definitive answer about what was going to happen. None of us had an answer as to what it was going to be. How could we? I just knew that it was love. Steve, Tracy and Karen, who had been with her during the intervention, said, "Well, let's just see. They're both amazing people. As long as they love each other and we love them, it's going to be okay." They comforted her through it.

Later that night, I sat in the dark in meditation, listening to the King James Version of the Bible on tape. All I kept getting is that this was love. Love. Love. In time, Sunshine and I started pushing the envelope a little bit at a time. She would stay over because I lived with my mom. I remember one time she wouldn't let her stay in the house with me, so we slept outside in the bed of a truck in the driveway with a blanket and a Futon mattress.

**Did your mom eventually come around?**

*Sunny:* She did. She couldn't deny how happy we were when we were together. We were just so jolly all the time. Remember when she said, "Now I see why they call it 'gay.' It's because you're happy all the damn time!" When she saw our joy, I think that was the turning point for her. She realized that she hadn't done me wrong; that

I was deeply in love, and that even though my sexual orientation didn't fit neatly into a category, everything would be okay.

I never got caught up in, "Does this mean I'm gay?" All I knew is that I love Sunshine. I understand that this may cause people to want to define me with a different label, but I love who I love. That I can't help. I was always clear about that. I've never really felt the need or the pressure of having to identify as a lesbian or as a lesbian woman. I've just always known that she was my girlfriend and when we got married, then she was my wife.

**I'm curious to get your opinion on something. I was just spending time in Sonoma County with my oldest friend who I've known since I was 5. In the last couple of years, their daughter recognized that she is attracted to women. She told her parents that – at least in her understanding – the term "queer" is now used to signify that someone is not interested in placing a particular label on their orientation, and that the word can encompass many different possibilities. Is this your understanding as well?**

*Sunshine:* Back in the day, "queer" was a derogatory term. Now it's being embraced by a lot of people, particularly those who are heterosexual allies to the LGBT community. I think what the word really signifies is gender fluidity. It embraces all levels of sexual attraction and expression and human expression. It encompasses any possibility.

**How about your parents, Sunshine? Are you in touch with them at all?**

*Sunshine:* Yeah. My parents are Jehovah's Witnesses. I came out when I was 15, and left home when I was 16, but they love Sunny now.

What Sunny and I have both realized is that it's also a coming out process for parents and for friends as well. It takes time to accept that, "My daughter is gay," and to allow that phrase to just roll off the tongue, because that's just what it is.

*Sunny:* My mom has come to fully accept my choice, and now introduces Sunshine as, "My daughter-in-love," and Sunshine calls her, "Mother-in-love." There was a difficult period of adjustment in the beginning, but they were all such loving people. There was no sense of hatred or anger coming from them at all. In my heart, I always knew that love is going to win here.

**How long have you been together?**

*Sunshine:* Coming up on 19 years.

**So you've had a great vantage point to witness a lot of changes as society has evolved to a level of much greater openness and acceptance of same-sex love. How has that affected the two of you, as individuals and in your relationship? Has it shifted ways that you are able to be with each other in public? Is it something that is helping to support and enhance your relationship, or is it something you even think about at all?**

*Sunshine:* I think about it often. Sunny is very affectionate. If she wants to hold hands, we're going to hold hands. She comes from a different mindset than I do, me having been discriminated against and even bashed at certain times of my life for being gay. I think I'm a little more reserved out in public. Once marriage was legalized, I saw a shift in the outer world in terms of how many more folks were holding hands – gay couples and straight couples alike. Sunny's always just been, "Hey. This is love. This is who I love." Not even with an attitude of "deal with it," but just expressing and living and being who we are, which has always been refreshing for me. We've never been confronted or condemned because of our love, which is really great because I would never want her to have to experience that.

I find that when people meet us and get to know us, they can feel the high vibration that Sunny holds. It's an attitude of, "Hey. This is who I love and that's the way it is." I think that because she carries this high energy, it's easy for people to go along with it.

*Sunny:* I totally agree. There's an agreement that we made early on; a soul agreement. I know it sounds cliché, but our agreement is that love wins. When I met Sunshine, love took me over. I'd never been taken over by love to the point where anything that seemed to be against it just disappeared. Anything that could be contrary to it couldn't exist in the face of our love.

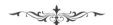

From the time I entered my teenage years, I have always considered myself a pretty progressive thinker when it comes to viewing all people as equal. Raised in a very liberal suburb of West Los Angeles and entering my teens in the late sixties, I was deeply influenced by the wave of "free thinking" all around me, and these values and ethics deeply resonated with my soul. Attending a *left of the left* liberal arts college in Northern California further anchored these values within me and the perspective of seeing all people as equal; whether straight, gay, male, female, rich, poor, educated or not. I've always viewed diversity as a good thing; a healthy component needed in our world on every level in order to maintain a healthy equilibrium and ecosystem.

For this reason, my expansive day with Sunshine and Sunny exemplified a courageous couple living their lives full out while not being bogged down by antiquated labels or cultural conditioning. I intentionally chose the word *courageous* because it does take tremendous strength and fortitude to live our lives in accordance with our values rather than being swayed or brought down by the ups and downs of fearful thinking that permeates throughout our society and in the world at large.

When Sunny shared that she preferred to stay away from being labeled a particular sexual orientation, such as a lesbian, gay, bisexual, etc., I truly understood and related to her purview. I share the same belief that when we place labels on people and things, the labels can serve as a form of cementing one another into a fixed and immovable position that can later be difficult to change. Of course we live in a world based in language and we're naturally going to call a rock, a rock. But there are certain labels that we can be mindful to not place a preconceived identity upon in order to allow room for their change and growth.

I witness in the millennial generation more and more young people that are not the least bit interested in being labeled. They don't wish to be placed in any semblance of a box. Perhaps this trend is in response to the collective culture beginning to recognize that certain labels can foster a life of acquiescing to certain limitations. I sense that it's all part of our evolution as a species. The more consistently that we recognize, in all of its shapes and forms, that love is love, we continue to transcend all preconceived notions that have become stagnant, rather than pliable.

Bravo to Sunny and Sunshine for serving as brilliant examples of love evolving beyond labels!

# Chapter 4

## OPENING TO THE PRESENT MOMENT: DELIVERING WITHHELD COMMUNICATIONS

*The Evolving Love of Rick & Susun*

My first meeting with Rick and Susun took place on a secluded Maui beach where these pictures were taken. Upon meeting, I was instantly impressed by how lighthearted, joy-filled and loving they were – both toward one another and with me. The entire time I was with them, I felt as if I were floating on a cloud of grace and love, encompassed in their sweet zone of unity. Watching them interact, I thought the two must have uncovered some kind of secret for keeping long-term relationships vital, intimate, and alive. It turns out they had, and in the conversation that followed, they shared it with me.

Over the twenty-three years they were together, the couple had made a regular practice of doing what they called a "Withholds Process," during which each provided for the other a safe and trusting space to communicate thoughts, feelings, judgments and resentments that might otherwise fester beneath the surface and erupt in an inappropriate or even hurtful way. The practice of taking turns sharing withheld communications while holding one another in an attitude of acceptance and non-reactivity enabled them to create and re-create an atmosphere of honesty and lightheartedness. As a result of consistently disclosing – rather than repressing – the changing landscape of their inner worlds, the two were incredibly present for one another and able to truly enjoy every moment of their life. Remarkably, the connection that flowed so easily between them continued even after Susun's death. Thanks in large part to the communication practices the two had developed while they were both in physical form, theirs is a love that continues from this world into the next and back again.

# Rick & Susun

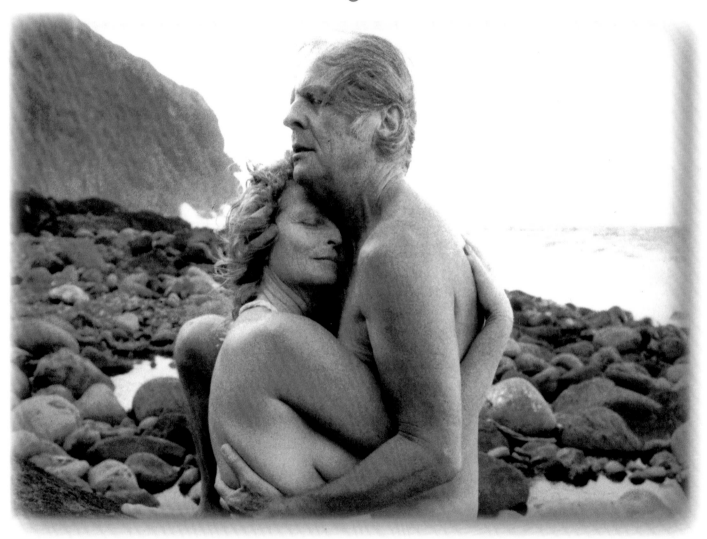

Rick and I came together in the summer of '75. I was a free spirit flower child in Hawaii and he was a Honolulu lawyer. There were so many opposites about us so kept to our motto, "Go for what you know," which ultimately resulted in more love for each other.

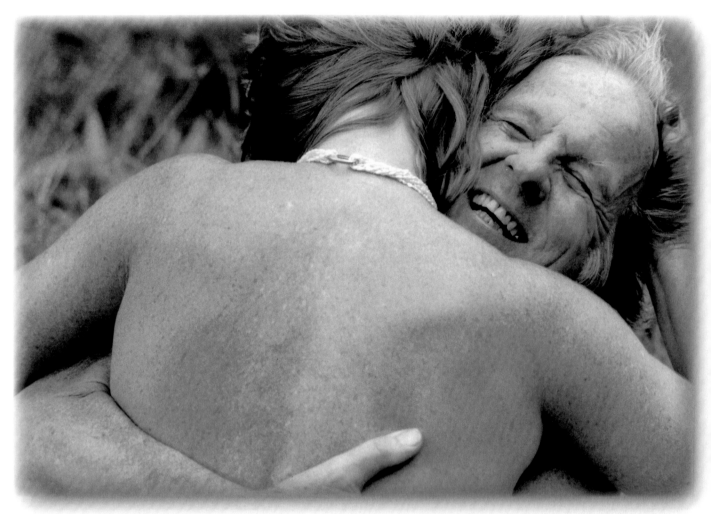

Susun is my guru of joy. She saw long before I did that fun was the highest form of life. Susun says, "What if you were fully realized? How do you think you'd feel?" Well, I'd probably enjoy it like an ice cream cone. She says, "Then let's act as if we were realized."

Shortly after we first fell in love Rick announced that he saw us as being equal, and we've spent the last nineteen years working out what that means to us. There have been untold opportunities for us to practice true equality.

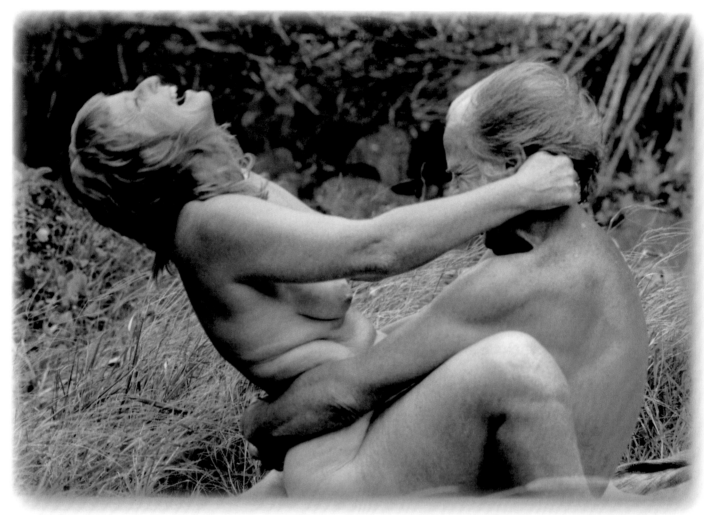

We focus on enjoying our differences. Susun is my main exterior reality. A lot of what I think of myself is reflected in what she sees in me. We practice seeing the best in each other and focus on each other's perfection.

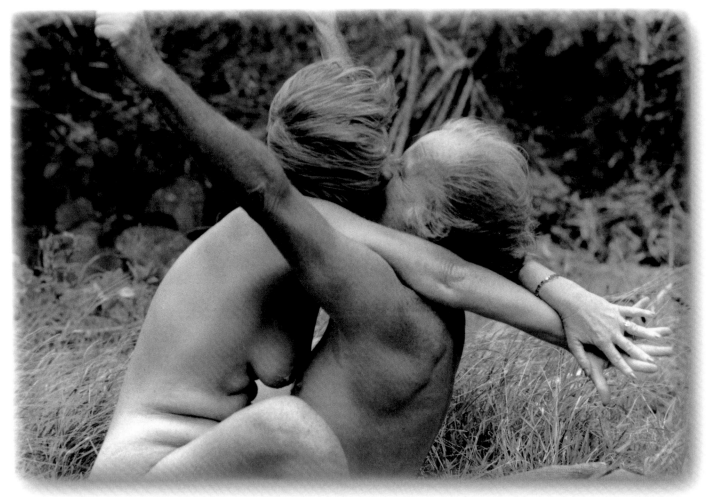

After all these years, Rick and I are still very different. But one thing has never changed and that is the desire we share together to experience God in each other's arms.

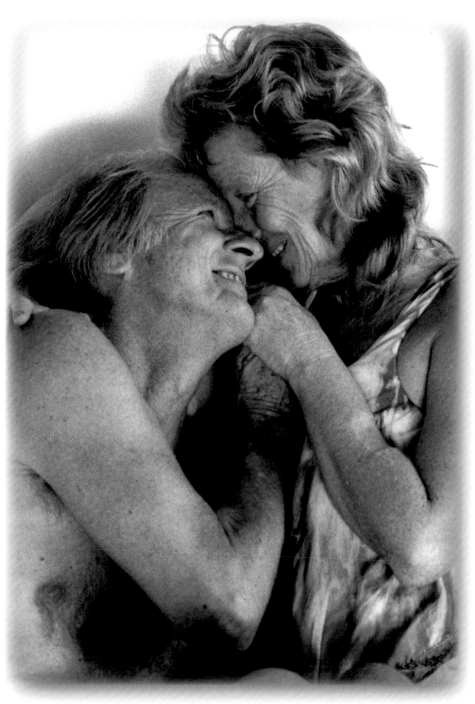

Anytime that I'm in judgment with Susun, it keeps me out of perfection, so I've learned that when I judge, to then forgive at the first possible moment. Forgiveness neutralizes the judgment and I see that forgiveness isn't related to my partner, it's about freeing myself.

Here, in their own words, are the principles and practices that supported Rick and Susun in creating the joy-filled and loving connection that the two will share for all of eternity.

# *Rick & Susun...*
# *In Their Own Words*
# *Interview #1*

## What has been your secret in keeping the love fresh, new, growing and fulfilling over all these years?

*Rick:* Susan is my guru of joy. She saw long before I did that fun was the highest way of life. In the very beginning of our relationship, Susun asked me, "What if you were fully realized? How do you think you'd feel and how would you react to the world?" I responded, "Well, I'd probably enjoy it, like an ice cream cone." And she said, "Then let's act as if we are realized." To the best of our ability, this is how we live.

*Susun:* When Rick and I came together, he had just turned 42 and I was 22. I was a free spirit flower child living in Hawaii and he was a respectable Honolulu lawyer. This seemed like a huge difference between us, but we found common ground in the motto, "Go for what you know," which to us means to go with our intuition about what feels right. The commitment to really listen to ourselves and to each other has led us to a deeper and more honest experience of love

*Rick:* The relationship itself has never been our goal. We spend our lives helping each other attain a higher awareness of self-realization. We are equals. As simple as that sounds, it has taken us a long time to get it. When we are being equal, there is no trouble between us at all.

*Susun:* Shortly after we first fell in love, Rick announced that he saw us as being equal, and we've spent the last 19 years working out what that means to us. Not only was it a novelty for Rick to treat the woman of his life as an equal, but as a young woman, recognizing my own equality was a tall order that I had to grow into.

*Rick:* We are now in our nineteenth year together, yet we remain remarkably different. We've learned to focus on enjoying our differences. For me, Susun is my main exterior reality. A lot of what I think of myself is influenced by what she sees in me. This always works both ways, so we practice seeing the best in each other.

**Over the years, when the differences between you led to conflict, what methods have you used for working through your challenges?**

*Susun:* Early on, I spent my days in simple flow, while Rick's were spent in careful order. We had fun, we made love a lot, and we frequently took distance from each other. We'd return with fervor and adoration, and when our old habits surfaced that got in the way of feeling happy and fulfilled, we made a commitment to always be truthful and thorough in our communication with each other. We held to this commitment, even in the midst of struggles when it felt extremely difficult or even impossible to reveal ourselves and explore our deeper motives.

*Rick:* Anytime that I am in judgment with Susun, it keeps me out of perfection, so I've learned that as soon as I realize I am being judgmental, I forgive at the first possible moment. Forgiveness neutralizes the judgment and I see that forgiveness isn't about my partner, it's about freeing myself.

*Susun:* After all these years, Rick and I are still very different but one thing has never changed and that is the intense desire we share to experience God in each other's arms. I'm now the age that Rick was when we joined

together. I marvel at the times and spaces that have woven their stories through our days. We like to say, "Nineteen years? It seems like yesterday! Nineteen years? It seems like forever!"

# *Interview #2*

A few years after our initial meeting, I visited with Rick alone following Susun's passing due to skin cancer. As we sat together in the couple's Hawaiian home, he shared the profound spiritual dimension of their relationship that blossomed after Susun's passing. Rick described how much of Susun's love he now finds himself receiving from the other side, and his experience of being gifted with the qualities about her that he loved the most. Although I had personally witnessed the closeness of their relationship, I felt little to no sadness as he spoke of Susun. Rather, it was as if she was still a fully present and essential part of his life.

## What is the greatest gift that Susun brought to your life?

*Rick:* When we met twenty-three years ago, Susun taught me how to love, she taught me joy and she guided me to open in a way that I had never known before. Others had tried, but she really gave me my graduate training in an area that is of the utmost importance to me now. Love is the entire focus of life. My specific spiritual practice is solely oriented around it. Susun gave me this gift and I will always honor the depth of what was right and real about our being together.

## When you were together, how did the two of you work through your challenges with each other? Did you have a specific formula or technique that was effective for you?

*Rick:* We had two tools that we used together. The first was in the form of an agreement, and it was the one actual agreement we had together. We agreed on the goal to free the spirit in one another and to attain as spiritually oriented an existence as we could. It frequently happened in our relationship that one of us was weak and caught in

emotional turmoil when one was strong. When this dynamic would surface, we were able to support each other because we agreed that whoever was currently strong would help the other by being accepting and offering a greater perspective. We had a mutual goal and commitment to get conscious as often as possible. That's the only commitment we needed. It was like throwing life preservers to each other. We were able to build a strong and trusting bond together by saving each other's lives a few thousand times. We created an atmosphere of freedom and acceptance for each other that supported our highest growth and expression. By anchoring in this agreement, we always had a place to go when confusion would arise. It supported us in remembering our purpose and where we were headed together. We couldn't define it or put it into words, but it always gave us something outside of ourselves to aim for.

I think it's critical to share a mutual goal of this kind. Otherwise, we would end up banging into each other without knowing what was going on. Similar to being in the ocean and trying to stand on a surfboard that's not moving, you just can't hold your balance. However once it's moving, the balance is easy. As soon as we would guide our relationship in the direction it needed, everything would work out. This was our philosophical approach to our relationship rather than specific commitments of any kind.

The second tool was a specific technique called "withholds" that we practiced whenever issues came up. They're called withholds because the understanding is that anything that I haven't said stands between me and my ability to fully love. Whoever was clearest at the moment was in charge. That person was the leader. Let's say Susun had something she needed to express. We would sit down and I would be in the role of being clear and present. My whole purpose would be to keep inflection, judgment and interest out of the question. What I provided was a safe environment in which anything she needed to say could be said and it would only be responded to with a thank you.

I would begin by asking the simple question: "Do you have anything that you have withheld from anyone?" If the answer were yes, I'd say, "Would you like to tell me about it?" She could say anything she wanted. She could scream, yell or curse. The issue might pertain to me, or it could relate to anything else in her life. Either way, my face would remain straight without any emotions being expressed, and when she would finish I'd say, "Thank you." I would give no response or reaction at that time. Even if I had taken what she said personally, I would not let it show. I knew that as soon as she finished we could switch roles (if needed) and I would get a chance to express everything she might have triggered in me. I knew that in the appropriate time, I would be able to give it back. This would take the charge off of needing to react while I was in the listening mode. What was critical about these sessions was the

opportunity for us to express ourselves without conversation, knowing that it would simply be accepted. We didn't need to argue, explain, or defend our positions.

This is a process we were able to practice at any time and any place we might be traveling, on a train, a plane, even in the jungles of Bali. Anywhere that an issue would come up, we could immediately go into this structure and deal with the conflict. Usually at the core of the issue would be feelings that we had toward one another that we were ashamed of; often times questioning whether we were worthy of the other. These were the feelings we didn't like to talk about, the ones that would fester. Neither of us would allow issues to be left unsaid for very long before we'd say, "Hey look, you got a few minutes? I need to do withholds." It was like saying, "I need to cleanse. I need your assistance." And the assistance would include sitting in full attention, with eyes present, and giving no response. It's an amazing thing to express one's deepest, most shameful secrets and get no response. It's wonderful.

The more often we practiced this technique, the greater we were able to trust each other to say whatever needed to be expressed, and that once the session ended, it was complete. There was no need to bring up the issue again as the process was a way of cleansing each other. I don't think we could have ever succeeded in our relationship without it.

### If the receiver felt strong reactive feelings, how were they dealt with?

*Rick:* The session would continue moving. If I were the receiver, for example, my question would always remain the same: "Do you have anything that you have withheld from anyone?" If I received two "no" answers in a row, this indicated that Susun was finished. Her pressure had been released and she had emptied the emotional charge that had been building. We were now ready to stop and switch. At that point, she'd be in the role of unconditionally listening as I would express anything she had triggered in me. It was her responsibility to receive whatever flowed through.

### I imagine this could go on back and forth for a while until the emotional charge was gone?

*Rick:* That's exactly right. Our intent was to neutralize the charge. When you get down to it, all of our circumstantial reactions don't have enough significance to take up the space of just one flower blossom, although

at the time they seem so real. We felt such a huge sense of relief each time we would use this tool, for it gave us the opportunity to be exceptionally honest with each other, and to continually recreate our relationship with one another.

**When you were first building this trust, you mentioned that it wasn't necessarily easy to communicate feelings without the concern that Susun would take things the wrong way or become defensive. It sounds like somewhere along the line you made a commitment to summon the courage and the willingness to step forward and express the truth even if it did provoke an initial reaction.**

*Rick:* Yes, that was a commitment we both needed to make. There were times when one of us had to step forward because the other simply couldn't. Each of us had to be willing to take on that role when issues came up. One thing I learned early on in the relationship was that if I thought that there was something about me that Susun couldn't bear, I was weakening her. I was automatically putting her in a position of second-class citizenship. Prior to being with Susun, I used to think I was protecting my partner by withholding my feelings, but what I was really doing was poisoning our relationship; I was making them a weakling. I've learned that what's really important is having a partner who is powerful enough to handle whatever comes out of me – and another person only gets the chance to demonstrate that power when I am willing to be completely honest with them.

I don't know if men and women ever fully understand each other. We use the same words but we're often meaning very different things. With Susun I learned that it wasn't always necessary to understand her; it was only necessary to respect her. I found that if I gave less attention to the meaning of her words, but instead listened to the way they were said and the timbre of her voice, I always knew what was going on inside of her.

When Susun demanded a level of communication from me that initially I didn't feel willing to give, I always knew that if I allowed myself to open up, it would ultimately be good for me. I'm clear that at these moments, my higher self was cleansing me and giving me exactly what I needed in order to grow. In this way, I see that couples walk the spiritual path together. Monks have it easy compared to people living in the world of partnership where men and women have to work it out together.

**Do you recall a particular moment in time in your relationship when you felt anchored enough in trust that you had a safe foundation to practice these exercises, or was it more an unconscious and gradual unfolding of trust?**

*Rick:* There was a turning point and it happened early on in the relationship. We were traveling around the world and Susun became pregnant during our stay in Thailand. While in India, Susun was too sick to go on, so she went back to the big Island in Hawaii and I continued the trip around the world. I was on the island of Crete and I remember receiving a letter from Susun expressing her inner commitment to living in the truth. I could tell this was a commitment that went way beyond the demands of her ego, and at that moment I began to trust. I knew that our life was going to be spent dealing with truth. Everything changed from that point on. I was aware that we had something outside of ourselves, grander than each of us to aim toward. At that moment, we joined in a shared commitment to the truth. We knew we could always fall back on that recognition. That was our way of trusting.

**Would you please share how your relationship with Susun has evolved as a result of her condition, and how the two of you moved through the caring of her during her treatment and eventually, her passing?**

*Rick:* Six years ago, Susun was diagnosed with a melanoma on her arm. The doctor's operated and thought that they had removed it all. This being her second cancer operation, our inner guidance told us to stop paying attention to cancer, and to focus on getting the most out of every day, so that's what we did. We stopped going to doctors, stopped taking tests, and stopped the whole process of inquiring. The result of that decision gave us seven beautiful years before cancer claimed her, or claimed her body, anyway. By the time it was diagnosed, it was way too late for any kind of treatment and it was very clear at that point that we were close to the end of her life. This is how Susun wanted it. She wasn't interested in the traditional medical choices of chemotherapy and/or radiation. It was a four month period of time that we spent knowing the cancer had claimed her. By the time we reached her passing it was such a sacred event, so peaceful and full of love. It was clear to me that all of the decisions and experiences that led up to her death had been the perfect choices.

Susun went through many of the common emotional and mental stages that we experience as we approach death, denial being the first. During this initial period, she was holding on to the conviction, "To live is something sacred and I must take heroic measures to maintain life." Friends convinced her that treatment was necessary and she did enter a very powerful herbal treatment that her friends came in and gave her daily for some time. This treatment seemed to cause her pain, and it was difficult for me to witness. I remember feeling, "Perhaps there's really nothing one could do about the cancer. Maybe it's not meant to be cured or healed. Perhaps it's time to let go." So there was a period of time when we had to wait until the consciousness of acceptance came. From that point on, it was a really beautiful process. I was interested in honoring the beauty of this time, placing attention on the spiritual level of Susun's passing. And that's exactly what we did. We finally were able to create a warm, sacred and accepting home environment for Susun.

**You mentioned that a near death experience earlier in your life somehow equipped you to have more acceptance and understanding of Susun's passing. Would you describe this experience?**

*Rick:* Around twenty five years ago, I had a profound death experience in which I visited the other side of life, so I know what's there. Due to this experience, my whole take on death is one of acceptance and happiness.

I was body surfing at a beach known as Waialea Bay on the big Island of Hawaii. On this particular day the surf was crashing against the wall of a cliff immediately to my left, setting up a wave that was perpendicular to the wave that headed to the beach. This is a fun wave to ride if you are exactly right on it. But I got caught in one that peaked very, very high. It suddenly collapsed and smashed my body head first into the sand at the bottom of the ocean. I heard my neck break. I knew what was going on as it broke. Next, without a moment's delay, I found myself about thirty feet up in the air and approximately twenty feet to the southwest of my body. I was headed for what I assumed was heaven. I was on my way. This most beautiful presence was with me and everything was super conscious and super peaceful. Everything was okay. There were no possible problems anywhere. I just knew I was okay.

I was in the company of a being who seemed to know everything *(at least compared to me)*. I knew that he really loved me and he was completely there for me. I can only describe the feeling as a sense of getting off stage and going home, a comfortable and wonderful feeling of ever-present bliss.

I got an opportunity to watch my life unfold, but it wasn't sequential. This experience took place in a beautiful little bay and from my heightened perspective, I could see the entire bay. Every detail was extremely vivid: the water in the foreground, the rocks and beach and the trees behind the beach. It resembled an amphitheater or a stage. Like a screen stretched across the bay, I could see all the events in my life working simultaneously. As I was viewing this screen, others were doing the exact same process of viewing their own lives on their individual screens. I received the message that nothing I was doing in my life was really any different from what people have been doing since time immemorial, and no different than what people will do in the future. This gave me a heightened awareness of what all the doing-ness in my life meant... it didn't mean anything! Life keeps moving forward regardless. It became clear that all of the "doing" and accomplishing in life is not what really counts; it's the quality of presence and love I bring to each situation that is meaningful. The real creation takes place not in the doing or building of things because these creations last only but a moment. What I learn and how I grow while doing these things is permanent.

Next, this presence, through a type of thought transference, suggested that since I now saw the whole thing clearly, there was no hurry to get to heaven because it wasn't going anywhere. As I discovered, this experience was all a subtle sales pitch to bring me back into my body. My spiritual work in the past had a certain urgency to it, a feeling that I needed to work harder to attain what I was trying to get. Well, here was my lesson and I attained it by dying. Next, I realized what had happened to my body and I said, "The neck is broken. I'm not interested in returning." The last thing I remember was this entity saying, "We'll fix the neck." Instantly, there I was in my body in the ocean.

**So when you came back to your body, was your neck broken?**

*Rick:* Yes. It took an enormous amount of conscious awareness just to get to shore. The one thing I did not want was attention. I didn't want anybody to be aware of me or to feel that I was hurt or to offer help. The last thing I wanted was other people's concern and energy. It seemed like the only way to handle this was by being absolutely still inside myself. I was given that still and inward time for the rest of the afternoon. A lot of people knew me, but for some reason as I lay on the beach they did not pay attention to me. I worked very hard to not show any sign of distress.

It's funny, I had this fear that somebody with shoes on would come up and take care of me. As I lay there in the sand for many hours I could feel the healing taking place. Once it was dark, I managed to get to my car. It was a very rough drive out of there and I could only accomplish it by going extremely slowly. Every movement was so conscious and slow. The car had to be maneuvered just the right way so that nothing shook my neck; my shoulders softened any sudden movement. It certainly was a time when I was absolutely in the hands of God. I was simply being guided, being told everything, and being shown everything. It was a remarkable experience.

The most meaningful insight that came out of this experience is that I now know about death and I no longer have any fear of it. I know that everybody who enters death kicking and screaming is going to be delighted when they open their eyes and what's really there. This experience taught me how to be with Susun. I could clearly feel the call for her to ascend, and if we accepted that her time was here and honored it, everything would be just fine.

**So what I'm hearing is that you weren't placing your attention on trying to figure out why she got the cancer and why this was happening.**

*Rick:* No, I didn't care about the why. I spent so much of my life chasing "whys" just to find out that they are all ephemeral. I mean, why anything? Why creation? If I can't answer that, then all the other "whys" are like Band-Aids on my need-to-know. So we didn't care. I think she may have had a certain element of inquiry asking, "What have I done wrong?" or "What have I harbored that was of a negative nature?" But it was a very small part. She worked it out. Four months was time enough. We felt that these four months were not an ending period; they were part of the ongoing nature of our relationship and we were committed to going through this together.

**How has it been making the transition from being with your beloved of twenty-three years to currently being on your own? What have you learned? What has all this taught you in your life?**

*Rick:* Well, let me take you back to her passing for a minute. Two events are notable on the day just before she died. Once she came into full acceptance of her imminent passing, all the energy in the house changed. All pain left her; all the discomfort was gone. She had a few days of extreme lucidity before her conscious mind began to

leave. During this time, she and our eighteen year-old son Achahn shared their good-byes. The two of them were joined together on the bed and Susun told him the things that every mother wants her child to know. She very clearly passed on to him what she had to offer and he was fully present, conscious and accepting of her love. There were three or four of us in the room sitting in meditation, holding the loving presence for this to happen. It was so beautifully spontaneous.

On that Sunday, very close to Susun's death, I was guided from within to get up, leave the house and drive. I went to my office and I pulled the blinds, lit candles and did the spiritual disciplines that were familiar to me. I became as centered as possible, sat in meditation, and within moments Susun appeared. She asked me to accompany her to the other side and that's exactly what I had the opportunity to do. We made the transition from what we know as life into what we call death so smoothly that I was barely aware that we'd crossed a line. She was holding my arm like in the olden days when the gentleman would escort the lady to the ballroom. When we got to the other side, her presence began to expand so large that her essence seemed to occupy my whole frame of reference. I couldn't see anything else, only her majesty. All of this expansion wasn't just in size, it appeared as if she was opening out of restriction and entering into her actual identity. I knew that it was time for me to go. As I was beginning to leave, she turned to me, but there wasn't any "she" that was turning. Her Spirit focused on me and I felt an energy pour into me through my crown chakra at the top of my head, an energy that hadn't been there before. I left the office and when I arrived home her caregiver said, "I think she just left." We both knew that Susun had just crossed over, even though her body was still alive. She died an hour or so later.

We kept Susun in her own bed and washed her body, anointed it and wrapped it as she had instructed. At this point our loving community was allowed in, looking on Susun's death with the greatest of beauty and grace. Everyone was given such short notice, but somehow they knew to be there. They came and stood in silence, in their own prayer, their own meditation in her bedroom. It was beautiful to have each of these people come to partake in the honoring, and to bring their own beauty to an event that's often so institutionalized. The essence of her presence was so clear, showing us the way of love, showing us how it was all okay. Susun's lifelong girlfriend from Ojai was there, and the following day she and I were delegated to load Susun's body onto a pallet that had been made overnight by somebody in the community. We then drove her to the crematorium and delivered her body.

I'm proud to say that nobody "with shoes" had anything to do with this death: no police, no doctors, no nurses, no ambulances, no 911, none of that. Nothing intruded on the sheer sacred beauty of the event. Incidentally, my

former wife, Toni Withington, was also present. Toni was one of Susun's caregivers who slept by her side and took care of her right up to the last minute. It was Toni who taught me many years ago to love enough so that I could be Susun's mate.

**Are there times that you tap into any deep feelings of grief or mourning, and if so, how do you deal with these feelings?**

*Rick:* During Susun's passing and right after her death, there were times I would go outside and break into anguish and tears, crying and lying on the ground, feeling like something had been torn out of me. I am fortunate enough to live in a place where I can scream without anybody hearing me. I even noticed the other day at a dance class that I suddenly began to sob. These feelings are an expression of grief, but they don't seem to be accompanied by drama of any kind. It doesn't seem as if I'm moaning about something that's not there any longer; it's really a basic release of emotion. It comes right out of the gut, lasts for a second and is gone. I honor it when it comes out. I'm almost glad to see it, and I say, "Oh, there you are." Screaming is the best way I know to release these feelings. I've also had many opportunities to move through the grief in my yoga and dance classes. My dance partners are very understanding and would always be there to hold me.

**When you were with Susun on the inner plane, you mentioned that you were imbued with a part of her that you had never felt before. Would you elaborate on what feelings or qualities you experienced?**

*Rick:* She asked me what I would like her to leave me, and I really did place attention on this question. I asked her to leave me her sense of beauty, her generosity and her ability to see. I also wanted to ask for her sexuality, but I dared not. She must have known, for she immediately offered it to me. I feel that these four attributes are all different prisms of her ability to love and be loved. It's interesting to watch my own performance in the world to see how these attributes emerge in me. Consequently, I don't think of myself as "just Rick" any longer. I see that I'm an amalgam of many loving influences. In a certain way, Susun still operates but it's through me. More accurately, it is an essence she bequeathed to me that I now work with. I am so grateful for this beautiful gift. I am struck by the level of generosity that's been coming over me lately. I find myself giving away things and I wonder afterwards:

"What in the world? You've really got to watch this." Then I remember, "That's how generous Susun was, and I asked for this quality to express itself through me." I like myself a lot better with her living inside of me.

**It's been fifteen months since Susun's passing. Would you elaborate on what it's like being on your own now?**

*Rick:* I'm very familiar with me. I've lived with me for sixty-six years now. So, yes, when Susun left it created a void at a certain level. And yet, I'm still here as the same me I've always known. I have no problem keeping myself company. In a way, this time with myself has been of great benefit. I am being given the opportunity to really devote valuable time to nurturing and cultivating my relationship with myself. I enjoy watching how this integration is taking place, what the new behaviors are, and what kind of a guy I really am right now.

On the other hand, no longer having a companion of such long duration to share such profound understandings with is a big change. Susun provided a wonderful balance in my life. I have a tendency to get a little carried away, keeping busy with my business and with other projects. I don't have a governor on these activities and it's taking some adjustment to find a healthy balance. To some extent, the balance of the two of us combined came from strengths we each had that we blended together. With her strengths gone, I find myself having to deal with those areas that weren't my strength, but hers. I have to compensate for the loss by remaining open to new activities and relationships that really support my growth.

When Susun died, we had just completed building a house. After Susun's death, my former wife Toni (who is really a wise person) suggested that I not make any decision of any magnitude for a year. That seemed like a wonderful idea. In fact, I just extended it for another year. I spent that first year finishing up our cycles, finishing what we had started. I didn't want to leave anything dangling. Just recently, I've finally gone through all her things. There was a tremendous amount to sort through, her art, etc. Everything is now in place and the house and grounds are finished. The things that we were doing together are complete.

I'm sure this has been a very healthy way to occupy my time. It's kept me extremely busy which I'm grateful for. It also seemed an appropriate tribute to our relationship to complete what we had put into motion. Our son is still

being educated, and so I'm taking care of that too. My goal is to reach a moment in which everything I've been doing, everything Susun and I were doing, everything that had to do with that period of my life is complete so that I can move forward feeling free and unencumbered. This is just a personal method of self-renewal. With all of my love and respect, I know that my time with Susun is complete and I am ready and open to moving forward while taking the love, wisdom, and all that Susun has given me into the remaining years of my life.

**You spoke of the four qualities that she has given you. In your daily life, do you ever feel her presence speaking and communing with you in a direct way? Or is it more through abstract qualities?**

*Rick:* I feel Susun's presence stronger now than at any time since her death. I have a feeling that certain aspects of her soul are now free to hang around once and a while. I primarily feel her in the joy I experience when I hear myself say something or when I appreciate a quality she gave me. This way of seeing and experiencing life wasn't there before. I didn't have the simple joy and appreciation for the beauty of a flower in the past. This trait symbolizes Susun living on in an intimate and powerful way. I feel that she's right here behind me, and when she speaks, she speaks through me.

**Thank you for the depth of your sharing, Rick. Is there anything else that you'd like to say?**
Ironically, what I want to say is that there's really nothing that Susun and I didn't say to each other; nothing we didn't do together. There were no secrets of any kind; nothing left unsaid. Because we communicated so regularly and so honestly, there are no "withholds" between us; no regrets about our life. This level of honesty and completeness has been so valuable because it allowed the two of us to stay on an equal footing so that I didn't have to run through any guilt or shame during or after her death. There are no hidden things I didn't tell Susun, or wished I'd told her. We got to the real fruits of the relationship by wanting something so real and so true that we were willing to do whatever it took to make it work. It involved learning to find the perfection in each other and then demonstrating that for each other. Susun left me in a state of love and I don't ever expect to fall out of that state. Everything starts from there now. Nothing is ever lost.

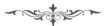

One of the greatest gifts that Rick and Susun demonstrated is how important clear communication is to our ability to truly enjoy each moment as a couple. I was reminded how valuable it is to slow down from all of the busyness and bask in the simple pleasures of life and togetherness. How often do we find ourselves on life's never-ending treadmill, too distracted to enjoy the riches that are right in front of us?

From my perspective, Rick and Susun's regular practice of sharing all they were holding inside while honoring each other's perspective without reacting to it held the key to the lighthearted joy that passed so easily between them. Though not always easy, the depth of understanding that is forged as a result of such honest sharing is well worth the momentary discomfort. Cynthia and I discovered this for ourselves a few years into our relationship.

By this time, we had been married for about a year and living together for about three, and this new chapter of daily cohabitation was reflecting areas of communication that needed sharpening and strengthening. Reoccurring themes and issues were arising and – seeking tools and practices that would support each of us feeling heard and respected – we enrolled in a weekend relationship workshop taught by a couple we both respected and admired.

We spent the weekend immersing ourselves in learning one powerful process after another, and by the end, we had gathered a treasured toolbox of practices to apply when needed – two of which we're still devoted to using on a daily basis (*Listed in the Tools and Practices section at the end of the book*). All seemed to be going well, until the final process on the last day of the workshop when we hit a wall.

The intention of this final exercise was to teach us how to provide a safe space for our partners to share communications they'd been holding in for fear that the other partner would react adversely. As instructed, we chose an *A* and *B*, and *A* was given specific guidelines on how to communicate an upset or an unmet need without blame, and while leading from an open heart. *B* was to listen fully without interruption until *A* was complete, and then each partner would switch roles.

Cynthia was the first to share, and as I readied myself to listen openly, she began to express her frustration related to a recurring pattern. In her purview, I was not following through with specific agreements we had made. As an example, I had agreed to empty and take out the garbage on a weekly basis. Because this task was not being carried

out within the timeframe she anticipated, she concluded that I was breaking our agreement. As she went down a list of upsets, I did my best to listen and stay open, but was feeling more and more misunderstood by the second. In my mind, most of her examples (*such as the garbage*) involved situations where I *had* followed through with what we agreed, only in a different timeframe than when she had in mind.

When it became my turn to speak, (*it's clear in retrospect that*) some deep wound had been triggered within me in reaction to Cynthia's sharing, and I could not find a way to return to my center. In that moment, I felt harshly blamed and deeply misunderstood.

The next thing I knew, we were being asked to wrap up the exercise and complete the workshop. This triggered yet another wound related to the pressure of being rushed when I'm not yet ready to complete something! I remember sitting across from Cynthia and feeling so angry, small and misunderstood, while thinking that the workshop had clearly been a radical failure, and upset that the format had brought me into such an upset and vulnerable state without providing enough time to reach a resolution. Given that we were two of the last participants still in the room, it was clear that even though I did not feel complete, I needed to pry myself from the seat and leave. In that moment, I simply had to trust that we could table this discussion and resume the inquiry after I'd had a bit of time for reflection and perspective.

Within a short while, Cynthia and I came back together and continued to explore the issue – this time arriving at a much clearer resolution. Rather than defending my position or making Cynthia wrong for hers, I simply let her in on the cascade of feelings that had been triggered by her expression of discontent. As she listened with compassion, I was able to trace my reaction back to a much earlier time in my life; to events in childhood that were still unhealed within me. The more Cynthia received and embraced my perspective, the faster my emotional charge dissipated.

Within a few minutes, I was able to see the situation from her perspective, unclouded by residual emotions from my past. I became willing to recognize and acknowledge those times where I really hadn't kept my agreements, and became clear that I needed to create specific guidelines to support me in completing the various tasks that I was agreeing to fulfill. Because Cynthia gave me the space to express my feelings without adding to the negative momentum with her own reactions, we were able to think creatively – like two people on the same team working toward the same outcome – rather than as adversaries.

The scenario that unfolded that day serves as a great example that by giving each other the gift of our non-reactive listening, understanding can grow in spaces once blocked by judgment, and even heated issues can be brought to resolution. Cynthia making the choice to express rather than withhold this grievance opened the door to a broader perspective of one another, free from blame and shame, where love's truth purely resides, and the joy of the present moment can be realized and shared.

As I left Rick's home the afternoon following our final interview, I was profoundly reminded how fleeting our lives are, and how sacred each moment is. Whether we're with our partners or spending time alone, I see that the greatest question we can ask ourselves is, "How fully am I giving and receiving love, right now?" All else is secondary.

# *Chapter 5*

## AUTONOMY IN TOGETHERNESS AND CONSCIOUS UNCOUPLING

*The Evolving Love of Shinzo and Manon*

.......................................................................................................

IN MY TIME WITH SHINZO AND MANON, I had the honor of witnessing two distinct chapters in their tale of evolving love. First, the blossoming passion and deep appreciation they felt for each other while in the honeymoon stage of their relationship – portrayed in the photos below – and later the touching way the two came together as friends to support one another through their separation and the healing of mutually wounded hearts.

# Shinzo & Manon

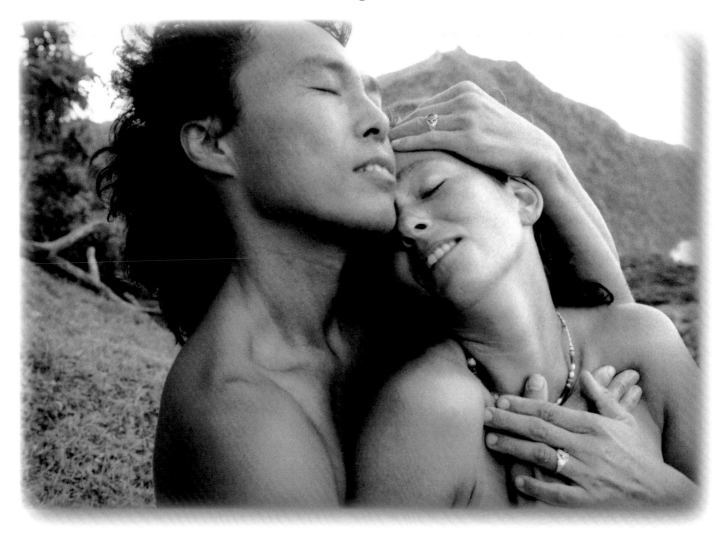

When I was opening to these vulnerable places, I knew that there was somebody very safe that I could truly trust for the first time in my life.

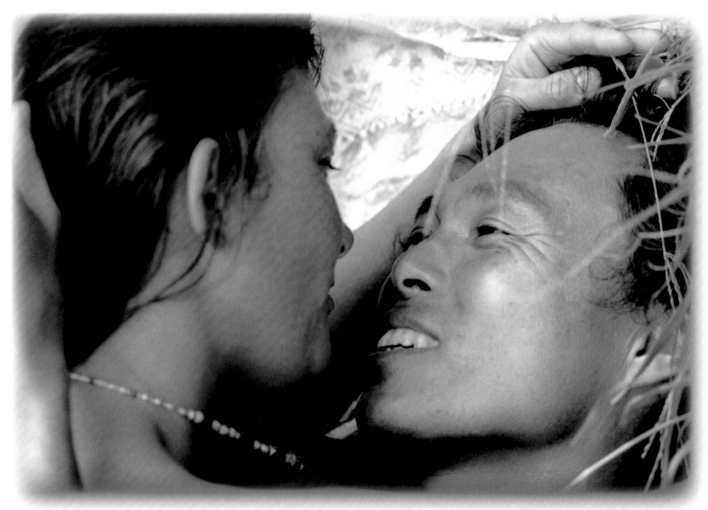

Shinzo moving here was very healing for me because previous to that, we had been in a long distance relationship, which was difficult.

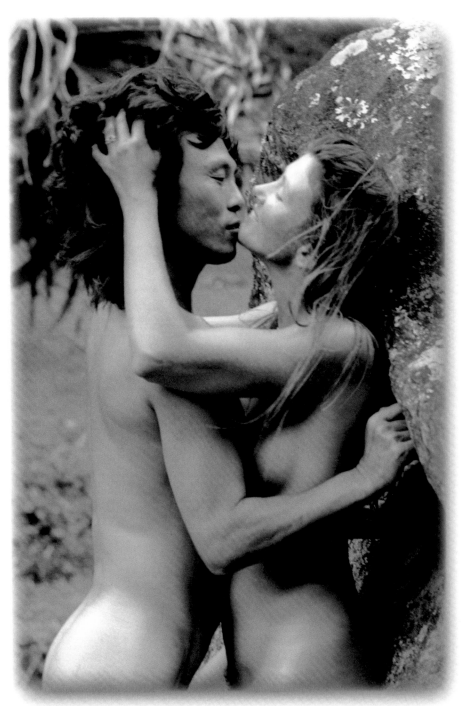

Through a deeper honoring of my needs I am more in touch with who I am and I can now help Manon heal more fully as I've been healing myself.

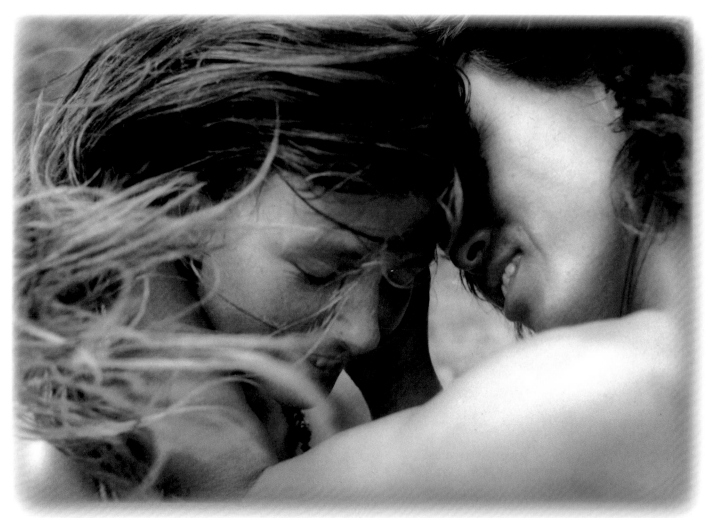

I see that we helped each other grow up and we came to a point where we both needed to fly as independent whole beings.

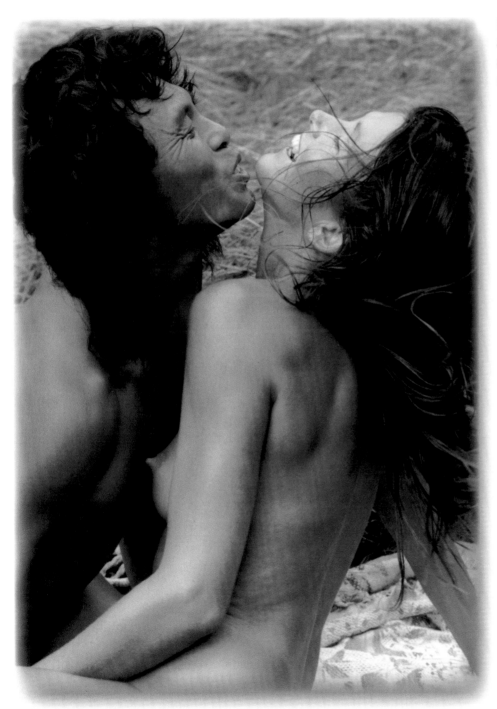

I have loved Manon more than anyone in my life. I've never met a woman that I've loved this much.

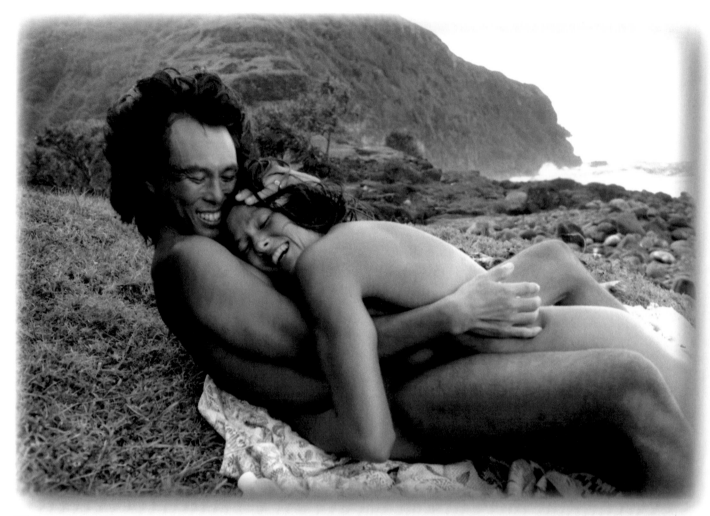

We've opened so many doors together. It's really beautiful to know I have a lifelong friend and very special intimate person that's always going to be there for me and I'll always be there for him.

As they spoke about the challenges that caused them to gradually grow apart, I was reminded that strong, enduring relationships must be built upon a foundation of both partners knowing that each is whole and complete within themselves. We all crave intimacy and connection, but if we become too enmeshed in another, we run the risk of losing our sense of self and the clarity of our own life purpose. When this occurs – as it did with Shinzo and Manon – the couple often grows apart, as each partner is compelled to regain their own autonomy. What I found so touching about their story is that even in the midst of their mutual realization that uncoupling was the healthiest decision, the two were able to comfort and support one another through bittersweet emotions, and honor each other through the changing form of their relationship. Their message of evolving love remains with me today: "The form may change, but if the love is genuine and we remain open, the love will never die."

Here are the insights they shared with me about the evolution of their love.

# Shinzo and Manon: In Their Own Words...

**When we initially took your pictures, you'd been together about a year. Please give me a brief overview that tells the story of your relationship from that time up to the present moment.**

*Shinzo:* I decided to move here to Maui so that Manon and I could live together. Up until that point, I had never lived with a woman, sharing my whole life with someone, both good times and bad. Those were tough times for me, I had lost all my money and I had never fully shared my pain with others. I felt empty inside and I realized that I really needed to open up and feel. Something in my heart was opening and craving to share my life with this wonderful woman. We wanted to be there for each other, to share our lives together and heal through our Tantric practice. Almost immediately, we decided to move in together.

*Manon:* Shinzo moving here was very healing for me because previous to that, we had been in a long distance relationship, which was difficult. And interestingly enough, soon after he moved over, I got pregnant. We were both clear that it was not the time to have a child, so I attempted a natural abortion with herbs, became very ill and almost killed myself. Suddenly, Shinzo was in a position where he had to care for me, care for my son, and basically care for the whole house because I was in bed for about a month. That was really hard on all of us and it tested our strength. Through counseling, I realized that on some level I had created this scenario to test how much he really wanted me; how much he was really there for me. So, we made it through that challenge successfully, and continued on for a while.

Then, my older son moved in with us to spend the school year, and this created a lot more issues and problems. It was very difficult for Shinzo and me because I was in the middle trying to make both Shinzo and my kids happy; trying to get the family to be a family, and it never really came together. It brought up a lot of feelings for me. I imagined that he didn't really love me because he didn't really love my kids. I felt that he wasn't totally available, ready to get married and make it happen.

*Shinzo:* I had a real challenge with Manon's children. I tried to contribute and did everything I knew how to do, but nothing seemed to work. I realize now that I was blaming her children, but there were really things about me that I didn't know how to deal with and I felt like I couldn't move forward with my life. Things were not flowing well and I felt deeply frustrated. I gained some deep teachings with her children, especially with her oldest son.

*Manon:* I started to pull back and recognize that perhaps my children and I were holding him back from living his dream for his life and perhaps he wasn't really happy. Perhaps he really didn't want to be there. We were beginning to lose sight of the beauty in each other, and we were not appreciating each other as much as we did in the past. We were criticizing each other a lot and focusing on what was wrong instead of placing our attention on the love, appreciation, honor, and the respect that we have for each other. It was sad to witness this because I knew that it wasn't how we truly felt about one another. Gradually, I began to feel that I could not fully be myself, as if I wasn't allowed to fully express who I am.

**Shinzo:** That's when Manon and I began couple's counseling. The more we talked, we realized that maybe it would be a good idea to let go of each other and create our own lives independently. My life and her life, allowing me to design my life the way I needed to. That was a couple of years ago, and since then, I've created my own home. Living on my own, I've really begun to feel my own strength and have a greater sense of myself.

**And what's your perspective, Manon?**

**Manon:** It's clear now that a part of Shinzo wanted to stay while another part needed to move on. Ultimately, it felt really good to release him and say, "Go. Go and do what you were meant to do and I'll do what I need to do," because it didn't match any longer. Shortly after we parted, I got involved in another relationship that served as a healing where I had a chance to perhaps give back some of the things that Shinzo had shown me.

I learned a lot in that relationship. It was quite a roller coaster ride and it just ended recently. On some level it was probably a way for me to avoid my deep feelings for Shinzo, for he was my beloved, and the man I thought I would marry. It felt as if that whole dream fell apart and disappeared. When I realized that it wasn't going to happen, it was too painful to deal with, and initially it seemed easier to get love somewhere else, to fill that painful hole. I've just recently been able to handle the whole thing and realize that it comes down to my lessons and my growth. I knew it then, but I wasn't ready to look at it to that degree. It was a very sad time, and I feel so grateful that I've now come back to a place of loving.

**What was the most difficult or challenging experience in moving apart as a couple?**

**Manon:** It was very difficult to let go of the level of intimacy and healing that we experienced with each other, a depth that I had never experienced before. I had never let anyone in that deeply. When I was opening to these vulnerable places, I knew that there was somebody very safe that I could truly trust for the first time in my life. I saw Shinzo as my mate, and then to actually realize that we had gone all this way to get to a place where it was time to let each other go was quite difficult and sad. I had become used to all of the love, intimacy and healing and it was really hard to let that go.

**Shinzo:** I went to Japan for three months to think things over. Being there served as a good excuse, somewhere far away from Manon, away from everything so I could somehow numb my feelings. I stayed focused on my teaching and that helped to keep my mind off of how I was absolutely missing the deep intimacy with Manon. I also had never gone to this deep a level of healing and love with anybody else. At the same time, I knew that it was right for me to immerse myself in my teaching and take some space from any form of intimate relationship for a while.

**What have been the most rewarding insights you have received as a result of this change?**

**Shinzo:** First of all, I really see that I'm called to do more teaching; I have a gift for it. I so enjoy the act of teaching and putting my whole self into the process. It's an absolute gift that I love to offer. And at the same time, my love for Manon is always there; nothing can change it. One way that I was able to support Manon while she was seeing this other man was by being quiet and offering her as much space as she needed. And when the day came that she was in need of support, I was fully there for her. That's my commitment, through my love for Manon I commit to a wonderful friendship. No matter what's going on, I'll always be there.

**Manon:** We've opened so many doors together. It's really beautiful to know I have a lifelong friend and very special intimate person that's always going be there for me and I'll always be there for him. This time apart has brought me closer to my children, and to consider the big picture. I see that it's time to become more specific about what I want in a relationship and how I want to integrate the children into the relationship. I've been taking a close look at many things that Shinzo addressed and I can now see that he was right about many of the stories and patterns that I act out with my kids. There's been tremendous growth and insights that have come from that. It's been a true gift learning how to let go of the person that I loved and trusted the most in my life while actually feeling good about it. Yes, there's pain and all sorts of other feelings but it felt good to be able to say, "I don't want to keep you here. This is not where you want to be and I want you to fly. Go share your gifts."

**So how did you learn to remain open to giving and receiving of loving care for each other while moving apart?**

*Manon:* I just had to keep letting go of him. Over a four or five month period, we did various forms of therapy. Initially, I was very clear about wanting to strengthen our commitment in going deeper, getting married and doing everything together. I was ready to go that route. I really wanted that, and it didn't happen. Because it was such a continuous process, by the time we finally let each other go, it wasn't extremely difficult because we had been letting go all along. I learned to keep my heart open and see things from more of a witness perspective. There was a part of me that knew what needed to happen for the highest good, so my emotions were being witnessed more so than taking me over. That's a significant insight that I've learned through this relationship; how to witness and process emotions so that I don't get totally wrapped up and lost in them.

*Shinzo:* Manon's answer to your question was so right on. She said "let go." During my teaching practice after we separated, I did a chi gung exercise before each class and the exercise focused on letting go with joy. I'm coming back to you, don't expect coming back to me, and just receive the gift. My biggest lesson is that I have to let her go. I have to let everything go and know that it's coming back to me through many different forms. I can't expect Manon to be my girlfriend again, yet I know that she'll be always there for me in one form or another. I know this because our love is so deep, and I trust that. I let go with joy. I do this practice almost every day. I tell my students to let go with joy and trust that love and goodness is coming back to you, but don't hold onto expectations of the form of what is coming back to you, just trust that the energy is one of love. So that's my commitment, to let go and trust in whatever form is of the highest service.

**What's your highest vision for the relationship or friendship that you share with each other?**

*Manon:* After completing this recent relationship, I was able to come back and reconnect with Shinzo, going a little deeper in healing together which was very powerful for me. I would like to always be connected, obviously as a friend, and possibly in doing healing work together. I'd like to learn more from Shinzo, having him serve as my teacher for deepening in my ability as an energy healer. I've always recognized that that's his gift and that he

has something very powerful that I feel part of. When I tune in very deeply, I realize we still have a similar vision. Perhaps it will be our path to do some level of healing work together, helping individuals and couples to open and receive greater love, guiding them in letting go of whatever's blocking them. I would be honored to be involved with Shinzo in this way. I really have no idea where this may lead.

*Shinzo:* I'd like to always remain close with Manon and I know that as I create my home, my temple, that she is always welcome. The best way to say it is that she's my closest friend. I'd like to create such a loving bond so that we would feel safe together in sharing the pains that come up in our lives. Perhaps someday with a new beloved she can come and share her pain or challenges, and if I have a beloved someday, I can honestly come to her and cry, or whatever's needed when I'm in need of support. That's the kind of wonderful friendship I wish to create together, knowing that I fully support her and she fully supports me.

**There's clearly a depth of love that the two of you still share very strongly. How does the love between you feel or look different now?**

*Manon:* For me, the depth of the love has been the same all along. Our deep connection has always been there. It was there throughout our entire relationship and it was there through the separation. It's been there silently, and I suppose I'm just noticing it more now. Of course the way that it's expressed, the level that we share with each other has changed as the form has changed. We barely talked or saw each other for a while, and on some level I was keeping him away, but there was always the love underlying all my circumstances. I suppose that I'm now feeling more open in my life to being truthful to that love and to see what gift it may bring.

*Shinzo:* In answering this question, it reminds me of the story of geese flying together. If one goose is falling, two geese dive down to support her back to the flock so that she doesn't die. When Manon and I were together, I had one wing and she had one wing. We tried to fly together as if we had two wings, but one would be flapping this way and one would be flapping the other (*laughing*). Now we can fly together, side by side, because each of us has two wings. There is a greater wholeness present and I can help her if need be. We can now travel a much farther distance together. I don't need to be another wing for Manon. She has two wings and she can fly without my help.

My vision is that she and I fly together in the same direction because we have the same goals, and as a result, we can fly much farther.

*Manon:* We've grown up a lot since the time we were first together. In some ways, we were both very young and we went through many stages in our healing process where we really needed each other's safety, each other's love, and each other's support for what we were going through. I see that we helped each other grow up and we came to a point where we both needed to fly as independent whole beings. So now, the relationship can be a lot more fulfilling in whatever form it takes. We no longer rely on each other's support from a deep sense of need. It feels so much more fulfilling because we're more mature beings now and we can choose to show up and be there for each other from more of a whole place within ourselves.

**Was there a part of you that felt at all guilty that you weren't able to show up for Manon with a deeper level of commitment?**

*Shinzo:* Yes, because as a Japanese man, I was taught that the man is the person who takes care of the whole family, and I have never been able to do that well. My time with Manon was more of a healing time for me. When I tried to take on that level of responsibility, my body and my spirit said no. Yet, I felt conflicting feelings, for as a Japanese man, how could I not commit to her and her family at that level? So, now I'm able to support her on a much deeper level because I respect her as a woman and as a friend. Through a deeper honoring of my needs I am more in touch with who I am and I can now help her heal more fully as I've been healing myself.

**Last question: "If you were going to die tomorrow, what would be the most important message that you would like each other to know?"**

*Shinzo:* I would tell Manon that I have loved her more than anyone in my life. I've never met a woman that I've loved this much.

*Manon:* I am so grateful for this relationship. The level of love and depth that we shared and the trust that I felt has been so powerful and beautiful. Shinzo, I've always felt that you were a real gift from God in my life.

Shinzo and Manon's story is a beautiful example of what my friend Katherine Woodward Thomas has termed "conscious" uncoupling. As she defines it in her book by the same title, "*Conscious Uncoupling* is a breakup or divorce that is characterized by a tremendous amount of goodwill, generosity, and respect; where those separating strive to do minimal damage to themselves, to each other, and to their children (if they have any), as they intentionally seek to create new agreements and structures designed to set everyone up to win, flourish, and thrive moving forward in life." Thanks to the work of people like Katherine (and to Gwyneth Paltrow, whose use of the term when announcing her 2014 divorce placed it squarely in the lexicon of our popular culture), we now have a vision of separation and divorce that offers far greater possibilities than those available when we're acting from our more primitive instincts to guard our hearts or to seek revenge.

Shinzo and Manon demonstrate that when we summon the courage to remain open during a breakup, we can more powerfully take ownership of our choice to uncouple. From this purview, there is no victim and a wiser trust can be revealed, honoring the realization that all is in perfect order to serve the highest good of each person. The love remains eternal regardless of the changing form.

Because they open us so completely, intimate relationships provide a perfect climate for invariably bringing to light all that is still unresolved and wounded within us. And this means we must walk a fine line in order to remain emotionally healthy: If we view our partners as a primary source of happiness, security, or wholeness, any change in the structure of that relationship will naturally trigger resistance and clinging. But one who understands that true love never seeks to hold anyone to an outdated expression, but allows for continual expansion and renegotiation, can embrace the ever-evolving changes in form and structure that unfold in every long term relationship.

It takes practice to maintain our sense of ourselves as whole and complete individuals even as we allow our hearts and dreams to merge with another. But without this foundation of wholeness, we may mistakenly come to view our

partners as the source of our connection, and in our dependency, resist the evolution that is essential for any long term relationship to thrive. I learned this lesson the hard way.

After the breakup of my first marriage, I felt devastated because I had assigned so much of my sense of identity and value to my marriage and to the connection I shared with my wife. When the relationship changed form, I didn't know who "I" was without her. It took a tremendous amount of patience to pry myself (literally) off the floor before I began to see glimpses of enjoying a meaningful, valuable life apart from her. This most challenging time served as a potent wake-up call that in order to create the partnership I desired, I would need to meet my partner from a solid sense of self, rather than looking to her – or anyone – to make me whole.

Throughout our twenty-plus years together, Cynthia and I have discovered a natural rhythm that helps us balance our mutual need for intimacy, and our equally-important need for autonomy. Because we are both independent thinkers and doers, we inherently understand that each of us needs a significant amount of time alone to devote to our unique purpose and passions, and to offer our individual gifts to the world. This gift of spaciousness – which feeds our individual sense of value – creates a vacuum which naturally draws us back together. This might consist of a Friday date night for dinner and a movie, or simply snuggling up on our living room couch in front of a warm fire. And, because we both have careers that require a fair amount of travel, we intentionally plan some trips together: I might join her on a sacred pilgrimage she's leading or she'll meet up with me in Europe following a photo session I've completed. We never mind our alone time because it provides the ebb and flow that makes moments of togetherness and intimacy so delicious. When we reunite, it's always with a mutual freshness of perspective and a heightened appreciation of one another.

Of course, I've had my share of moments when I felt left out or neglected, but I've learned to use these as an opportunity to ask myself, "Is this something I genuinely need from Cynthia, or is my inner-child simply needing more attention?" If it's a genuine need, I'll voice my concern and we will explore adjusting our schedules to allow more together time. But if my inner guidance tells me "Little Carl" is requiring more attention and love, I now understand that it's my responsibility to find ways to meet those needs. I also remind myself that Cynthia is committed to living her life full-out, and this is one of the core qualities that I admire most about her. I would never want her to diminish her light to try to ease any insecurity arising within me, for in the end this would only foster dependency and create resentment. Above all, I am committed to her fulfilling her destiny, and I know that she feels the same toward me.

Maintaining a degree of autonomy is essential for love to evolve, and a good place to begin is to consider our partners first and foremost as friends whose happiness and well-being we truly care about. Nature does not support dependency – not in the long run, anyway. As Kahlil Gibran wrote, "Love one another, but make not a bond of love. Let it be rather a moving sea between the shores of your souls. Let there be spaces in your togetherness, and let the winds of the heavens dance between you."

# Chapter 6

## CREATING TRANSPARENCY AND TRUST

*The Evolving Love of Ron and Jorge*

Over the years, as Cynthia and I have shared the message and purpose of this book with friends, clients, and even business acquaintances, we've been moved by the candid discussions that it's inspired. One such conversation took place over the phone one afternoon as my editor Danielle and I were talking about a particular nuance of this project.

As we talked, our conversation evolved into a discussion about how common it is in heterosexual relationships in particular – and especially when the couple is raising a family – to become limited by the traditional expectations we assign to the masculine and the feminine, and how easy it is to lose ourselves in these roles without even recognizing that it's happening. Danielle made the observation that – in her experience at least – gay couples seem to be better able to navigate around the pitfalls that so many heterosexual couples fall into. In fact, she said that she knows many gay couples who are still happy together after many years for the very reason that they give one another the permission to be who they authentically are, and not to simply fulfill the other person's ideas about who they should be.

She then told me about Ron and Jorge, a couple who she had the pleasure of meeting and traveling with several years ago, and whom she described as "ridiculously happy," and suggested that they would be perfect candidates to interview for this book. We set up a phone conference; they both instantly resonated with the message of this book, and a couple of months later, I met with them in their home near Irvine, California.

From the moment I walked in their front door, Ron and Jorge couldn't have been more hospitable, caring and connected. I arrived into Los Angeles the night before our planned day together and they kindly invited me to stay

that evening in their guest room. I was inspired by all of the beautiful artwork from around the world that graced the inside of their home. There existed a sense of lightness about them and we instantly hit it off, both in the depth of our conversation and the sense of shared values that it revealed.

Throughout my entire day together with this couple, I was taken by how differently they express themselves and navigate life, Ron being more demure and grounded while Jorge brings a refreshing mix of exuberance, unwavering candor and spontaneity. Amidst these differences they've seemed to find a way to blend and balance each other out, akin to the Yin and Yang principle of Eastern tradition. A common quality that I observed operating between these two was a constant sense of honor and respect for one another, each giving space for the other to BE who they are. They clearly have found a way to fulfill their individual needs while also honoring the needs of the relationship. There was an inherent trust that permeated the space as they continually demonstrated their commitment to honor one another for the totality of who they are, while simultaneously supporting each other in growing beyond current limitations.

# Ron & Jorge

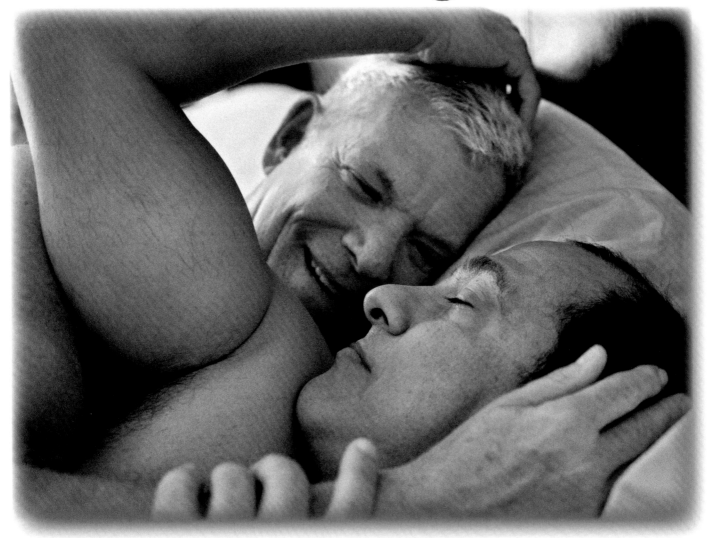

When Jorge and I first met, there was a connection on such a deep level in all areas. The night in Athens that we spent together, we had walked up to the top of the hotel and we saw two shooting stars, over the Acropolis.

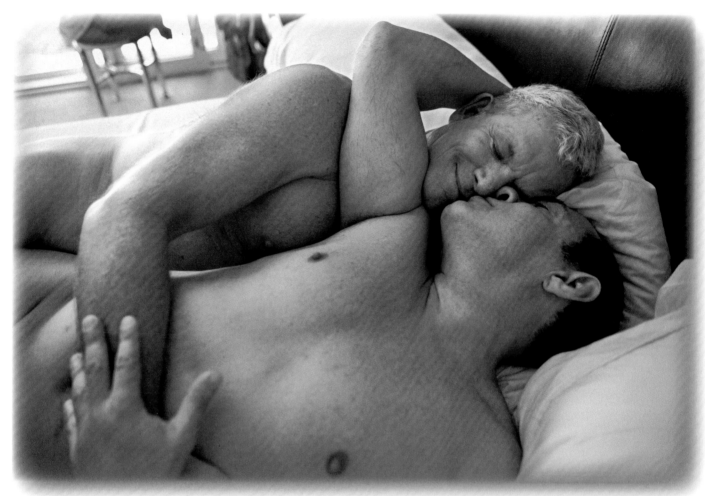

I knew that Ron and I had come together for a great purpose. From the moment we met, there was a plan being revealed to us and we were going to do great things together.

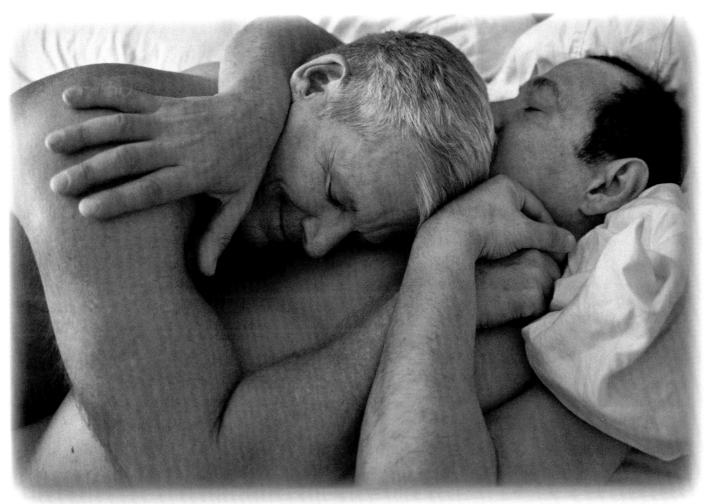

I'm constantly amazed by and appreciative of the gifts that Jorge brings to the world, to the people we meet, to every aspect of our lives. I see the beauty and the sacredness of what he brings and I think he sees the same within me.

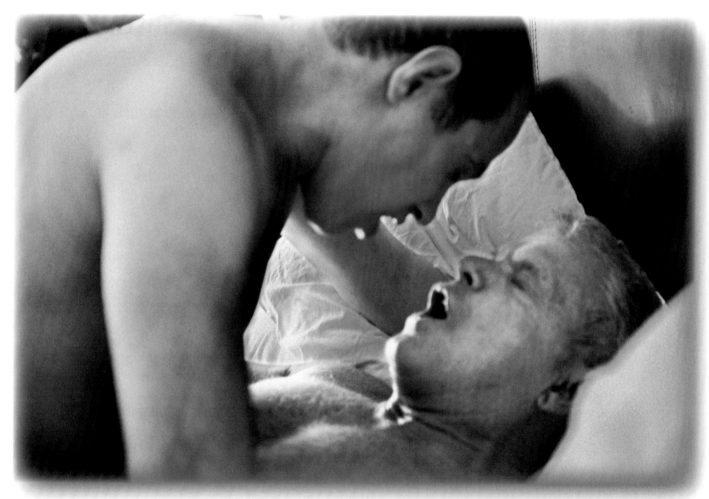

Right after I moved in with him, I knew it was going to work, because, above all else, Ron was just my friend. I knew that this is a man who can handle me; that this is a man who really gets me.

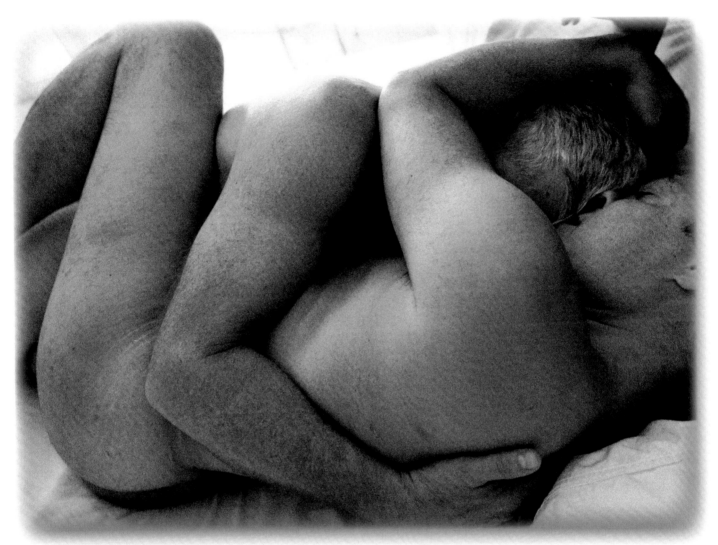

Physical intimacy begins a relationship, but eventually it has to evolve into deeper forms of intimacy that can be expressed not just in the bedroom, but throughout every experience you share, even in a crowded room.

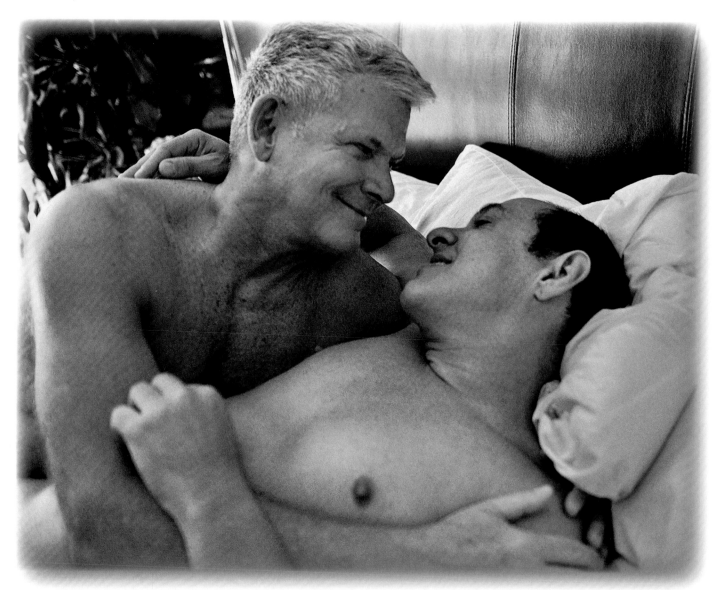

Ron and I both value each other's worth, as good friends should, and we hold each other in the highest esteem. When we're out somewhere and I know he's really proud of me, or he sees that I've done something well, he just gives me this look. I'll look in his eyes and in that moment we are more one and more in each other's arms and in each other's spirits than in any other moment.

Jorge and Ron's journey of evolving love has added a richer dimension of wisdom to my life, contributing a broader spectrum of colors, textures and applications to the toolbox I draw from when navigating my intimate relationship with Cynthia and other important relationships in my life. Thanks, guys!

# Ron & Jorge: In Their Own Words...

**Let's begin with the story of the first time the two of you met. How did you first meet and fall in love?**

*Jorge:* Well, I was living in Dallas; Ron was living in California. And we met in Mykonos, Greece.

*Ron:* Not a bad place to meet!

*Jorge:* No, not a bad place to meet, but usually a place that you don't go to find...

*Ron:* ...a husband, or a life mate. It's usually a place you go to find a mate for the evening.

*Jorge:* I had been noticing Ron all week. The first time I saw him, he almost ran me over with his motor scooter. After it happened, I thought to myself, "Oh, that guy almost killed me, and he didn't even notice that I was right in front of him!" And then my next thought was, "Well, it's lucky he's cute." After that, I began "running in" to Ron without ever really meeting him. I'd get seated at a restaurant and notice him at the next table, seated with his back to me. Or I'd see him in the coffee house, on the other side of the room.

*Ron:* And I never saw Jorge, at all.

*Jorge:* He never saw me, maybe because he was always surrounded by so many people. I didn't know he was there with a group of 50 guys.

I kept on thinking, "He's really good looking, but boy he must be a real player." And then the last night I was there, I was in the club and it was four in the morning. Ron came up to the dance floor and just stood there watching me dance. When I noticed he was watching, I left the dance floor and went to the other side of the bar.

I knew he had seen me and I had felt the connection between the two of us, and it scared me. There was something in my spirit that told me this was going to be something. And when I saw that he was watching me and our eyes connected, I wasn't sure if I was ready for that something. Just then, the club closed, the lights came on, and a friend of his had just asked me to go to a party. The moment the friend walked away to get the details about the party, Ron came over to where I was standing and asked me if I wanted to go for a walk.

*Ron:* We went for a walk down by the pier; by the harbor. It was a beautiful night.

*Jorge:* We walked, and talked, and ...

*Ron:* ...Spent the night together.

*Jorge:* And we've been together ever since. Ron was scheduled to return to the States the next day and I was planning to leave for Athens the day after that. After our first night together, he said he would stay an extra day in Greece so he could have a date with me in Athens. So he stayed and we actually had another date; a night together in Athens.

Then, when I was on the plane to London on my way home, I called him and told him I had a week more left before I needed to get back to work. So, I landed in Dallas and got back on a plane to California the next morning to visit him for a few days. We started travelling back and forth between Dallas and L.A. every two weeks to spend time with each other. Three months after that he asked me to move in with him, which I thought was kind of soon.

*Ron:* I was losing my roommate and it was just a situation that inspired the thought, "Okay, this is a perfect chance." We both felt really good about it. We felt that connection.

*Jorge:* My friends thought I was crazy, and my sister did too. They all said, "You don't even know this guy!" But the timing was right, so I trusted my gut. I wanted to move out of Dallas anyway. When I met Ron, I had just lost – over the period of ten months – two of my closest friends to AIDS. I was very sad and depressed and felt I was losing my grasp on happiness and life. In a period of time when it was rare for gay men to be intimate and really love and commit to each other, I started wondering, "Will I ever have a relationship? Will anybody come into my life who truly loves me?" I was letting everything that was happening around me really affect me to the point of... I think I was losing the will to want to even live.

**I understand. I remember when my first wife and I were separating and that's similar to how I felt. I never felt like I would take my life, but I just didn't see any purpose in living. I didn't see the purpose or the value of whatever would be next.**

*Jorge:* Exactly. And luckily my sister saw how much I was hurting, and that is why she suggested that I go with her on her vacation to the Greek islands, to lift my spirits. It was a place I had always dreamed of going and it felt good to know that one of my dreams was coming true. Being there got my juices going again – and Ron was a big part of that.

I've told Ron from day one that he brought me back to life. I found him while I was in the midst of so much doubt – about life, and about whether love would ever find me. All I saw was sadness around me and I was just engulfed in that. When I look back at that summer, I know that I was really losing my connection to happiness. When you lose your happiness, you lose all your will to go on.

From the get go, Ron started talking to me about traveling, because he works in travel. He started mentioning all of the places in the world I had never seen – some I had never even heard of – and the possibility of going to some of those places brought me happiness and a feeling of wanting to live again. I realized that I had a choice about what steps I took from that moment forward. Even though I felt all this sadness, and had been through so much loss….

*Ron:* …There was hope.

**That is so beautiful. Ron, for Jorge, meeting you represented hope.**

*Ron:* I was just being myself. We came from totally opposite backgrounds – in fact, we couldn't have come from more divergent backgrounds. I grew up on a farm, and was raised in a bible belt, Christian mentality. And even though I have never had a relationship with a woman, I didn't come out until my early 30s. I was too concerned about what others would think.

*Jorge:* Ron came from this Midwestern family with very western values, very dinner at 6 and bed by 10. I came from the Cuban spicy family that was a little less disciplined, and a lot more social and expressive.

*Ron:* It's interesting, because I had dinner with my friend James Van Praagh a few weeks before that trip to Greece, and he said to me, "You're going to meet somebody and fall in love on this trip." I said, "What!? I fall in love every night!" It was interesting to watch how the scenario unfolded; how I hadn't seen him all week long until the universe brought us together on the last night. I even told Jorge that night, I remember this clearly, that he was an old soul. For somebody to tell someone they've never met before something that deep in a nightclub at four in the morning was a little out of context. I can understand why it kind of freaked him out a little bit.

*Jorge:* The next day he actually told a friend of his who was staying in the same hotel as part of the group that he had just met his husband. He is very confident!

*Ron:* There was a connection on such a deep level on all areas. We didn't even know each other. Then the night in Athens that we spent together, I'll never forget that either, because we had walked up to the top of the hotel and we saw two shooting stars, over the Acropolis.

**You can't even do that in a movie!**

*Jorge:* We were like, "Oh, wow! This is magical." I knew that we had come together for a great purpose. From the moment we met, there was a plan being revealed to us and we were going to do great things ...

*Ron:* ...Together.

**What were some of the early signs that this relationship would endure through time?**

*Jorge:* Right after I moved in with him, I knew it was going to work, because, above all else, Ron was just my friend. He took me for who I was. He didn't confront me when we had a difference of opinion, even though sometimes I wanted him to because that is what I was used to. He'd just say something like, "You know what? I'm not going to go there right now because that's not going to serve you or me."

I knew right away that this is a man who can handle me; that this is a man who really gets me. I was very honest with Ron from the beginning. I was honest with him about my expectations, and about what I thought I could commit to with him. Being a 35-year-old Cuban man who had been dating for a while, I knew who I was and I was not going to make promises that I could not maybe keep. I decided from the beginning that I was going to be totally honest about my views, my feelings, and my assets as well my weaknesses as I understood them. I really came to the table with all of who I am. It's interesting that sometimes when someone gives you the permission to be totally who you are, that's when you find out who you really are.

*Ron:* When I met Jorge, I knew that this person was going to change my life, enrich my life, and bring me to another dimension. We both knew it was a good fit. What's gratifying is that over time we have seen just how much we contribute to each other.

**When the two of you reach an impasse about something, say for example you're in an argument or in a discussion that is escalating, what are some ways that you have found to work through that, to get to clarity, to come to some sort of resolution? Are there particular methods or processes that you have found work well for you?**

*Jorge:* It may sound overly simplistic, but our process is about loving each other. That's our process. It's about him knowing me and me knowing him. When I start getting out of hand, he'll look at me and say, "You're out of hand right now and you know what?"

*Ron:* … I don't want to talk about it. I'll tell him, "I'm not going to talk about it at this point." Because if the conversation is already escalating, then talking about it in that moment is not going to be productive. It's much better to table it for the time being, and come back to it when each of us is less reactive. Because we're committed to each other, we know that whatever comes up, we're going to work it out eventually. We don't need the other person's immediate agreement in order to let go of our own upset. Jorge and I both have a strong sense of independence, of each being our own person. A lot of times you don't see that in relationships, and that can be a danger if one or both partners are not strong and independent on their own.

A big part of what works about us is that we realize that there are areas, especially at this point of our lives, where we just aren't going to change. As much as I may want Jorge to be different in certain areas, I'll frustrate myself and drive myself crazy if I keep expecting him to change to match what I'm wanting to see. I don't give him the responsibility of making me happy, and I don't take his happiness on as my responsibility. I'm responsible for my own happiness, in the end, and it's got to be independent of whatever choices he does or doesn't make. A lot of people have the fantasy that it's their job to make their partners happy all the time, but, really, you can't control that. Not long-term anyway.

Jorge and I acknowledge that, while we are traveling this path through life together, but within that, we are also on our own individual paths that are continuously evolving. When I think about all the ways we have both evolved spiritually and psychologically over the last 20 years, I think we've been able to grow together rather than apart because we are mindful of and transparent about who we are now versus twenty years ago.

**What would you say is the key to couples growing together as they evolve, rather than apart?**

*Ron:* Well, I think appreciation has a lot to do with it. I'm constantly amazed by and appreciative of the gifts that Jorge brings to the world, to the people we meet, to every aspect of our lives. I see the beauty and the sacredness of what he brings and I think he sees the same within me.

*Jorge:* We both value each other's worth, as good friends should, and we hold each other in the highest esteem. Some of the most intimate moments I've shared with my husband have been outside of the bedroom. When we're out somewhere and I know he's really proud of me, or he sees that I've done something well, he just gives me this look. I'll look in his eyes and in that moment we are more one and more in each other's arms and in each other's spirits than in any other moment. That intimacy of the spirit is important as any intimacy of the flesh. Physical intimacy begins a relationship, but eventually it has to evolve into deeper forms of intimacy that can be expressed not just in the bedroom, but throughout every experience you share, even in a crowded room.

In addition to appreciating one another, I think loving ourselves has also been a key to our ability to grow together after all these years. I approach this relationship very selfishly in the sense that in the end, the more I love myself, the more I can feel Ron's love for me. If I am not content within myself, I really have nothing to give him – and in fact, if I'm not loving myself, I will unconsciously be seeking to take love from him in order to fill that void. It's only when we feel loved within ourselves that we can give love to another.

**How has the quality of trust evolved in your relationship through time? Have there been certain moments or lessons you've each learned that deepened your sense of trust for one another?**

*Jorge:* There was a moment early on in our relationship that has a lot to do with how much I trust Ron and why I have trusted him from the beginning. I was still living in Dallas and had come out to see him over Halloween. We were at this huge party at the House of Blues and there were beautiful people everywhere. Ron and I were standing by the dance floor, talking, and we're both dressed as Indians, and this other guy comes in, dressed in a very similar Indian outfit to the one that I'm in. We all start talking, and I notice that this gentleman is a very, very, very good looking man. And I get the distinct feeling that he really likes Ron.

We talked for a while and then suddenly Ron excuses us and says, "Why don't we go, I need to go to the bathroom, do you need to go? Come on, I'll take you there." And as we're walking to the bathroom, he's in front of me and I'm in back of him, and in that moment, I start having trust issues. I'm thinking, "Boy, he really was talking to that other guy for a long time." All of these little things started just coming into my mind, especially because I am just getting to know Ron myself ...

Right in the middle of this internal dialog I'm having with myself, Ron stops walking. There are people everywhere, behind me and behind him, but he stops anyway. He turns around and looks at me and he says, "I want you to know something. It doesn't matter who's around, I'm with you." Then he grabbed my hand again and turned back around and kept walking. It's as if in that moment, he could feel my doubt about him. He somehow felt me asking myself, "Should I trust this guy? This guy I don't know?" Because out of the blue he just turned around and looked at me and basically said, "Don't worry, you can trust me." That was a huge turning point for me and a defining moment that reassured me that this is right. This is good.

*Ron:* I think that love and trust just have to go hand and hand, because if you don't trust someone, there's no way you can be transparent with them. And if you're committing to live your life with someone, that person deserves to know who you really are.

*Jorge:* We started our relationship by articulating very clearly who we were and where we were headed. From the beginning, I made it a point to be very open with Ron about what my ideas of what an ideal, workable relationship would look like. I also told him that along the way there would of course be needs that I have that were not getting met, or moments where I might perceive myself as not being what I thought he wanted or needed in a relationship, but that the most important thing to me is that I needed to have the freedom to tell him everything I was feeling.

*Ron:* It really comes down to the willingness to be fully transparent.

*Jorge:* Transparency is what makes this relationship work. By the age of 35, I had been in various intimate relationships and came into this one at a point of really wanting more out of my life. I was very honest with Ron

about all the things I wanted, and told him that for us to stay together for the rest of our lives, we would have to stay honest, because that is the only way to ensure that both of our needs are getting met. I wanted to be able to be myself with Ron, and not have to hide anything.

Out of all of the men I'd dated, what made the biggest difference in this relationship is that Jorge had a very good sense of who I was. From the get go, he really got me. He basically said whatever challenges come our way, we'll face them together, openly, with the intention that both of our needs are going to be met.

Ron didn't put a lot of limitations on me in our relationship. He just said, "I trust you, and just be honest." This has been the one relationship where I have been, because there's been no need to hide anything. I feel very secure. It's funny how when somebody gives you the permission to be who you are, you really want to bring the best version of yourself to that person.

*Jorge:* In a way, the transparency between us gives me a sense of security, because I know that no one knows Ron as deeply as I do, and for that reason, I don't have to worry. He could be in a bar filled with the most gorgeous male specimens that you could imagine, and I don't worry about it. He knows the value of what we have together, and if he is going to make a decision to sacrifice that over someone he has just met in an instant, then what we have isn't what I thought we did. If I have to worry about him in a bar, then I have to worry about him in the supermarket, at a gas station, at the gym, and I just won't go there.

I trust him fully because I love him, and I hope that along the way we can continue to be honest with each other. If I get to a point where I am scared that I'm going to lose him, then our relationship has already devolved to a very scary point. That cannot happen when we are being transparent with each other about who we are and what we want.

**Can you share with me the qualities and attributes that you admire the most about each other?**

*Jorge:* I admire that Ron is a man of his word. He's honest. He's sensitive. He likes to have a good time. He can let go. I can count on him. I love how he loves me. Our relationship hasn't been work. You've got to work at it, but it's not work. I love that about him, that he's brought me into a relationship that doesn't seem like it's work all the time. He is my soul mate.

**And you?**

*Ron:* I love the fact that Jorge has this incredible strength of character. He's a strong person. I think everybody sees that, and I see it the most. He has a depth to him and an incredible wisdom. He is sensitive, and giving, and I also love his spontaneity. I love the childlike part of him. I love the beauty of his soul and the depth that he brings. I feel honored that I know him so intimately because I've spent the quality of time with him that I have. He has principles that he will go to the grave to defend, and they're beautiful. A lot of it revolves around family and qualities of love that you don't find sometimes in a lot of people you meet.

**What would you say is the most meaningful thing you've contributed to one other, or learned from one another?**

*Ron:* The most meaningful thing Jorge has given me, which – it kind of chokes me up – is that he brought me back to my family. Coming from a strong Christian background like I have, I really separated and distanced myself when I came out. I didn't feel like I would be accepted, so I distanced myself from my mother. By that time, my father had passed already, so Jorge never met my father, but he brought me back into relationship with my mother. Jorge is so family orientated and I'm so damn independent and probably the biggest gift that he has ever given me is reconnecting me with my family. The last years of my mother's life, she was very grateful to him for being there and for bringing her son back to her.

**That is a very meaningful gift. What qualities do you feel that Jorge encouraged in you that made you more willing to open up to your mother, to your family?**

*Ron:* More than anything else, he pushed me, because somebody needed to push me to go out of my protective shell and to realize that they will be accepting and that this is a priority and it is important for me to do.

**He helped to give you the courage that it could be possible to connect with them?**

*Ron:* Yes. In seeing how easily he connected with them, I realized that it was possible for me to experience that connection as well.

*Jorge:* I knew I had to connect with Ron's family and experience for myself where and how he grew up. And I knew that he had that fear that almost all of us have as gay men, of not being accepted.

Gratefully, I was never fearful of that because I was accepted by very loving parents from the get go. I never "came out" of the closet. When I was 17, I told my parents "I'm bringing my boyfriend over," and their response was, "Well, I hope he likes Cuban food." That was the biggest reaction I got from both of my folks.

In time, I developed a great relationship with Ron's mother, and I believe that in me she had found – really for the very first time – an unconditional friend. To me, she wasn't the founder of the church. She wasn't the grandmother or the devoted wife. She was just my friend, Frida. I was not scared to be transparent with Frida; to show her who I was. Thus she showed me who she really was, and she hadn't let anyone into those parts of her, ever. She gave me an incredible gift.

**It sounds to me that by being authentically who you are, you became a bridge that helped Ron and his mother relate more authentically with one another. That is a beautiful example of what unconditional loving can do, if we are willing to be fearless in that way. I can see that you interacting with her in this way is just a part of your nature. You're so disarming and you have this beautiful spirit. I can see how you could just come into somebody's space and inspire them to open up because you're so authentic and caring.**

*Jorge:* Thank you.

**It's also a powerful reminder that in an intimate partnership, the intimacy that's created doesn't just stay between the partners, but has the potential of rippling out to include our immediate families as well. I can see in your eyes, Ron, just how meaningful that was for you.**

*Ron:* It was, and I might never have experienced that had Jorge not come into my life in that way. We're best friends, you know? Being with him is like having a relationship with somebody that I really like and are friends with. We've had that sexual chemistry and emotional intensity right from the beginning. And we also have a connection that is much deeper, that I think has contributed greatly to the longevity of our relationship.

Following my day with Ron and Jorge, I felt like I was floating on a cloud of pure love and peace. They demonstrated a consistent way of being together that was steeped in honor and pure acceptance – not from a place of denying their differences, but from having learned how to communicate and work things through in a clear and thorough way that brings a wider scope of understanding and resolution.

In my relationship with Cynthia, situations often arise that present me with two choices. Whenever I'm faced with anything that feels unresolved within myself, I can choose to either share what's going on with Cynthia, or to remain silent and work it out internally. Usually, if I take the latter course, there's a part of me that feels as if I'm withholding something from her, even if it has nothing to do with her.

As an example, I recently came across a "deal of the century" on some used lighting equipment posted on Craig's List. The seller was practically giving away a variety of equipment that would be of tremendous benefit in my new studio. When I contacted the seller, he informed me that he had just offered it to someone else. Without missing a beat, I offered him double the asking price. He considered the offer briefly and then said yes. I made arrangements with him to pick it up later that afternoon and the deal was complete.

When I hung up the phone, I felt an unsettling sensation within. My ethical standards told me that my action was a bit unscrupulous and I felt a little shameful, knowing that if I had been the person that had been promised the equipment and then lost the deal, I would have felt disappointed. And the truth is, I have been that person in past

situations. When Cynthia arrived home later that day, I initially didn't share with her the details, only that I scored a great deal on this equipment. Within twenty minutes after our discussion, I was clear that if I didn't disclose to her the details, it would feel as if I were hiding something from her. So, I approached her in the kitchen and fully discussed the entire transaction. She paused and we both acknowledged that I had acted out of an old pattern based in scarcity that didn't match my ethical principles or my present consciousness around abundance. She then said, "Well, what's done is done," and that was the end of both the discussion and my residual feelings around what had happened.

This situation reminded me that even the most subtle of withholds from our partners brings some degree of distancing. And even though this example didn't involve Cynthia directly, if I had chosen not to share the details with her, I would have missed the opportunity to include her in my process of working through my feelings of shame and guilt. By consciously making the choice to voice my actions and feelings, it helped to strengthen the ties that continue to weave a stronger and more stable rope to balance and support us throughout our daily interactions.

I'm not suggesting that it's necessary to share with our partners everything that feels unclear or unresolved within us. In fact – as Ron consistently demonstrates in his relationship with Jorge – there are times when it's healthy and empowering to choose "not to go there," and to cradle a question or concern within the confines of one's own inner sanctum in order to seek answers from the intelligence that's ever-present.

Here are a couple of questions that can be helpful to ask ourselves in order to determine whether to share or not to share: *"If I don't discuss this inner conflict with my partner, will it feel as if I'm keeping a secret from him/her?"* Or, *"Will sharing this conflict help to bring us closer?"* If the answer to either question is 'yes,' than it's probably wise to bring your partner into the discussion. If the answer is no, then the better choice may be to seek clarity from the wisdom that resides within.

It's important to note that the act of being transparent applies just as strongly in our relationship to ourselves as it does with our partners. The more willing that I am to truly be seen for my smooth and rough edges alike, for my accomplishments as well as my failures, and for all the parts that make me both human and divine, the easier it is to let go of shame and judgment. In this way, transparency can create an upward spiral of increasing trust between partners: the more authentically we show up, the more of ourselves is available to be fully present and loving.

# Chapter 7

## ESCORTING PASSAGES: DEEPENING CONNECTION THROUGH DIFFICULT TIMES
*The Evolving Love of Makeshta & Sage*

.................................................................

As our relationships with one another mature through the passage of time, we invariably experience losses, tragedies, or other trying circumstances that may shake the very foundation of our partnership. How we respond when faced with such challenges determines whether our union will be undermined or strengthened as a result. Makeshta and Sage demonstrate how even a loss as tragic as the death of a child can deepen the bond between partners.

My first meeting with the couple took place at their home in Maui, when Sage was eight months pregnant, and I had the opportunity to photograph the tenderness of their love for each other while in preparation for the birth of their daughter, Mahealani. Our next encounter took place in Graton, California when Mahealani was two and a half, and the three of them were living with Makeshta's grandmother in the Bay Area, where Mahealani was receiving weekly chemotherapy and radiation treatments for a malignant tumor behind one of her eyes.

Witnessing the three of them together, I felt as if I had entered the most sacred of temples. This little girl carried the wisdom and lightness of a true spiritual master and her parents fully recognized and honored Mahealani as their spiritual teacher. There was not a trace of fear in their way of being with each other, just a rich and tangible sense of honor. I could see how these devoted parents were absolutely giving their all to their child and I felt a sense of surrender emanating from all three of them; a greater acceptance to however Spirit's highest plan was to unfold. I

walked away from the experience so much more attuned to life's temporal nature; seeing everything as more fresh, alive and connected.

Our third and final meeting transpired two years later, back in Maui, approximately one year after Mahealani made her transition. Both Sage and Makeshta held such a clear conviction that the greater purpose in their coming together was to birth their daughter and learn from her wisdom. Remarkably, they chose to take this deeply intense, love-filled and painful experience and use it as a catalyst for their individual and collective growth. While many couples might crumble and lose faith through such an ordeal, these two chose to strengthen in their faith and gratitude.

The couple's shared appreciation of ceremony and prayer deepened the profound bond that saw them through the joyous birth of their beloved daughter, the two and a half years of pursuing treatments, and through the time of her ultimate passing. From the moment of conception, their daughter acted as their teacher. She became the template, the glue and the purpose for her parents to build a life together. After her passing, their renewed commitment to their ceremonial practices opened each up to greater realms of love, trust, vulnerability and surrender than they had ever known.

# Sage & Makeshta

The qualities that I honor the most about Sage are her patience, her clarity, and the way she freely gives me the freedom to make my own choices.

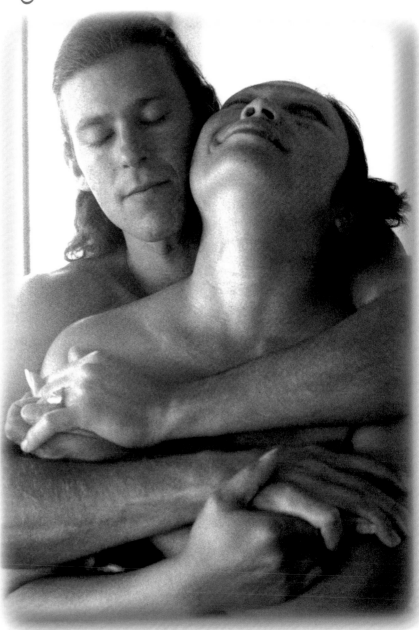

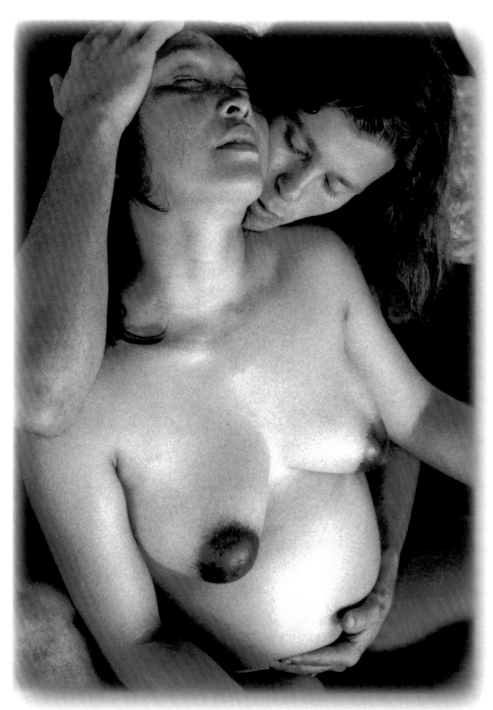

I honor Makeshta's youthful innocence. Perhaps at that age I didn't appreciate it, but now in my life I can look at this beautiful quality and truly honor what we all go through at that younger stage of life.

We receive great value from taking part in sacred ceremonies together. They're a time of being close to each other and hearing each other's prayers while going deep within ourselves and releasing whatever is burdening us. This leaves us in a state of being thankful and prayerful for where we're heading.

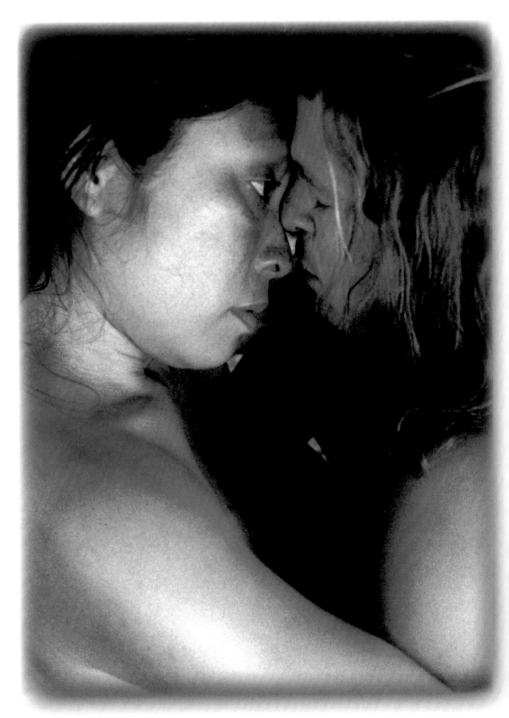

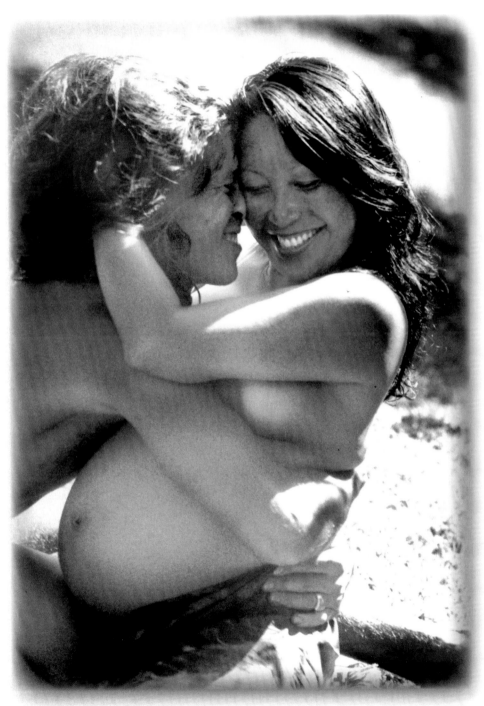

Our relationship is really a reflection of my relationship to everything else; how we relate to all things in our lives such as the plants, the animals, other people, and the Great Spirit. Ceremony is a conduit that strengthens this connection.

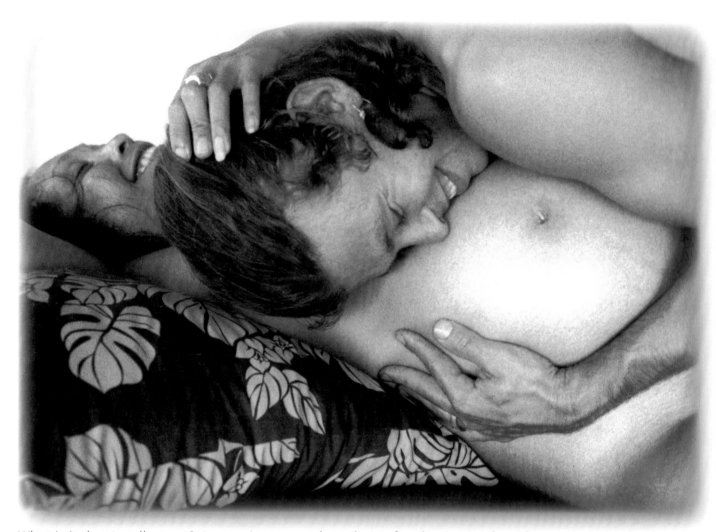

What is it that I really want? Just a nice warm place that is familiar to me that I know I can return to. In the relational space between us, we've created a hearth, a fire that's warm and nourishing; something that will always be there.

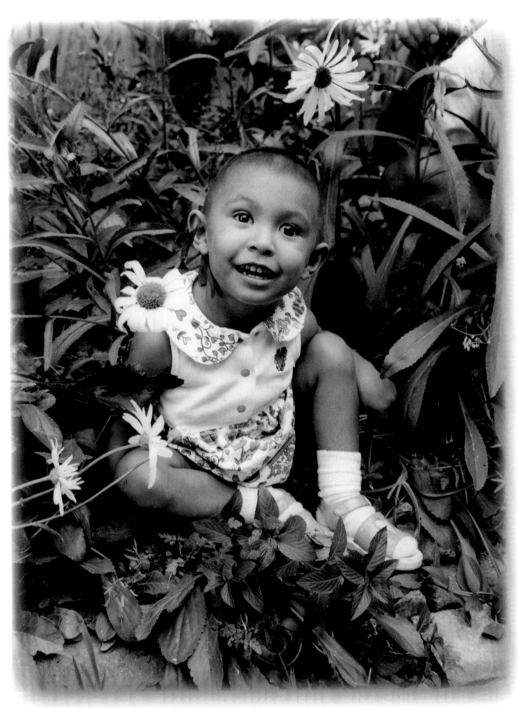

Our daughter is the greatest gift that Makeshta has given me, and the greatest gift that I could offer to humanity. This child was conceived in love and she reminds me that our relationship is truly about love; it's about continuing this essence, this sense of love. It's why we exist.

Both literally and figuratively, Sage and Makeshta escorted one another through each stage of their daughter's journey, providing for one another a safe and trusted haven that they could consistently return to. The age difference between them afforded each the benefit of a different perspective. Sage brings wisdom from her greater life experience, while Makeshta offers vitality and openness to new possibilities.

Here is their story of how their love evolved, in their own words:

# Makeshta & Sage: In Their Own Words... Interview #1

**How did you both meet and fall in love?**

*Sage:* Well it's not so highly spiritual! Do you want to tell your side?

*Makeshta:* Okay, I was on a journey. I'd lived in Alaska, and before that, Colorado. Before my visit to Hawaii, I was clearing away a lot of my past by paying off debt and giving things away. I was traveling really lightly, staying with friends on Oahu.

*Sage:* A surfboard, a backpack and a skateboard.

**Makeshta:** One day I had the urge to get on a plane and go to Maui. While I was waiting for the plane, I met a friend of mine from Colorado who was living on Maui. She told me that I could stay at her house that night, and from that moment on it was as if there was a force that was supporting me every step of the way to live here on Maui. Everything was set up. Soon after I arrived, I got a job and began thinking about what I wanted in my life. I was having thoughts of a family and a place to really settle down. I worked in a restaurant at night, and after work I would go to the restaurant's disco-tech to dance and blow off steam. Casanova's, the one and only disco on Maui! It was very 90's. I didn't go because I had a particular attraction to anyone. I wasn't meeting friends, and I didn't know anyone there. I just found it a great place to go and let loose, to get out of my mind and into my body. That's where I met Sage, on the dance floor. She was without a doubt the most energetic and expressive dancer in the place. I felt safe with her because I could tell that she was just there to dance without any expectations.

**Sage:** In the Maui community, I was known as a ceremonial artist, leading Native American sweat lodge ceremonies. The truth is that for about nine months before meeting Makeshta, I had done this routine of going to the techno night every Wednesday. I needed an outlet that had nothing to do with sacred ceremony so I would dress in the sexiest, most raunchy outfit I could find *(laughing)*. I'd walk in with this very dramatic black cape, go onto the dance floor and unveil and unleash, really stirring things up! And all I'd have to drink is carbonated water. Then at the end of the night when I got everybody out there and really moving, I would take my cape, put it back on and I'd leave. I was there to unleash and unwind, not to meet anybody. When I first saw Makeshta on the dance floor, literally all I saw was a mass of long, blond hair in front of his face. Then, when I looked in his eyes, I was struck by how deeply green they were. He was wearing this horrendous matching outfit that consisted of an inside out t-shirt and striped shorts.

**Makeshta:** I was just a cook.

**Sage:** He definitely wasn't trying to attract anybody, and it wasn't the kind of outfit that attracted me. He was simply dancing and having fun. When I think about it now, there was something very mysterious about him, penetrating through his eyes. Even in that demeanor I could see this complete innocence about him. He came up and danced with me as everyone around us was dancing together. I felt safe in asking him to walk me to my car.

Through conversation, I learned that he worked in the restaurant next door to the club, so the following night I dropped by to check him out. I had dinner by myself and watched him throughout the night. Unaware that I was there, I wrote Makeshta a note saying, "Come up to my house. I'll pick you up after work." All I could see when he received the note was this huge smile on his face and I thought, "Cool, this will be fun. Take him back to the temple." And it was a really great experience. That period of my life totally revolved around sacred ceremonies like trans-dancing and Tantra. I felt I was at the height of my individuality, and expressing who I truly am as a woman. I had already gone through two marriages along with many short-lived relationships, and I was clear that now no man was going to rule me! I had my own little temple and my own sacred garden and I could bring anybody I wanted there and honestly share what I wanted out of a relationship. I was very clear on spelling out what terms were necessary for me. Whether they liked it or not, this was who I am. So, when I brought Makeshta back to my place that evening, there were candles and crystals everywhere and in the center, my altar bed. I told Makeshta, "If you want to learn who I am, this is what I'm into," and we began with practicing Tantra meditations. We caressed and started breathing together. I have to admit, that was the first time I'd ever been in a relationship with someone where we actually started off on that note. There was nothing romantic about it. We didn't lust for each other when we first saw each other.

*Makeshta:* I was actually very open and hungry for information about how people can live in a more positive and evolved way, and I really didn't know where to start. I grew up in Sonoma County and my parents were involved with this so-called spiritual community that I felt was very pretentious. I think they had some high ideals, but in reality, the way they lived their lives was pretty much the same as everyone else. It felt more like a cult than a spiritual community. So, I was pretty wary of people that spoke about spiritual knowledge because people can talk a lot, but walking their talk is a whole other matter. But this was different; my experience that night with Sage was very profound. She'd say breathe and we'd breathe together. She took us through this powerful meditation and it gave me a clear sense that this was a genuinely deep person.

*Sage:* The rest was Spirit's doing, because everything unfolded very quickly. Through a series of circumstances, three days later Makeshta was without a place to live, so his surfboard, skateboard, and backpack went into my truck and that was it. He's been at my place ever since. We had known each other for just three days!

## What qualities do you honor the most about each other?

*Makeshta:* Sage has needed to be very patient with me in our relationship, and patient about how things happen and evolve. I appreciate that she is not set on how things are "supposed" to be; she simply allows other beings – whether it's the animals, the person she's living with, the plants, or her daughter – to just be who they are. She's very comfortable in stating her boundaries. She'll tell me, "This is what I like in my life. This is what I can tolerate. If you want to do something that's different or opposed to that, go ahead, you're free to leave at any time." Yet at the same time, she's very patient in allowing those deeper parts of myself to guide my decisions and to come around if that's my wisest course. So the qualities that I honor the most are her patience, her clarity, and the way she freely gives me the freedom to make my own choices.

*Sage:* I most honor Makeshta's youthful innocence. There's no question that there's a generational difference between the two of us, and he reminds me of the innocence that I had when I was his age. Perhaps at that age I didn't appreciate it, but now in my life I can look at this beautiful quality and truly honor what we all go through at that younger stage of life.

## How have you learned to anchor a deeper trust with each other?

*Makeshta:* We talk about what our deep intentions are. I receive great value from taking part in ceremonies together such as being in the sweat lodge. This is a place where we can really go deep. It's a time of being close to each other and hearing each other's prayers, and at the same time, going very deep within ourselves and releasing whatever is burdening us, which leaves us in a state of being thankful and prayerful for where we're heading.

*Sage:* We have a strong spiritual path and because we share in these ceremonies together, we're always learning about each other on a very deep and personal level. I can sit back and listen to Makeshta while he's praying in the sweat lodge and I sincerely know what his truth is in that moment. Then, when we come out of the lodge and we're in real life, how can I not trust this person who gives so much of himself as he's praying so deeply with the Great Spirit in this sacred lodge? Honestly, anyone who would be untruthful in the sweat lodge would get it from Great

Spirit; not from me. We've learned to practice honest and clear communication in our daily lives, and we have certain tools that we use when it gets scary for us. We might say, "Let's go smoke the pipe," because it's literally a "Peace" pipe and this ceremonial act helps to bring us back to a place of honor and reverence between the times of the sweat. It leads us to greater clarity about where we're coming from within ourselves and gives us a greater ability to fully listen to what the other person is needing to express. That's our life.

**What I'm hearing is that through participating in these ceremonies together, you are able to let go of your egos, get out of your own way, and give yourselves over to the greater Spirit.**

*Sage:* In a nutshell that's what it is. When you first asked about relationship, it was interesting where my mind went because my whole life has been based around the relationship I have to the earth, the animals, and the trees. If I can't feel at one with all these other beings, then it would be difficult to know oneness with this man that I live with. So, our relationship is really a reflection of my relationship to everything else, how we relate to all things in our lives such as the plants, the animals, other people, and the Great Spirit. Ceremony is a conduit that strengthens this connection.

**What would you say is the greatest gift you have given to each other?**

*Sage:* Our daughter. She's an extension of my life. She's the greatest gift that Makeshta has given me, and the greatest gift that I could offer to humanity. This child was conceived in love and she reminds me that our relationship is truly about love; it's about continuing this essence, this sense of love. It's why we exist. She's such an incredible light being and she's teaching me why I made this commitment. She's teaching us how to teach. She's saying, "Show me how you got to this place in your life. Show me what you really are." Then she'll reflect all of that back to us during those times when we forget that we're pure, born out of love. She'll pick up a discord in the tone of our voices. At times when Makeshta and I are talking to each other and there's an opposing tone under the surface of the words, she'll say, "Mommy, Daddy, don't talk, don't talk." She's indicating to us there's something present that is not coming out of pure love and it's not worth the energy to continue until we figure it out and until we can be with each other from pure love. She first began saying this when she was only a year old. Out of nowhere, "Don't talk, don't talk." Quite often, people

don't listen when their children give them a message like this. They just think their child doesn't know any better. But it touched us to consider that our daughter is able to teach us! We have to stop in our tracks and I'll say, "Look Mahealani, I'm needing to explain to Daddy how I'm feeling. I'm not angry with him and even if it sounds like I'm angry or it doesn't sound right, it's okay. We're going to figure this out." So now she's learned to sit in the discussion, listening, observing and learning how we reach a place of resolve. I'm so clear that her initial reaction in telling us not to talk is the wisest choice we can make. Maybe sometimes we just need to listen.

*Makeshta:* She's a being that I helped enable to be here and she's a gift back to me at the same time. We all have unique ways in which we use our energy, and being a part of creating our daughter was one of the best uses of my energy (*laughing*)! She continues to be a gift back to me, constantly offering so much joy. She's currently taking eleven medicines and I'm becoming more and more creative with our morning routine. I alphabetize each medicine, going through the whole alphabet while she takes each one, and it's so much fun because she's fully receptive to any little change, any variation she notices and evaluates. She takes it in and then is open to what's next.

**When you're in the midst of a challenge - whether it's related to Mahealani's health or something that's surfaced between the two of you, how do you work through that challenge? How do you reclaim that level of trust and safety in order to be present and available to get to the other side?**

*Sage:* Sometimes it takes being by myself in order to get to the other side. I've learned that some of the issues that come up just have to do with something that I'm going through. I might need to step away from it, to cool the fires down in order to get back to a place where I'm open and able to receive what I need to hear from Makeshta. Or, I might need to listen to my own inner guidance, which then allows me to offer that wisdom back to Makeshta. It requires that I be alert and not let the ego take over and tell me, "This is how I feel and this is what I know." Once I've had enough time to step aside and cool down, I'm then able to talk with Makeshta and openly hear what he has to say. I'm aware I can only get to this clear of a place when I set myself aside for a moment, or sometimes even for a day. Often, by the time we get back together to work on it, it's not even worth it anymore, it's no longer an issue.

*Makeshta:* Often, I'm able to shift out of the struggle just by releasing what I feel needs to be the outcome of the discussion. I'll take a moment and examine what we're talking about and how I'm feeling. I'll ask myself, "Am I holding any tension in my body?" "Is it really that important to hold onto what I think is right?" Then I'll take a deep breath, soften my eyes a bit and just accept what's coming to me. I might ask, "Why am I here?" I'm here for my daughter, Mahealani. And really, "What is my intention for her?" It's to be healthy and whole, experiencing a good life. "What am I doing in this moment to support this intention?" If the answer is nothing, or if I'm hindering this from happening, I need to adjust what I'm doing, usually by releasing what I'm holding on to. And then things can flow again and I realize how joyful life is. I'm learning how to let go of the idea that I have to prove or achieve something. As an example, I see that the gardens around us have flourished because we've allowed them to be, not because we made them a certain way. That's what human nature needs, taking the necessary space and allowing our inner guidance to direct us.

**What would you say is the greatest form of support that you can give to Makeshta?**

*Sage:* Loving myself and staying within the right intentions that I have for a peaceful loving, conscious existence. If I can maintain living consciously and with a lot of joy, love, spirit and beauty, I'll certainly want to continue hanging around with myself (*laughing*). In turn, I think that would be the highest form of support that I could offer Makeshta because I know that's what he wants for himself as well, and so this offers us the ability to mutually participate in this form of existence together. Also, Makeshta naturally knows how to manifest and create things.

**What is the greatest form of support that you can receive?**

*Makeshta:* Sage's visions support us both. She offers me the gift of these visions with such clarity and direction, and I have so much energy that needs to be wisely directed. I'm grateful to have projects that use my talents and benefit us both. As an example, I'd always loved plants but didn't know very much about them before we met. Sage introduced me to her garden and she taught me about plants. Before you knew it, I had a landscaping business on Maui. Things happen very fast with us. Our way of giving and receiving with each other is very fulfilling and it offers us a sense of wholeness.

**Tell me the highest vision of your life together.**

*Sage:* The highest vision is living a life steeped in ceremony such as the traditional Lakota Sundance Ceremony in South Dakota that we just got back from two weeks ago. This serves as an example of living together with people who share like ideals about what we wish to experience while we're here, sharing the intention of connecting Spirit and Earth.

**Are you saying that in your day to day life when you're not in a structured form of ceremony, you place your attention on experiencing that same level of sacredness and interconnectedness through your life?**

*Sage:* Yes, and I think we try. We get up in the morning and our current routine is to feed back to Mahealani her life force, which she needs in order to heal herself. So, in a normal day if we see anything that's waning to a degree where we feel stuck, we'll go to the ocean, or Makeshta will take a stroll to talk to grandfather tree, or I'll find time to plant, or write, or bead. All these things bring us back to that place of appreciating this wonderful thing that we have in life that connect us to the light, to the life force of living.

**Would you share about the journey that you've been on with Mahealani and how you've used this journey to strengthen your relationship?**

*Sage:* Well, she has a condition called Retinoblastoma which is an eye cancer that only children get, and we didn't detect it until she was about a year old. Once discovered, the first thing we did was pray to Spirit. We did our best to prepare ourselves for whatever might come, whether it be the worst possible outcome or a miracle. Throughout this time, she was only showing signs of good health, never any symptoms of pain. Once she started showing signs of vision loss, we really became concerned. At that point, it was important to take action and that brought us here to San Francisco to seek the best for Mahealani in Western Medicine.

When we arrived we didn't have a diagnosis. We didn't have medical insurance. We trusted that we were in the

hands of the Great Spirit and all of those things were going to come about. And so our experience has been one miracle after the next, being at the right place, meeting the right people and having her in the hands of medical professionals that are sensitive to our needs, values, and beliefs. The doctors are amazed that every time we go in for her treatment, she looks perfectly healthy. In the entire process of receiving chemotherapy she hasn't suffered any apparent side effects other than hair loss. She continues to have a lot of vitality in her body, while the chemotherapy – along with other treatments that she's receiving – are helping to shrink the tumor. It's reassuring to see that there's a way to blend prayer and alternative and western medicine together to help our child.

However, fears do still come up as I question whether I'm doing the right thing or if there's anything else that can be done. It requires that I address that old part of myself that doesn't fully trust that I'm always being guided and empowered by the Great Spirit, that higher voice. So it takes me a while to kick myself out of it and say, "Look, you're doing the best you can. You do everything out of love for this child. You do everything to support her in living her life to its fullest." Even if it may not be a long life, we know that every day she will receive this level of loving support. So, every day we wake up and see what we can do to take care of her needs in this manner. It's brought us closer in a deep desire to work together as we have this one intention, to cure Mahealani. Our level of communication has deepened in addressing what we can do, what we should be doing and how we're feeling. I might suggest to Makeshta, "I think you need to go to the ocean and surf." It's important to do this for each other because it's easy to get so personally involved with this situation causing us to forget about caring for ourselves. I do try my best to take care of my needs, but Makeshta does a better job at reminding me. He'll ask, "What can I do? Can I give you a massage?" Or, "You could soak in the tub." This period of time has really shown us how much we care about each other.

## *Makeshta:* We're both such free spirits that if Mahealani hadn't come into our lives, I don't think we'd be together because we're on such individualized missions. We're here to take care of Mahealani and to care for each other. Each day our connection grows deeper and we deepen in our understanding of why we were put together in the first place.

## *Sage:* I really do enjoy life with Makeshta, and we genuinely like being together. I spent much of my adult life searching for something until I finally asked myself, "What am I looking for? What is it that I really want?" Just a

nice warm place that is familiar to me that I know I can return to. And that applies with Makeshta as well. In the relational space between us, we've created a hearth, a fire that's warm and nourishing, something that will always be there. And if Makeshta were to need space, I wouldn't feel threatened because there's this fire, this place, and it will always be there for him as it will be there for Mahealani. I think that when you get down to it, that's what most people are looking for, a safe place they know they can come back to.

# Interview #2

## Would you both give me an overview of the events that have taken place since our last interview?

*Sage:* About a year after our last interview, Mahealani passed on. It was as if things accelerated the process of the cancer and her tumor. None of the therapies, the chemotherapy, or the radiation worked. After nearly completing the treatments, the tumor actually came back. We had been flying back and forth from Maui to northern California for check-ups and one of the doctors recognized that another growth had developed in her left eye socket. They suggested further rounds of intense chemotherapy, but we asked Mahealani what she wanted, she said "No more chemotherapy," so we opted for the radiation treatment.

We did several weeks of treatment in Honolulu, which helped her be to pain free as there was no pressure on her eye or in her brain. During this time, she functioned pretty normally, for as soon as the pressure went down, she was able to play and do things that she enjoyed. Then after a while we began to notice outward symptoms. Apparently the tumor had been growing inwardly towards the brain, causing her less ability to move her arms and legs, until finally she was bedridden with no feeling from the shoulders down.

Yet she was still very conscious and able to speak to us and listen to us. We would sleep with her between us at night and I would rest my cheek on hers so she would know that I was right there. Her dad would read her stories. He would bring her into the garden and spend many hours carrying her around and talking about the garden. Mahealani was extremely conscious until the very end, which actually came fairly quickly.

The day that she left, my father flew over from Oahu. He had this sense to be with her, with no idea that she was on her way out. No one knew, because she remained pretty conscious throughout. That evening after my father left, we carried Mahealani upstairs for her bath and Makeshta mentioned that she felt very different in his arms. We placed her down on a makeshift altar that we had prepared and we stood around her in a circle with an aunt and uncle who had shared much of the journey with us. As we stood there, her Aunt Kelly, an intuitive, started to sense that Mahealani wanted to speak to us, and so, as proxy for Mahealani, Kelly started telling us what Mahealani was experiencing. She wanted to let us know that Mahealani had made the choice to come through Makeshta and myself in order to have these Earth parents who would maintain the environment she needed in order to do what she needed to do while she was here. She knew that we would be strong for her and that we'd be close to her. She wanted us to know that what she was here to do was ground a very special spiritual energy that could not be put into words. Humanity might call it love, but it was something much greater than love. And in her passing, this particular energy would encircle and ground onto this entire planet infusing all of us in this energy. As Kelly was speaking these words, I was noticing that my pulse was perfectly synced with Mahealani's and Makeshta's. We were all in the exact same rhythm with each other. Then, suddenly, we felt Mahealani take a little breath followed by the words, "I love you." That was it. At first I wasn't quite sure that it was her last breath because it was so light, so I asked her Uncle Brian, a naturopathic physician, if he would check to see what state she was in, and he confirmed that she had passed on. There was no breathing and her heart had stopped.

It took me quite some time to assess how I was doing because I felt no remorse or sadness, just an incredible sensation of peace. Within the hour, I asked Makeshta to draw a bath and we bathed her together in waters of Hawaiian salts mixed with tea leaves. I floated in the water with Mahealani telling her how much I loved her and that I was with her. We carried her out, put her on the altar, and I began giving her Lomi-Lomi massage using pasquinate, a very special oil to the Hawaiians that represents wisdom and knowledge. We then picked out a dress, clothed her and placed her body on the altar. Everything unfolded in such a natural way. We called immediate family who were in the vicinity and everyone came, including those from a Native American Red Road Community that we belong to. All her uncles brought their pipes and performed a ceremony for Mahealani. The evening went by very quickly. Up until this time, it had been a draught season here on Maui, but for some strange reason there was lightning and thunder over the west Maui Mountains and it started to rain. From that day on the draught was broken. And so we knew that Mahealani, as she said, was grounding onto this planet her purpose in bringing a special energy here to mother earth.

At home, she laid at rest with us for three days and we chose to have friends, children and family come over and eat and sleep with us during this time. After the third day, her body was cremated and a week later we brought her to the Iao Valley. Makeshta and I arrived before our friends and family so that we could place her ashes in a place where no one except her father and myself would know. Beforehand, we asked permission of the honored Spirits of this sacred valley to bring her ashes. As soon as we began chanting in Hawaiian to the Iao Needle, two adult hawks and one baby appeared and we knew that this was a good sign, this is what was wanted by Spirit. We carried her ashes up to a special spot and placed them amongst the plants, trees and waters where she now rests and flows. Later, we proceeded down to meet up with our friends and family at another spot where we shared her remaining belongings.

**What would you say have been the primary lessons and insights that you have received from this chapter in your life?**

*Makeshta:* Life is precious. All that we have is right now, this moment. It's important to love each other, to love ourselves, and to fully share and express that love.

*Sage:* I always thought I had an answer for many of life's questions, yet I never really understood death. I questioned the mystery of it. "Why do we have to go through this process and is there really an afterworld?" And then Mahealani showed me the way; she showed me the spirit world. She taught me not to be afraid and she modeled for me that the greatest motivation, the biggest ceremony that I would ever go through, is when I am waiting to pass on. I now feel relieved, for I know that our ancestors who love us are there waiting. Knowing that my daughter's going to be there at the time of my passing gives me such hope and such ease. It relinquishes all the worries and fears about who's going to be there for me. I'm certain that she'll show her face and show me the way. She's given me the opportunity to grow from this experience and possibly share with others the reminder not to be afraid, that the afterworld really is a beautiful place with loved ones there waiting for us.

*Makeshta:* Being with Mahealani through her birth, her life, and her death showed me that we can have everything complete and in order before we die. There's enough time to do it all. Whether our life is 3 ½ or 80 years doesn't matter. We can live in a good way, placing everything in order, and go with such peace, grace, and beauty;

without struggle, through total surrender and trust. Mahealani showed me this truth. It was not something taught; she just knew it. She's my guru and I'm following in her footsteps.

## What would you say is Mahealani's key teaching for each of you?

*Sage:* The most important thing to Mahealani was to know that Makeshta and I were together. She kept us focused on being together and now it's up to us to realize and honor that message. It's clear that one of the key reasons she came into our lives was to unite us in doing beautiful and great things on this planet. Our energies work really well together and Mahealani was the glue. And so now we actually feel more of a purpose because we look at each other and realize that if she could commit her lifetime to getting the two of us together, then that's what we're here to honor. We're here together, dedicating our lives to the highest forms of work and service.

*Makeshta:* In addition, she has taught us both that her consciousness lives on and we continue to cultivate and develop our relationship with her, even beyond her body. So, we see her through our relationship to the world, especially here in Hawaii where she was born, here on Haleakala, the house of the sun. We see her in the light coming down from the heavens when the elements change, and when the winds or the rains come, and in the butterflies. Through all the dance of elements we see Mahealani. We're so much more intimate with our surroundings because we had her and because we've now released her.

## What is the greatest message you want Mahealani to know right now?

*Sage:* "Sometimes human existence is really hard and I know that you're in a way better place than where we're at right now." When I am having a hard time I say "Baby, Mama's having a really hard time, can you please help me?" and a butterfly lands on my nose or some gift is offered to me that makes me smile, or someone tells a joke that reminds me so much of her. So what I want her to know is that "*I know* that you're right there with me always, breathing into me all that love that you did when you were here. I do feel you and I acknowledge you, even in missing your physical body, but I'm going to be okay. I'm actually looking forward to life as long as I am here and I am looking forward to being with you as well when the time comes."

*Makeshta:* "Mahealani, I love you, sweetie and I carry you wherever I go. I also know that you're way bigger than me and so each day I wake with enthusiasm because it's a new day to know you and experience you more deeply."

**Would you tell me more about your grieving and honoring process?**

*Sage:* It's not all grief and honoring. There are actually moments of bliss and joy, brought on by my deep realization of life after death. It's exciting for my psyche to now embrace this. I'm in a place of honoring the fact that Mahealani is now with Spirit. It's a real truth to know that there is joy and love and excitement that lies on the other side of what we rarely acknowledge exists. This is the big mystery for us, but until we get there, we won't ever really know.

Why be in a state of morbidity or feel afraid of it? Why not embrace it like anything else that we embrace without a full understanding? It's only when my attention floats back to the physical connection that I miss her touch and the feeling of holding her. I think, "This is what it felt like. Oh my God, I'm really missing her." And then I realize that I have two choices. I can sit there and go deeply into those feelings of longing, or I can snap out of it and return to the present moment, right here and now. But, there are times when the pain is so great that I'll call out to her and ask her once again to help Mommy. I'll hear the sound of something so sweet that reminds me of her, which tells me, "I hear you Mom, but guess what? This is the reality." Once I have that realization, I'm okay with it.

The most challenging part of this grief process lies in being able to share my experience one-on-one with others who can experience it along with me. I find that many people are grieving in a way that is heavier than my own, so it's hard to explain why I'm not grieving as deeply as they are. At times, I run into people who are in tears, especially parents. They're ready to break down and I say, "No, it's perfectly okay. It's alright." And you know, immediately they change or they look at me and say, "Wow, you are okay. I'm looking at you, you look great and you are okay." And I say, "Well, we can also experience the other side of it because there are times when I am really down and if that's the side that you relate to, I can go there with you."

Because Makeshta and I were there with Mahealani in the light that she shared with us, we've been lifted through that experience. Being in other people's perception of death with their deep yearnings and longings are sometimes

the hardest moments because they're actually projecting from a place of really not knowing our experience, not having been there. Due to our conditioning and our fear of death, so many of us are not trusting or willing to be there to experience one hundred percent of the death cycle, and this denies us the opportunity to grow into what is inevitable. And if it is inevitable, why not allow it to be graceful?

*Makeshta:* I've had times when deep feelings of anger have come up. I've been able to identify the roots of that anger and realize that I was copying that response from past experiences, from other people's behavior. In these moments, I've been able to send that anger back and acknowledge that I'm not really angry. It was very awakening to realize that I had been responding in a habitual way to how I thought I was supposed to respond to such an event as death. Sometimes the way that I've grieved is through spontaneous crying. I'm fortunate that I enjoy gardening and people pay me to care for their gardens. I found that crying while pulling weeds was perfectly acceptable. It didn't hinder me at all. It gave me plenty of time to release while being in a safe place. One of the wide range of emotions that I felt was a sense of relief, knowing that she was out of her suffering. It was extremely painful watching her body deteriorate. She had such a strong Spirit, and even though she didn't show it on her face, I knew somewhere in that body, it was suffering. I'm so clear that at the end of the suffering she experienced a celebration.

Up until recent history, humankind has been celebrating death. I would want everyone to celebrate my death because I see it as a graduation. I've truly reached a place of real peace and understanding. I know that she's in a good place and that she lived and died with such grace and beauty. I cannot be upset about that. I guess the key for me was allowing and acknowledging everything that came up without putting too much weight on it. I've arrived at a place where I feel at peace with this whole process of birth, living and death.

## How have you been nurturing yourselves individually and with each other to heal?

*Sage:* I continue to care for our home in the same manner that I cared for it when Mahealani was here. In doing so, it reminds me of the quality of life and the environment that we offered her. This is filled with a peace, consciousness and awareness of each other and for all family members, including the animals and plants that live with us. Continuing in this tradition grounds me in how our life was when she was here and helps in maintaining a feeling of her presence. This comforts me tremendously. As far as nurturing a part of my personal self, I've always

been a very spiritual person. Being a ceremonial artist, I'm always in ceremony and looking for ways to express Spirit. Since Mahealani's passing, I've become more active in Native American ceremony. At this time in my life, this participation in Spirit has more meaning and more function than ever before and gives me great pleasure and a sense of satisfaction.

*Makeshta:* One of the ways that I've been nurturing myself is through taking care of our four dogs. The mother had three puppies right before Mahealani passed away and they've become a focus of our energy. I make sure they're well cared for and I cook two meals a day for them. This consistency helps me to stay balanced and it offers me an outlet for all the caring that I practiced during Mahealani's time here. I'm also caring for myself through honoring what feels right for me in the moment. If I make a decision to do something ahead of time and it doesn't feel right in my body when the time approaches, I won't push myself into doing it. I must feel it wholeheartedly. In terms of my relationship with Sage, I seize opportunities to offer touch and massage, and to care for her health. We set aside time and we pray together, and we work together while continuing this whole process of procreation.

During the time that Mahealani was losing sensation in her body I came to her and I said, "Mahealani, we're going to pray for you in the Sweat Lodge." She looked at me and said, "Dad, don't pray for me, pray for yourselves," and in another interaction she basically told me that she'd healed herself. So, I've learned to release the burden of trying to heal someone else, and now the focus is being placed on healing myself, primarily through acknowledging what makes me happy and what I love to do. Wholeheartedly, I'm being with plants and sharing my enthusiasm of the natural order with people. Oh, I just saw a shooting star!

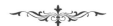

Following Sage and Makeshta's journey into expanding love was a most sacred experience for me, and my capacity for compassion grew exponentially as a result of knowing them. In the time I shared with them, I was deeply reminded that we always have a choice in how we interpret every experience in our lives and that we have the opportunity to use even the most painful of times as a tool for building greater compassion, love, and intimacy.

One of the most precious and tender gifts that has come out of growing together with Cynthia in our twenty-plus years of relationship has been the honor of showing up fully for each other throughout the passing of our

two surviving parents. Both Cynthia's mother and my father lived long and relatively healthy lives and we both developed strong and loving bonds with each of them.

Cynthia deeply loved my father, Bud, and engaged with him in a myriad of ways, sometimes being silly and playful (such as dancing together on the sidewalk outside a restaurant) while in other moments provoking thoughtful discussions ranging from politics to spirituality. She says that he served as the kind and loving father she never had, and her relationship with him meant the world to her.

My connection with Cynthia's mother, Susan, grew over time – particularly in the last few years of her life. She was a most creative woman, and at the core of her soul an explorer and adventurer who never had the opportunity to venture out into life's expansive and diverse paths. Over time, I learned how to be with her in a way that honored her talent, wisdom and goodness. I don't believe that she had ever before received this level of consistent kindness from a man, and our bond brought healing and love to her heart in ways that she had never known before. She truly considered me as a son.

During the last couple of weeks before Susan's passing, we spent a good portion of time with her at the convalescent home where she was living. Shortly before Susan passed, she made sure to have private, one-on-one time with Cynthia, her son, David, and me. During this most precious interchange, she wanted me to know the special bond she shared with me and how deeply she cherished my considerate way of being with her.

Throughout this focused and devotional time before and following Susan's transition, Cynthia and I naturally co-created a very sweet and tender atmosphere with each other. We mutually felt an honoring of life's changes while at the same time allowing ourselves to remain open to all of the feelings that surfaced– ranging from a stark sense of loss to a rich appreciation for the beauty and goodness of Susan's soul. Because Cynthia and I share similar spiritual beliefs, I was able to be present and supportive with Susan as the tides of emotion would shift from moment to moment, day to day.

Similarly, at the time of my father's passing, Cynthia and I were gathered with other family members around him, holding his hands, feet, head, shoulders, torso and legs. Cynthia was guided to sing one of his favorite songs, *"All The Way,"* and the song concluded at the precise moment that he breathed his last breath and left his body. For weeks, I reveled in the grace and perfection of his transition, and the constant and loving anchor that my beloved partner provides for me.

These pinnacle experiences are doorways into gratitude that each of us will experience. *These* are the moments that not only define us as individuals, but that enrich our relationship with a greater level of depth, honor and mutual trust. It is through the sharing of life's changing chapters throughout the years and the unwavering presence during challenging times that build our strength and prove our true character.

Because Cynthia and I view life as a sacred journey that arises from a source that is far beyond the physical, we can show up for one another with a deep sense of faith and support, trusting that there is a greater purpose and plan at play. This does not imply that we deny the flood of feelings that surface; we feel them, honor their truth and use the tools that we've acquired to embrace love's fullness, particularly showering this love on each of our inner-children. When the child that lives within each of us feels fully loved and supported, we can show up as adults with an anchored sense of strength and wellbeing.

No doubt that throughout this precious time during the passing of our two parents, we were given a most sacred opportunity to show up fully for each other and give of our strength, our love, and our unwavering compassion. As a result, a greater unspoken trust has been woven into the fabric of our relationship. I believe we've become more like family; a safe place to exhale.

# Chapter 8

## CREATING SAFETY THROUGH PHYSICAL INTIMACY
*The Evolving Love of Ron & Margo*

.................................................................

IN THE FORTY-PLUS YEARS they were together, the evolving love between Ron and Margo served as a catalyst for a tremendous amount of growth for each of them, both individually and as a couple. As I met with them periodically over a span of nearly ten years, I was moved by their increasing willingness to openly share the details of their long-term relationship, which had seen many ebbs and flows, and offered many opportunities for rich teachings. The two spoke candidly about all the milestones they had shared, from making the initial commitment to one another, the raising of children, of becoming preoccupied with career and too-busy lives; about the period of restless experimentation that led to a temporary separation from one another, and finally, about their conscious, mutual agreement to re-commit to their relationship from a wiser and more truthful foundation. Witnessing this level of devotion between two mature people had a profound impact on my life.

# Ron & Margo

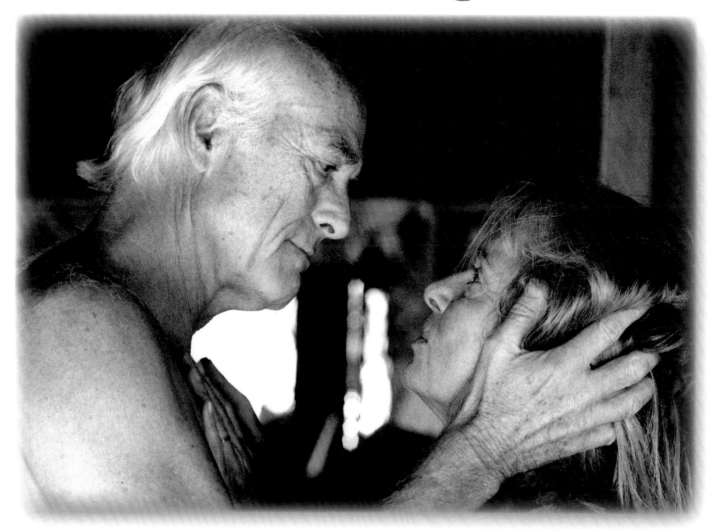

My love for Margo is the deepest thing I know. Through my relationship with her I'm able to glimpse the divine, to know eternity, to feel the presence of all life.

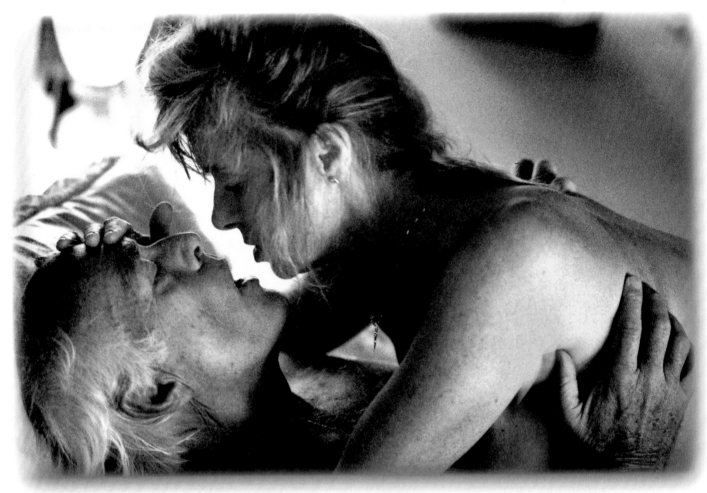

Our growing trust brings us surrender, and surrender is the absolute oneness of our relationship.

A valuable key for us lies in our willingness to hear each other's needs and recognize that it's safe enough to give them to each other.

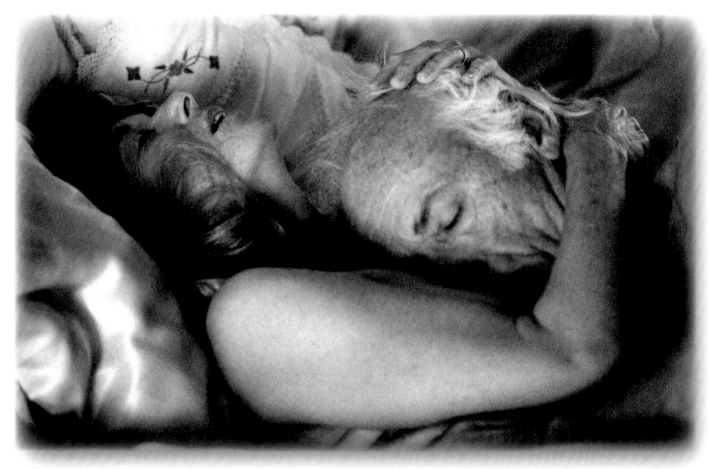

It's so powerful when we're lying together, when we forget who we are, when our egos are totally submitted to this, and we grow into one.

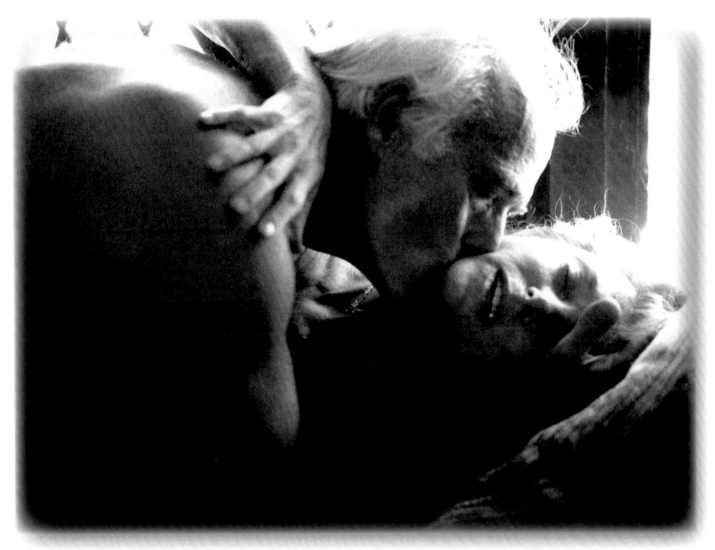

In a sense, we've had to be each other's healer because once we get that energy moving inside the other, our inner healer is present to draw the energy out.

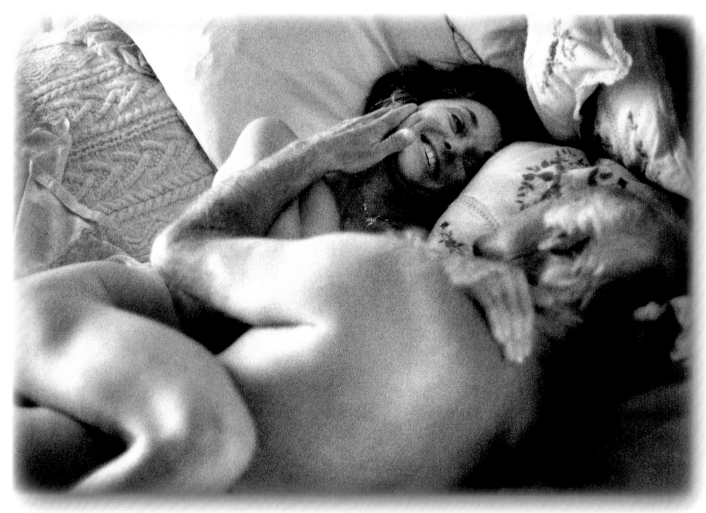

I joyfully, effortlessly and spontaneously share my knowledge of healing through opening totally to loving my beloved Ron and receiving his love.

My first visit with Ron and Margo took place at their gorgeous home on the cliffs of Point Dume, just north of Malibu, which the two had custom built down to the last detail to reflect their unique style and creative expression. At the time of our first meeting, it had been fourteen years since the two had recommitted to their relationship; an act which gave birth to what turned out to be a priceless daily ritual: As a way to support deeper emotional intimacy and the rebuilding of trust, the two made a vow to come together each and every day with the intention of being physically open, giving, and receiving with each other. I found it significant that they referred to this daily practice as their *promise*. I knew from experience how easy it can be to talk ourselves out of doing something just because we don't *feel* like doing it in the moment, but once we elevate a practice to the level of a promise, there's no room to wiggle out of it!

My second meeting with the couple took place under a tree at a favorite hillside park. Wishing to preserve every detail, I recorded our long conversation during which each of them graciously and honestly addressed my many questions. Again I was moved by their continued willingness to be completely open and candid, at times probing deeply into areas that weren't necessarily easy to discuss. I was especially impressed with Ron's commitment to catching himself in points of view that the male ego might reflexively guard or protect against, and then consciously making the choice to go deeper in his responses. How inspiring it was to see an "older" man exhibit this degree of softness and transparency while sharing both the highs and lows of his process, in order to deepen trust and intimacy with Margo.

Our last interview took place at their new custom built home in Central California, near Sequoia National Park. The house was situated just above a beautiful riverbed and natural sunlight seemed to stream in through every direction. Shortly after building the home, Ron was diagnosed with stage-four lung cancer. By the time I met up with them, he was still able to walk but was steadily weakening, and it was clear that his body would not be able to defend itself much longer. He had come to terms with knowing that within a matter of months, his body would perish.

Our conversation was punctuated by many silent moments of rich, contemplative time out in the garden, overlooking the flowing river. To this day, I've never witnessed anyone who knew that they were dying (while still up and walking) embody the courage to speak so candidly about his life, his triumphs, his regrets, and the sacred journey he shared with Margo, of deepening into safety, intimacy, and love.

Here, in their own words, is Ron and Margo's tale of evolving love:

# Ron and Margo: In Their Own Words Interview #1

## How do you describe your love for each other?

**Ron:** My love for Margo is the deepest thing I know. Through my relationship with her I am able to glimpse the divine; to know eternity, to feel the presence of all life. We practice opening up to each other every day. That's our secret. We are learning that when we can trust enough to completely surrender to each other, we are on the road to intimacy. I experienced a quantum leap in my love for Margo and it continuously grows all the time, even after – or rather, especially after –thirty-seven years."

**Margo:** I joyfully, effortlessly, and spontaneously share myself by opening totally to loving my beloved Ron and receiving his love. We come to union as I let go of negative judgments and control and give the loving spirit within me the freedom to flow out and touch the same spirit within Ronnie. This process brings a greater and greater experience of touching God; a heartfelt feeling of completeness that is true ecstasy. To come together without barriers to each other, we simultaneously unite with the greater presence of our God-self. Through the power of love, flowing within us and between us, we experience the truth of who we are and that gradually sets us free. I honor Ronnie's openness and willingness to join me in this way and it is our greatest form of support."

*Ron:* Our love has not always been what it is now. After many years of an "average" marriage of raising kids and building careers, we both saw clearly that our relationship was floundering on the jagged rocks of superficiality. We spent those years letting life take us where it may without a lot of focus or direction. We both felt an emptiness with life, a hunger for something that felt missing, and a lack of joy.

*Margo:* After years of marriage, life was busy and predictable and I was getting restless. I wanted to be where the action was. I wanted to be liberating the blacks in Selma, protesting the Vietnam war in Chicago, taking LSD with Leary and Alpert. I felt life was passing me by. The New Age movement led me into introspection. Who was I? What did I want? Was I really happy? We drifted apart. I began to question our relationship. My new friends were exciting; Ronnie, by comparison, was boring.

*Ron:* We started to consider life without each other. The more those thoughts enveloped us, the greater the distance increased. I'm not sure of the exact moment, but at some point I knew it was over and so did my beloved Margo. The sadness was unbearable.

*Margo:* I needed space and time to explore my interests, and it felt like my marriage was holding me back. And then the universe created a situation where we let go of each other, each of us getting what we thought we wanted. Ron was given someone to adore him, and I was given the freedom to go my own way.

*Ron:* We were separated. We went out with other people. We tried open marriage. We did everything that we could. She disappointed me, I disappointed her. Everything else in my daily life was working fine. My career was going well and materially at least, I had all the things that I wanted, but I couldn't seem to make this marriage work.

*Margo:* We were apart for about a month before we realized we wanted each other back. We had the chance to renew our relationship, drop our doubts and resentment, and choose each other again. This time I knew what commitment meant, and so did he.

*Ron:* I think we were both mature enough to know if we ran away from this relationship, we'd end up running away from other issues. We knew we had to push through this barrier, no matter how hard and hurtful. I remember the two of us sitting in our bedroom side by side and finally deciding that we wanted this marriage. But how in the hell would we make it work so that we were both fulfilled? Fulfillment is what we both really wanted, to feel the presence of God, to unravel the mysteries of life together, to be playful and spontaneous, to be nurtured and supported. Wasn't that why we got married, to be more than we were alone?

I posed this question to Margo and her response began us on our new path together. She said it not only wasn't too much to ask, but all those qualities were the same as she was looking for. That was the happiest moment of my married life. Just knowing what we wanted. Expressing it washed away much of the fear and angst of the past. We talked and talked and talked. Finally one of us came up with the idea, "Like a piano player going to practice the piano every day, why don't we come together and practice our love every day so that we become masters."

This was the turning point. After 25 years of marriage, it finally occurred to us that this marriage was ours and we could make it anything we wanted. We realized no one else has this, no one who has ever lived or who is living now. No one has a relationship exactly like we do. That night I remember saying, "We can make it into an art form. We can make this something very, very special if we're willing to do this." Margo said she was willing and I said I was willing. That was the beginning of our new path together. That was the day we made our *promise*. To this day we don't know where it's taking us, but it's so exciting.

**What is "the promise," and how has it supported you in anchoring this deeper trust with each other?**

*Ron:* We promised to figure out what being married actually meant to the other. That promise required a willingness on both our parts. We had been through many trials and errors together and our trust was not in tact because we had disappointed and betrayed each other a number of times. We made a conscious choice to come together as one. If something came between us and challenged our willingness to be open, that was the exact thing that we had to work on. Our *willingness* was the key that finally brought us trust. Every day as we practice this, the willingness is there and the trust grows because we're building on positive experiences each day.

**So when you say "willingness," do you mean the willingness to trust love over your fear?**

*Ron:* Yes, our growing trust brings us surrender, and surrender is the absolute oneness of our relationship. When we surrender to this level, we're in total trust. That's the way it's been with us since the promise was made 14 years ago. Part of the promise in our re-commitment to each other involves a process that we share together each day. What I'm about to describe happens to be our formula, but every couple will develop their own unique form and path. Our promise involves coming together every day and being with each other physically, in whatever way has meaning for us in that moment. We tend to use the sexual energy because it's the most potent energy that we have, and because we love each other so deeply that energy just sends us soaring so high.

*Margo:* Initially we shower so that we're both clean. I usually go first so that when Ronnie's in the shower I'll get out and fix the room. I'll light candles, put on music, and open the windows. We begin our connecting time by meditating without any talking. There's lots of other time in the day for talking things out, and this is an energy that goes beyond words. The things that come up, we don't have to speak of in that moment. We get out of our own way.

*Ron:* Speaking can become used as a distraction that keeps us from connecting. When thoughts come up, it's easy to say, "Well, I have to get through this first and then we'll do that." And then we remind ourselves that what we've promised is to do the exact opposite. We've promised to come together even if we're not fully present today.

*Margo:* After we meditate lying in bed together – usually for 15 to 20 minutes – Ron will turn to me or I'll turn to him and we'll align our chakra bodies and begin.

*Ron:* The energy builds and it's always different. I hold her in my arms and we look into each other's eyes. We flow our love to each other, we open our hearts together, and we pray together. We keep it sacred as the intention is to grow in our love so that we become one together listening to our needs and honoring them each day.

*Margo:* I like a lot of massage, and Ronnie likes sexual contact. Sometimes I'm not sexually connected until the very end, and we always end it with traditional intercourse. When Ronnie massages my head I'm amazed at how open I am to receive him at the end. This degree of giving and receiving has been a gradual process of trust that we've had to learn together.

*Ron:* When we were first starting this new process, we had to find out what each of us wanted physically when we came together. We asked each other these questions 20 years ago but it wasn't very clear at that time. I found I was giving Margo what I wanted and she was giving me what she wanted and never the twain would meet. Needless to say, it wasn't particularly satisfying. It was very difficult for me to look inside myself and ask, "What do you really want?" Most of the time I really didn't know, so it appeared to Margo like I didn't care.

Consequently, we would end up merely going through the actions of making love. Gradually we became braver in our trust and we began investigating what it meant to really trust each other. We were then able to start giving a little more. I realized that receiving was a big issue for me. It was difficult to do nothing but receive. So my attention was focused in this area for a period of time.

*Margo:* Then I began having some difficulty giving.

*Ron:* I had a tough time learning how to do nothing but give what Margo was asking for. So we went through a time where all Margo would do is receive from me what she needed.

*Margo:* This was such a valuable key for us; our willingness to hear each other's needs and recognize that it was safe enough to give them to each other.

*Ron:* We now see that we have cycles of giving or receiving that in the beginning might feel a little new or fearful. Each experience has us growing into the next one. It's a willingness to go through it together and see where it takes us. The trust comes from declaring, "I'm going to do this," and then seeing I can and that it's taking me to exciting places. The trust builds and builds and builds.

*Margo:* In order for that divinity inside to grow, I remain trusting so that I might release the crust of my ego. Over the years, Ron has become intuitive enough to know where I still need to surrender, which is usually a matter of letting go of my ego and allowing my natural essence to open and flow. For me surrendering is about being receptive in my body. When I feel a tendency to resist or shut down, it's just a wakeup call for me to open up. The fear is there, the old wounds are there, as is the ancient conditioning of strange irrelevant beliefs. All of that is released as I place my attention on the inner god/goddess of all that is, which seems to be trapped inside until I coax it out. Having a partner to work on this with is an integral part of my learning to love. It's not only learning to love my partner, it's opening to loving the process. As I open up in ways I have never opened before, inevitably I feel a rush of energy. It's this wonderful reward that both of us experience, like an all-encompassing swooning sensation.

*Ron:* With this wonderful reward, trust is being built. It took a long time, years into the process. Every now and again I would feel so tired or so aggravated, or so busy and it would occur to me, "You can't do this." And then I'd recognize, "That's an act of fear because I've promised. I willingly said I was going to do this." When I look at this as a gift to me personally, I become bigger and feel more valuable in this relationship we're building together.

*Margo:* In a sense, we've had to be each other's healer because once we get that energy moving inside the other, our inner healer is present to draw the energy out. The love is what we trust. Sometimes we don't trust each other as much as we trust the love.

*Ron:* And this deepening of trust comes out of our intention every day as we re-commit to growing and being as one.

*Margo:* We used to spend a half an hour connecting in this way and now it's grown into two hour-long sessions.

*Ron:* If that seems daunting to someone reading these words, it needn't. You can start with a minute and it will grow. The willingness to come together for the sake of the oneness of the relationship is the key element that opens the door for everything else.

*Margo:* All of the protective layers that are in front of our love are so deep and complex.

*Ron:* It's so powerful when we're just lying there, when we forget who we are, when our egos are totally submitted to this, and we grow into one. That's the reward, that's the vision, that's us standing hand-in-hand on the top of the mountain. In my daily life however, it's very easy to go back to the ego and start wanting my own way again. I witnessed this young couple as they were getting married yesterday and I wondered how much they really know about life's dynamics. Were they aware of how luring the tendency is to be "right" in any given situation, and how easy it is to place blame and guilt on our partner and on ourselves while insistently holding on to the stance, "I know I am right." Are they aware of how much that this costs us? I've learned that in a mature relationship, in a sacred relationship, we give it up to God. We just give it up.

*Margo:* When we first began this promise, I felt a lot of deep, cathartic emotions. Now there's less emotion and more breathing through the fear as I am letting it go. I'm not feeling sidetracked or stuck nearly as often. I can see that these fears are not the real part of me. My true Self is the inner, invisible life force…I don't know what else to call it, but I look at it as God. That God/Goddess is in me, and Ronnie and I are playing the God and Goddess part right now as human beings and we're allowing the fears of our humanness to release as we embrace our man and woman-ness.

*Ron:* It's very interesting, this man/woman dynamic, because in this process together we trade off. More of my feminine side comes out while more of her masculine surfaces. We become more whole in the process. If there's a challenge in front of us, we take a deep breath and say it's an illusion, this is not really anything important. Let's just let it be without giving it any energy… and in moments it's gone.

*Margo:* Before we began this practice, I was restless. I was often seeking greater fulfillment outside the relationship because I didn't know that we could have it together. As a matter of fact, I didn't think sexuality was very spiritual at all. I used to shut down, close my eyes and wait for it to be over. Now I'm finding that the more I give, the more open I become. When I get lost and confused and the barriers of my personality come up, all I have

to do is remember to give. When I do that, all of the fear washes away and the healing, connected energy begins again.

*Ron:* It's all about keeping my word no matter how much fear may arise. The action of moving through the fear and embracing it as it surfaces continues to strengthen and enrich our relationship. When I look at the fear in front of me as a gift, I know that our relationship is just zooming. We've seen it work a thousand times. It's endless and it's wonderful. It's been 14 years now since we made this promise with each other and it's so exciting that we said, "We'll go wherever it's taking us because it's anchored in love, it's anchored in trust and surrender." We went through some difficult times--not as difficult as a lot of people, but hurtful enough— and this was the best thing that ever happened to us. To finally say we're going to make something very special of this.

*Margo:* Everything was different after making this promise. I felt like a new bride. We couldn't keep our hands off each other. Passion was back and it stayed. I realized as I make this time and space together a sacred one and connect lovingly, balanced in the body and spirit, it is always healing.

**When you have a challenge that comes up with each other and it feels like you're locking horns, what is your particular process of moving through it?**

*Ron:* I can remember as a much younger man, I would be adamant that I must have things my way. This would cause us to argue and fight for two, three, or four days. We would then finally come together and make up, make mad passionate love, and then start the whole cycle over again. Well, it's very different now because there's something else to go for, and that is the good of the relationship. Does this thought serve the good of the relationship or not? When I feel like I'm not getting my way or insist that I'm definitely right and she's definitely wrong… is that good for the relationship, really? No, it isn't. It's absolutely destructive. It's uncreative, and when I start reminding myself of this, I pop right out of it and place my attention on the value of the relationship.

*Margo:* I'm now a lot better at silencing my words when I'm tempted to react. I used to  randomly speak out and say, "I'm so depressed," or "I don't know what's wrong with me." The conversation would then focus on these questions, and I'd want to talk about it, causing the argument to worsen, and I would talk myself into being really depressed. I then learned not to give these thoughts as much energy so that when I'd get in that restless, confused, or antsy state, I would turn music on, go downstairs and twirl and dance, or go upstairs and sit in my meditation place to breathe and release. I learned that it would always be best for me to leave Ronnie's presence; to go within and change my thoughts, rather than seek his support or reassurance in those moments when I was feeling insecure or disconnected.

*Ron:* I am learning how to be in the moment and to deal with the issues as they come up. If I deal with it now, it's over in a minute. If I open my heart and she tells me what's on her mind, we deal with it at that very moment. It's erased. All the energy's gone and we go on our merry little way. That took a long time to learn.

*Margo:* Yes, it took a long time to learn, "I hear what you're saying, and would you hear what I'm saying," rather than insisting, "See it my way, will you?" "No, you see it my way." And now we're able to say, "I hear you, but this is how I'm looking at it."

*Ron:*     I see that the primary thing that we had to learn was to not try and fix everything. I know when something's upsetting me and I express it to Margo and she replies, "Well, why don't you do this," what I'm hearing is, "This is a fix, that'll fix you." That isn't what I want to hear at all in that moment. I know how to fix me. It's just that I don't feel like being fixed right now. I want to express what I'm feeling and then I want compassion. I want to know that she heard me and that she is there for me if I want to talk about it. We don't have to fix anything with each other. What was it that Thich Nhat Hanh said that was so simple, yet so beautiful and so complex in its own way?

*Margo:* "Darling, I am here for you."

*Ron:*    Just to be there as an open, compassionate partner, saying "I'm here for you." That's all that's necessary. That's what makes me feel the best when I'm really upset. To share this with her as she snuggles up to me and says, "I'm here."

*Margo:* And then the response is, "I am happy that you're here for me."

*Ron:* Pretty simple, but boy it's very powerful because that's what we always want to know.

*Margo:* And ending it with, "Thank you, I'm happy."

*Ron:* Yes, that's all we really want.

*Margo:* Just to be heard.

*Ron:* Darling, I am here for you.

**What would you both say is your commitment in your life path with each other?**

*Margo:* I would say that it's our commitment to the relationship.

**And your highest vision with each other?**

*Margo:* "Loving you enlightens me."

*Ron:* That's wonderful. One night after our meditation, she looked deeply into my eyes and said, "Loving you enlightens me." That might be it.

# Interview #2

**It's been roughly eight years since our first meeting. Ron, would you explain your current health condition and what you're dealing with at this time?**

*Ron:* It's fourth stage, non-small cell lung cancer, which is by all intents and purposes incurable, but perhaps treatable. It's constantly bringing up for me the uncertainty in life. We always think we have things wired, as if we're in control. The truth is, there is no control, there never has been control, and there never will be any control. I live in this constant question of whether I'm going to live or I'm going to die. And if I am going to live, how am I going to live? Am I going to be a healthy person or am I to be in pain all my life? All of these questions rule my life. The day-to-day things that I used to worry about such as getting the car fixed and going to the store, they're all just things that have to be done. I'm seeing how everything is run by the most intricate little things in my bodily system; the way my breathing works or whether I'm cold or hot. Then I'm hit with the realization, "God, nothing works!" That's what I'm currently experiencing all day long. Every moment that goes by feels like it's passing; a precious, passing moment that I can't get back again, so I want to make the most of every experience. And the pain is something else. Throughout my life, I've learned to get away from pain, obviously, but lately when I can't get away from pain it teaches me so many lessons as it continues to push me to the very threshold of where I can possibly stand it, to the very wilderness of my will where I simply can't hold it anymore and it's just too painful. I was in a place like that the other day. I was in bed and in a more expanded reality than I am right now, a wider, deeper, more mysterious place when I felt the pain coming on. It started coming in waves. Every five or ten seconds another wave, and each wave was more powerful and somehow more telling. As the levels increased, I finally got to a point where I said, "I cannot possibly take it anymore." Then the next level came and instead of a huge sob or moan like I was previously doing, I actually laughed because there was a sense of humor that emerged. There was something that was so perfectly prescribed for me. I saw that no one in the world could possibly get what I was getting at that particular moment. Their experience would be specifically designed for them. And that's how perfectly unique we all are. There are no two things for any one thing. It's all one. Everything is one. It all gets down to one. And at that very deep, mysterious place where I went into that laughter, I connected to

some dimension where there was another me. A me of ancient times that was designing me, and I was saying, "When he gets to this level we won't have to go any farther than that. He'll get it here." And that's when I got it and began to laugh. I resonated with that being and with myself, and suddenly felt whole. I got the lesson that there was obviously suffering or something that we all must address first and foremost in all of our lives, and we would if it were more evident. Because it's not at the forefront in our lives, we use our indifference or our busyness and say "I'll get to it later." If there were a baby at your front door step and it was wailing in absolute utter despair, you could do nothing but save it before you did anything else in the world. That's the way we should look at the world every day when we get up. Save it first, heal it first, then work with it. That's what I'm getting out of this experience. It's a huge learning lesson that makes me drop all of my old clothes and look at myself anew, through myself, through my friends, leading me to discover who I really am. I guess that's the final analysis anyway.

## How has your current health condition impacted your relationship with Margo? How has your love grown and expanded as a result of this?

*Ron:* You would have to go back to looking at my life prior cancer. I began taking a greater look at who I was and what my relationship was to the world, to my beloved wife of 42 years and how we felt about things at certain levels. Then all of a sudden, here is this diagnosis that says I have a terminal illness. I went through a few days of shock where nothing really registered. This challenge is presented and little by little I have to go through my life and seek to understand the deeper parts of it that were not deep at all. The incredible love that I have for my wife, my family, the Earth and my friends was limited by a feeling that it would always be here; never giving thought to that time when it might end.

Well, when the time comes to delve into that realization, everything deepens. Every breath seems to deepen. Relationship with God deepens. My thoughts for Margo and what we've shared together deepen, and her joining in my path begins to deepen because the impact of this news equally affects her, as if she has the disease as well. So we come together at this much deeper, richer place and, although it's difficult to express, it really **is** bliss because we're **so** intimate…so one. Due to my condition, we've just reduced ourselves from two separate entities to one. The cancer has magnified this by ten thousand fold. There are so many insights. I'll tell you the story that we were talking about yesterday.

Lately, there have been so many times that I've been in tremendous pain and Margo's been right there for me. Believe me, it's no easier on her than it is for me. Even though I experience the pain, I'm certain that she experiences exactly the same pain. She opens, she's there, she's with me, she goes through the pain and she never for a moment, for one breath, leaves my side. And that eases my pain. That's what heals it. I think that a lot of people would be afraid to open this deeply and actually feel this level of desperate pain, because we're all afraid of pain. But, if you can do it, the rewards are so great because after the pain finally subsides, there's this glow and glistening in the eye, a kind of re-christening in seeing each other anew, and then again, constantly seeing each other in a fresh, new way. After 42 years, seeing that little baby love coming out, that pure perfect love directed at me and then I return it back to her. The circle starts and…it's almost worth the pain (*laughing*).

**Margo, how do you see yourself growing as a result of this deepening?**

*Margo:* Well, certainly in this situation, being in the present moment is really the only place to be. I can't find any reason or sense for it in the past. I could drive myself nuts thinking, "Well we should have done this or we could have done that, and maybe this was the reason." Or, if I dwell on the future it's too scary, and I don't want to program fearful thoughts. I want to stay with the optimism of living rather than dying.

The truth is, Ron's living and he's going to die sooner or later, but we don't know when. I remember Ram Dass' story about a time he was doing hospice work with this woman who was complaining on and on about how awful it was that she was dying. So, he listened and listened and then he said, "You're so busy dying, and you're not dead yet! You're so busy dying and you're not busy living!" That moment switched her around. I think we try to stay in that frame of mind, and we are certainly blessed.

Friends and family are showing their love by visiting and being present with Ronnie and me because they know the time is limited, and we know the time is limited. We don't want to leave each other's side. I quit most of my other activities just because I want to be together over doing anything else. Certainly the emotion comes up and it takes me a bit deeper, opening me up a little bit more. Maybe it even shows me where I'm still holding on just a little bit (*emotional*).

*Ron:* I'm seeing this time like a final absolution of my life. In my quiet moments I think about who I was and how I used to respond to life; how I was false over here, or not very forthcoming there, and oh so arrogant at other times. I see all of this and I smile at myself as I forgive those past actions for I know I'm no longer that way. It's very interesting to simply watch all those old ways of being gradually fall away, ending up here where I'm just naked; I'm just Ron; a man who's desperately trying to learn how to live life in a good and conscientious way; in a good way. I'm trying to see the beauty in life, in other people, in nature, and even in animals. Often it's hard to see beauty in others because we can be so competitive, but to fully see the absolute beauty in everyone we meet, responding to life that way, well, one day of that is worth a thousand years of the other.

This is a time without definitions. It's a time when everything is wide open. That's why I feel there's a type of absolution; a final blessing. Look at it all. There are no definitions anymore. I know what you did back there wasn't right. I've forgiven myself, I've forgiven the people who've hurt me. None of that really matters anymore, does it? The definitions are all gone and I have a chance now to make my own definition. And if I live another year or two, I know that hour by hour, week by week I'll continue to grow, but I'm now growing out of the compassion part of my heart. I'm going upward and not down any longer. I'm not saying that before this diagnosis I didn't have a certain amount of spirituality, but I have far more now. I feel that I – the roots and compassion of my heart –have taken such a strong hold that nothing from the previous chapters of my life can lodge me out of there. I can only go upward and that's what these last months or years are about. So, this final absolution down to the very end where I reach a point and my work is finished, I then move on to other bigger and better things (*laughs*).

**It seems like a double edged sword: it's natural that we question all the suffering in the world and why we experience so much pain. Yet earlier you shared how the greatest growth throughout your life has usually come through feeling pain and suffering.**

*Ron:* So consequently, if we don't deal with our suffering, we don't grow. We avoid the pain and so we just stay monotone and bland throughout our lives and then when something desperate like a crisis diagnosis comes along there's not much to turn to. There's nothing there. I'm seeing that all love comes out of pain. And it doesn't have to be your own pain. It can be someone else's that you share; have compassion for and allow yourself to feel. I don't

really have a fear of dying. I think my fear is in feeling intense pain and being incapable to do anything about it. The fear is of feeling like a victim and ultimately, not trusting in God's presence.

This is exactly what tests our faith and this is what makes the faith stronger and more solid. You're flying along fine and all of a sudden these incredible pains and fears come over you and at that point you have to say, "Well, do I have faith or do I not?" And if you don't, you get yourself in the hole, you go into depression and you might resort to drugs or drink. We were talking about this very thing this morning. Margo had to look at this challenge and either stand boldly with courage, going forward like she did, or she could have gone out, bought herself a bottle of vodka and gotten as drunk as a monkey, running away, off to her mother or whatever else people do. This is the downward spiral that many people seem to fall into. Eventually, if you do finally pull yourself out of it, you come to the realization, "I do have faith. It may not be the strongest faith in the world, but I do believe I'm going to get out of this, one way or another, and no matter the direction I take, I'm going to be okay."

That's true faith and you're tested every moment of every day when you're under a terrible crisis like this. I've got to keep saying to myself, "I do have faith." I keep asking, "What should I do?" The answer is always, "Have faith." Then I smile and wouldn't you know, I have faith (*laughing*), I have faith!

*Margo:* This has made us even more transparent to Spirit and to each other. Because our relationship is so strong, we're able to go through death and dying together. As a result, we're opening up more fully and sharing deeply on a spirit level. It's a richer sense of communion through the unseen loving presence that doesn't need a body. I think that when Ronnie passes, when he drops his body, we'll still be connected. I trust that the deeper we open to each other, the greater the possibility there is to experience our union without being in the same dimension.

*Ron:* Yes, we've made plans for that.

**I'm hearing you say that through having faith, you recognize and live an eternal life.**

*Margo:* Whether you live or die is not the question, but that you move forward in faith and know that God is in this cancer and God is in this voice. God is everywhere and everything, and we're just trying on this life for a

brief period of time. As is inscribed on the tombstone of Rajneesh, a spiritual mystic and teacher of Tantra, "I was never born and I'll never die. I just appeared on this plane for these fifty eight years. We will meet again."

*Ron:* And the final destination is self-realization, opening to fully seeing God in each other.

**What I'm hearing is that you're now facing the ultimate faith and in reexamining your life, you're looking at how faith has or has not been present while being met with the ultimate challenge of faith in this moment.**

*Ron:* Yes, this is absolutely the biggest challenge of faith that exists. This is where we really have to come forward and walk our talk. I know who I've been all my life and I know who I've pretended to be. I know who I really was and I know who I was avoiding being. So, as I take all of this insight that's here at the end of my life and I brush aside all the things I don't want anymore, I'm left feeling quite pure without many opinions or judgments... just faith…faith that it's all okay. There's an awe in waking every morning, in breathing again, in seeing the earth and my beloved with her shiny eyes staring at me. It's all brand new. So this is the grandest challenge of all. The greatest adventure of all.

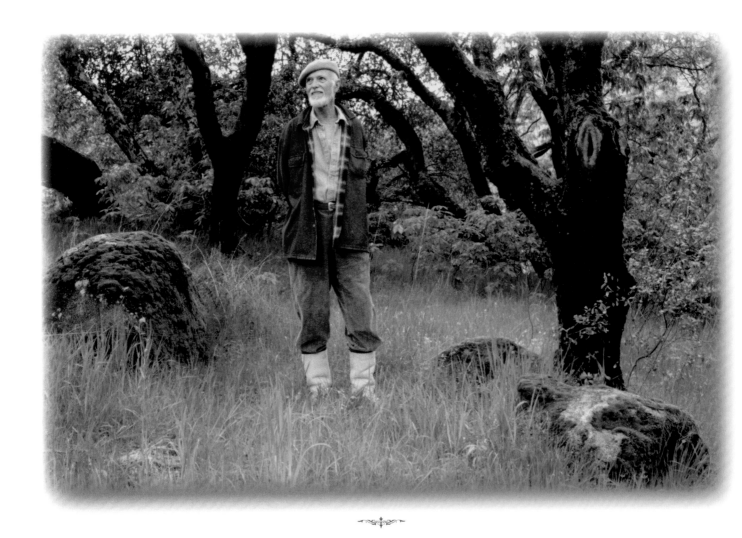

As Ron and Margo's love story so beautifully illustrates, true intimacy grows in the presence of feeling fully safe and accepted by our partners and within ourselves. How can we possibly open up to giving and receiving this degree of love without the essential element of complete safety?

Ron and Margo's *promise*– to regular physical intimacy, and to making time each day to truly listen to and honor one another's needs – expanded the boundaries that each of them had previously placed on love. That each partner

was able to remain so present through the pain and uncertainty of Ron's impending transition is a true testament to the intimacy that developed between them as a result of this single devotional act. They modeled for me the importance of cultivating a daily time of sanctuary together. And I've also learned – as Ron and Margo did – that even when this fabric of trust is frayed, it can be mended through time, attention, and a shift of perspective.

In the initial courting stage of my relationship with Cynthia, I learned a potent lesson in protecting the safe space between Cynthia and me by respecting boundaries around intimacy. We were strolling on the Santa Monica Promenade with some friends one Sunday afternoon, when I momentarily broke away from our group to greet a young, attractive woman that my friend Benjamin was dating. As I approached Jennifer, we immediately found ourselves in an embracing hug that (*I was later informed*) continued far too long for Cynthia's comfort and acceptance. When I returned to Cynthia and our friends, Cynthia was furious. She began to yell out her feelings at a level the entire block could hear. In that moment, I felt like crawling under a rock and hiding, but instead, I stayed there with her and remained present to a multitude of feelings cascading through my body and mind.

Once the shock of being the recipient of such intense emotion settled, I was able to begin assessing what had caused this scenario to unravel so quickly. My first reaction was a defensive one: "*My god,*" I thought, "*she's so wounded from past experiences that she has no idea how harshly she's overreacting!*" Then, I began to see the conflict from the perspective of the vast differences in the cultures in which each of us was raised.

I was born into an upper middle class white family in an affluent area of Los Angeles, and from my teenage years to the time of this story, I had lived the life of a freethinking, alternative artist deeply influenced by the hippie movement. In my circle of friends and even acquaintances, sharing long, embracing hugs of affection had always been commonplace and seemingly innocent. In contrast, Cynthia was raised in an African American home in an economically-depressed neighborhood of Minneapolis where people were far more concerned with day-to-day survival than they were with the expression of *Free Love*! Throughout her life, Cynthia had been focused on raising herself above the cultural and financial struggles she witnessed as a child by vigilantly cultivating personal responsibility.

When I replayed the scene with Jennifer through Cynthia's lens of perception, I could see how her version of the movie was far different than the script I'd imagined! Here was her new boyfriend moving away from our group, exchanging a long, juicy hug with a beautiful young woman and transmitting massive sexual energy. And to top it off, her boyfriend didn't even bring the woman over to introduce her.

As I continued to review this scenario, I began to recognize some authentic truth in Cynthia's assessment. When I looked objectively at my actions, I was able to see that I was emitting a level of *sexual leakage* with Jennifer. This is an expression that I borrowed from Cynthia because I like its visual potency. By placing myself in Cynthia's shoes and asking myself, "*How would I feel if the roles were reversed and I witnessed her exchanging sexual energy with another man?*" The truth is that I wouldn't like it and a part of me would feel rejected or not fully honored or appreciated. And I could certainly see how it would diminish my willingness to be intimate with her. Recognizing this, it became easy for me to make a different choice – one that more fully honors my love for her, and my desire for her above all others. Once I was able to view my actions in the context of deepening versus diminishing the intimacy and trust that flows between Cynthia and me, preserving that safe space became my first priority.

From Ron and Margo, I learned that building a strong and sturdy safety net within my relationship with Cynthia demands that I become more mindful of my actions and words. If I make choices that are inconsiderate of Cynthia's feelings or her perspective in a certain matter, the safety net that makes intimacy possible begins to fray and tear.

True intimacy is a byproduct of how well we demonstrate fully honoring our partner and being true to ourselves. If we try to reach an intimate state without first building this foundation, it will never feel truly solid and authentic. We must begin from the ground up and be willing to show up fully as each layer of trust is cemented into being. We must have the courage to delve deeply into our fears as they surface and handle them with transparency and personal responsibility. It's a big undertaking, but the payoff is more than worth the effort: As maintaining the intimate, trusting relational space with our partners becomes our daily focus and priority, love blossoms in the fullness of its glory and we begin to breathe more deeply, knowing that we are safe and cradled in unity – both with our beloved and within the world. This is the path of devoted love warriors.

# Afterword

## LOVE IS A VERB

WHEN YOU COME ACROSS A truly happy couple – you know, the kind that laughs easily, touches one another often, and whose every interaction seems effortless and free-flowing – it would be easy to jump to the conclusion that the two are simply soulmates who are "meant to be," and that's why their connection seems to come so naturally. However, if you were granted access to the dynamics that occur in their relationship behind closed doors, as the couples featured throughout this book have so generously allowed, you would see that the effortless way they relate to one another is not because they found their twin flame or were born under a lucky star. More likely, it's because they have discovered that maintaining long-term intimacy requires a commitment to love, even in – and especially in – those moments when we feel neither loved nor loving.

Once a relationship has grown beyond the initial honeymoon stage, our experience of love must evolve from a feeling we seek from being in our partner's company, to an action or a series of actions that we consistently take to keep our relationship healthy and thriving. In other words, love is much more than a feeling; it's a verb, as singer and songwriter John Mayer suggests in his song of the same title. He writes:

*Love is a verb*

*It ain't a thing*

*It's not something you own*

*It's not something you scream*

*So you gotta show, show, show me*

*That love is a verb*

These lyrics underscore the concept that love is a growing, evolving organism that requires regular care and maintenance. In the same way we'd never expect a business to succeed in the absence of leadership or a child to thrive without support and guidance, we cannot neglect our intimate love relationships, or take them for granted, and expect them to continue to evolve.

The strengthening and expansion of love requires that we consistently feed it with courage, vision and faith. A relationship can only grow to its most resilient and healthy state when it receives the vital nutrients that sustain its purpose. Just as plants require sunshine to feed them with light, love needs us to shower the light of truth upon all our choices, actions, and the circumstances created as a result of them. To create partnerships as long-lasting and fulfilling as those depicted throughout this book, we must continually renew those partnerships through practices that support communication, self-expression, and the sharing and honoring of one another's needs.

# Evolving Love: Tools & Practices

## BY CYNTHIA JAMES

*I*T CAN REQUIRE GREAT courage to speak up and voice our authentic truth in moments when our expectations have been dampened or our feelings hurt, and yet harboring resentment will never yield satisfying results. The tools and exercises you'll learn in this section are intended to help you prevent patterns of polarization, separation and unhappiness that can create walls in even the strongest of relationships. By committing to the regular practice of the principles outlined here, you will have everything you need to create an intimate relationship with your partner that is built upon a foundation of shared values, and to continually strengthen that foundation, even when times are tough or communication breaks down.

Before describing the intention and practical application of each exercise, I'd like to first offer some general guidelines that apply to all of them. The more that you are able to maintain an awareness of these principles – both when practicing each exercise, and in your day-to-day interactions with your partner – the stronger and more resilient your partnership will become.

### Create the right environment

Before requesting your partner to articulate in any of the practices outlined here, it's important to create an environment that is conducive to your success: Make sure you allow ample time to explore each practice, so you can complete each interaction without being rushed.

### Come prepared

For the sake of clarity, I recommend that couples do as much "inner work" on their own as is possible and practical before coming together with their partners. I'll talk more about this as I describe each exercise, but in general, the more clarity you can bring to the interaction, the smoother it is likely to go. Preparing for each exercise ahead of

time also increases your chances of following through on doing them together. The more forethought you've given to each topic, the more naturally each of you will be able to discuss it when you find yourselves with a few extra moments. I also suggest creating space for these interactions and to avoid deep conversations just before bed or when in public places. Emotions can run high and you want to be able to process in a way that does not result in having to take your anger or upset to bed with you.

## Begin each exercise with appreciation

Cultivating an attitude of appreciation is a point I cannot stress emphatically enough. In the vast majority of couples Carl and I work with, one partner is naturally more motivated to "work" on the relationship than the other – usually because he or she is most aware of a need that is not being met, or a growing problem that would better be addressed before it escalates into something more serious. The partner who is being invited to explore these practices as a way to deepen or improve the relationship will often encounter some internal resistance to doing so. Feelings of inadequacy; fears that they've done something "wrong," or reluctance to addressing certain topics for fear of where they might lead are all common reactions.

For this reason and many others that I'll address as we go, every exercise that I'll share with you here will yield far better results if both partners commit to beginning each interaction by sharing something they appreciate about the other. Even the willingness to engage in an intimate conversation is an act that is worthy of appreciating.

The real purpose of these exercises is not to fix someone or something that is broken, and it's certainly not to go on a fault-finding mission. Their purpose is to help you foster more intimacy, understanding, and true empathy for one another – and this requires that each partner feel safe to share themselves candidly. Beginning each practice with a few words of appreciation for one another supports this sense of safety, while also reiterating the intention behind each interaction. If in the course of the exercise, hurt feelings or withheld communications arise, establishing a climate of appreciation beforehand will make it easier for each of you to keep these feelings and emotions in perspective.

## Commit to the practice

It's important not to begin any of the dialogs offered here unless both people are committed to seeing it through. If one partner consistently fails to show up, this may unwittingly trigger feelings of abandonment or resentment in

the other. When deciding to embark on this exploration toward greater intimacy, make sure it's clear that the two of you are making an agreement that you each intend to honor.

If an exercise you planned to do together feels too challenging for one or both partners, or if life simply "gets in the way" and you find you will not have sufficient time or attention to devote to it, be sure to renegotiate the commitment, rather than simply forgetting about it, or hoping it will disappear. The successful renegotiation of previous agreements, in and of itself, is a powerful way to build greater trust.

## Listen generously and speak consciously

To the best of your ability, arrive at each interaction having emptied out any pre-existing expectations of what your partner is going to say. Instead, view these practices as a time of discovery; an opportunity to learn something about your partner that you've never seen before, and a chance to evoke a deeper quality of sharing from him or her by listening from a state of "beginner's mind."

When speaking, do your best to keep your sharing focused around your experience, rather than on your interpretation or judgment of your partner's actions. For example, "You never listen to me," is a statement that will evoke much more defensiveness than, "I'm feeling misunderstood right now. Can I try again to share my perspective of what happened?" Speaking from our own experience provides safety for our partners that allows them to listen to us fully; whereas blaming them for our feelings will almost always cause them to react in a reflexive, defensive way.

Assigning blame to another is a convenient shortcut that our brains will often try to lure us into. After all, blame buys us time from having to examine our role in the interaction, and can also keep us, at least temporarily, from experiencing the more vulnerable feelings that lie underneath our anger. But once we really understand the consequences of blaming our partners, we may find ourselves more willing to take a breath, pause, and rephrase our comment in a more responsible way.

## Give your partner the benefit of the doubt

The last guideline I am going to suggest that you adopt before exploring these intimacy-deepening practices does not exist in the realm of doing or speaking, but in the lens that you see your partner through as he or she is sharing with you. There are five facts in particular that I am going to ask you to presuppose are true:

1) I know my partner loves me.

2) I know my partner wants me to have a great life.

3) I know my partner would not intentionally hurt me.

4) I know my partner is doing the best that they can in this moment.

5) I know my partner wants to be closer to me and might not know how.

With these general guidelines in mind, I invite you to experiment with the exercises offered throughout this chapter. Remember that the intention behind the two of you exploring these topics together is not to ferret out problems; it's not to fix something that's broken, and it's not about analyzing your partner. The invitation is to use whatever comes up as an opportunity to heal past wounds, to know your partner more intimately, and to remove any obstacles within yourself to experiencing the full depth of loving.

## Practice #1: The Power of Gratitude

As Walter and Carla's story beautifully demonstrates, developing an understanding of what makes your partner tick holds the key to appreciating – rather than becoming annoyed by – the differences between you. Research has shown that some of our differences are due to the fact that the human brain operates according to one of four primary thinking styles, and that each of us tends to gravitate to one style over the others.

The following exercise helps us to better understand why our partners do the things they do, and to more clearly see the sometimes hidden values that underlie their viewpoints and behaviors. Thinking style is a primary factor in communication, and by understanding our own thinking style preference as well as that of our partner, we can improve the way we relate to one other.

♥ The **Logical Thinker** is clear and rational. This person enjoys data, math and science, tends to be objective and facts-driven, and is a good problem solver. They enjoy all aspects of analysis – assessing strengths and weaknesses, weighing pros and cons, prioritizing, segmenting, and seek to find the meaning behind the data.

They may be critical and hard to approach, and tend to only believe information they receive from trusted sources – new sources must prove their competence to earn their trust.

♥ The **Practical Thinker** craves structure – plans, guidelines, processes, procedures, rules. This person tends to trust the tried and true and is cautious of the new and different. They therefore tend to be predictable – 'why reinvent the wheel?' They tend to be process-oriented, and may enjoy outlining, organizing information, and sequencing steps. They like concrete concepts and favor a traditional, pragmatic approach, focusing on implementation, action, execution, but may lose sight of the bigger picture. They usually prefer safety and security to risk-taking.

♥ The **Relational Thinker** is intuitive about people, socially aware and likes caring for others. They tend to favor a humanistic management approach that includes discussion and interaction. In decision making, the Relational Thinker tends to be inclusive – the health of the group is paramount. They also trust their "gut," and may overlook the need to consider facts and logic. They usually like interaction with people, feeling empathy towards others and solving problems through an emotional, not logical process.

♥ The **Creative Thinker** is intuitive about ideas, and tends to seek the novel, the new and different. They have a sense of adventure, enjoy the unusual, and are usually strategic in their approach. They like to get things started, focusing on a vision for the future and the strategy to achieve the vision, but may lose sight of the details and avoid practicality. They tend to see the whole picture and not detail, liking change and trying new things, enjoying being busy with several things at the same time, having imagination and a gut feeling for new ideas.

It's important to underscore that none of these styles of thinking is any more "right" than any other, nor should it be our goal to partner with someone whose thinking style is similar to our own. Understanding how your partner gathers information and forms conclusions about what is needed in any particular situation will give you a broader perspective for appreciating the unique contributions that he or she makes. Please remember that we all have "learned" ways of behaving but our default will be clear in times of stress, chaos or challenging experiences.

## Practice #2: Taking Back Our Projections and Healing Core Fears

Because our partners know us intimately, they have greater access to our hearts, minds, desires and fears than perhaps anyone else. And along with this access comes a greater likelihood of unintentionally opening old wounds.

Evolving Love asks us to continuously surrender to deeper levels of vulnerability and transparency, and past traumas and present fears often surface as temporary obstacles to this opening. Our reactions are protective mechanisms of a wounded inner child trying to do its best to ensure our safety. And, with the right support and care, we can support one another in healing the wounded places within our psyches that are still untrusting of love.

The most important thing we can do to avoid becoming reactive when our partners are experiencing the pain of an old wound that's been triggered is to remind ourselves that their pain does not belong to us. It is not in response to a present moment situation, but a remnant of the distant past. The only thing we have to concern ourselves with is the desires, needs and requests our partners make of us from this moment forward.

Here are some reflective statements that Carl and I explore with one another when one of us is in the midst of an emotional reaction:

*What I felt is…. or What do you feel?*
*What I need is… or What do you need?*
*What I request is… or What is your request?*

You can continue to explore these phrases/questions until everything that needs to be expressed has been said. Or, you can cycle back and forth between the two of you, taking turns asking and answering these questions.

One word of caution: If you find that your partner's reaction is triggering strong emotions within you, it is best to take some time out to process your own feelings before trying to support him or her. Engaging with your partner while you are in the midst of an emotional reaction can create astounding wounds. When our fight or flight mode is activated, we will be tempted to say things we don't mean, and to react in ways we would never want someone we love to react to us. Depending on the strength of our reaction and our history with the subject that triggered it, we may even find ourselves bringing up issues from the past that have nothing to do with what's happening in the present moment. All of this is the wounded part of us doing its best to guard against further pain.

Taking time out to assess your own state of being will prevent scenarios like the one above from escalating unnecessarily. You can ask yourself, "Am I tired? Hungry? Stressed? You might discover that you're over-reacting because you're under a lot of pressure at work, or worried about the wellbeing of a family member or friend. This is

*not* the time to confront your partner, nor is it a time to offer your emotional support. It's time to be with yourself to get to the core of what's going on with you.

I recommend that couples make agreements with one another – when communication is clear and emotions are not high – about how they want to handle upsets. The end result is usually far better if one or both walk away temporarily and wait to discuss the issue until after they've regained their balance.

Some couples mutually decide to hang up the phone rather than say something they'll later regret. The important thing is to set it up ahead of time so both partners are clear about what's going on and not tempted to give in to feeling abandoned or rejected. Carl and I have this language down pat. We'll say to the other, "I'm triggered right now and can't respond in a calm or clear manner. I promise to get back to you when I'm ready to talk. Thank you for understanding."

## Practice #3: Delivering Withheld Communications

A withheld communication is like a volcano that can erupt at any unforeseen moment. And while it's true that it takes courage to voice a concern, admit to hurt feelings, or express an unmet need or a nagging fear, it's also true that expressing a withheld communication becomes infinitely harder if you wait until the volcano erupts.

When we've become aware of something that doesn't feel quite right, and allow this awareness to fester beneath the surface rather than communicate it, we deprive our partners of the very information they require to give us what we need, and we also deprive ourselves of the possibility of having our needs met. Often we stop ourselves from communicating because we think our partners should already know what we need without having to tell them. Becoming responsible for our own needs is therefore the first step in resolving withheld communications.

Symbols that represent conscious communication, such as a velvet heart, or a talking stick similar to those used by Native Americans, can be very helpful in aiding this process. Whenever I perform a marriage, I give each couple a rose at the end of the ceremony, and suggest that any time communication between them reaches an impasse, the partner with the greatest objectivity leaves the rose for the other partner to find it. This is an indication that the one making the offering is willing and desirous of moving back into a state of loving. The partner seeing the rose then has time to re-open their heart and mirror back the desire to tear down the walls of separation.

Below is a list of potential questions to ask one another when delivering withheld communications. To get the most

out of this exercise, it's best if both partners agree that when one person is holding the rose, the heart or the talking stick, the other person will listen without interrupting:

- ♥ How do you feel?
- ♥ What do you want?
- ♥ Does this feel similar to anything in the past that might be influencing the upset?
- ♥ How will holding onto this position expand or diminish our level of intimacy?
- ♥ What do you need to say?
- ♥ What agreements have been broken?
- ♥ How can we move forward in love?

Taking turns going through this dialog gives the person who is speaking the experience of really being heard, and affords the one who is listening the opportunity of deeply understanding his or her partner's experience.

## Practice #4: Maintaining Autonomy in Intimate Relationships

When creating a successful, long term relationship, the ability to negotiate mutually agreeable ways to maintain each partner's autonomy can be every bit as important as carving out time to be together. Having a strong sense of self is fundamental to each partner's self-esteem, and for this reason, continuing to pursue individual interests and passions should be encouraged from a relationship's very beginning. Allowing our identity, interests, or daily routine to blend completely with that of our partners can cause us to form unreasonable expectations on their time, and may leave us feeling dependent on them for our happiness, sense of security, or social life.

Because our individual values and needs change with the passage of time, I believe it's important to revisit how each partner defines his or her own need for "me" time as the relationship matures. Life transitions such as the birth of a baby, the last child leaving for college, or the retirement of one or both partners may also cause a need for some reflection and renegotiation.

Up until a couple of years ago, Carl worked from home, while I worked outside of the house in a busy office where I interacted with people from the moment I walked through the door each morning. Carl's work as an artist afforded

him plenty of solitude, as well as time to enjoy his own company and think his own thoughts. When I'd come home at the end of the day, I needed some space and time to myself before I was ready to engage with anyone else, while Carl was eager to catch up on our days or to go out and socialize with friends.

A similar dynamic sometimes accompanies us when we travel together. While on a recent trip to Italy, for example, Carl was up at the crack of dawn to photograph each day's spectacular sunrise, while my idea of a relaxing morning was sitting in the piazza with a hot cup of tea and a good book, occasionally pausing to contemplate the scenery or appreciate the people passing by.

Without the communication skills to navigate these fundamental differences, either of us could have easily jumped to any number of inaccurate conclusions: *You don't enjoy spending time with me anymore. My interests are not important to you. We must be growing apart.* In truth, we were both simply choosing to spend some of our free time in the way that provided stimulation or rejuvenation – consistent with what each of us, as individuals, most needed in that moment. Then our time together was easier because we brought our whole selves to the moment.

If we don't take into account our partner's (or our own) need for autonomy, we may erroneously take it personally when they express a preference that differs from our own. Carl and I created the following exercise to make it easier for couples to discuss differences ahead of time. Just by gathering a little information about how each partner prefers to spend his or her time can head many a misunderstanding off at the pass.

Take some time on your own to identify which statement in each section is most true for you, and when complete, share this information with your partner:

## MORNINGS

- ♥ I am a morning person and wake up energized and ready to go.
- ♥ I like to take my time getting up and getting started.
- ♥ I love to have coffee, get on my computer and work early in the morning.
- ♥ I prefer time for centering and /or quiet time in the morning before working.

## VACATIONS:

- ♥ I love to rest and be still.

- ♥ I prefer to be active and devote most of my time to exploring my surroundings.

- ♥ I like to have all plans mapped out prior to leaving.

- ♥ I like to leave space for spontaneity and "playing it by ear" when on vacation.

## DAILY ACTIVITIES:

- ♥ I like to look ahead and create plans.

- ♥ I calendar big events, but like to leave as much space as possible unstructured.

- ♥ I love to have things prepped for meals in advance and eat at home.

- ♥ I like to see what inspires me in the moment regarding preparing a meal or eating out.

## SOCIAL SITUATIONS:

- ♥ It's easy for me to dive in and get to know people. I like to initiate conversations.

- ♥ I'm tentative in getting to know new people and prefer people coming to me to initiate conversation.

- ♥ I prefer being in small, intimate groups.

- ♥ I feel energized in big crowds and when attending large events.

## IF WE HAVE AN EXTRA HOUR BEFORE GOING ON A DATE, I WOULD LIKELY:

- ♥ Fill the time with as much activity as I can fit in, and get dressed just prior to departing.

- ♥ Prefer to get dressed ahead of time to allow ample time to arrive at the destination.

Once each of you has completed this exercise, take some time to discuss your revelations and make some agreements on how you might like to move forward. Carl and I have found this exercise particularly valuable when it comes to navigating "time" issues, because we now understand how the other person operates.

## Practice #5: Supporting One Another through Difficult Times

Let me start by saying that there is no one-size-fits-all exercise for supporting a loved one through a difficult time, but there is one quality that, if brought to the interaction, will absolutely result in the two of you growing closer as a result. That quality is empathy.

After my mother passed, and after I'd finished handling the majority of her affairs and the memorial service was over and there was nothing left to manage to distract me from my own emotions, it was as if my legs could no longer support me. I spent nearly a week at home feeling exhausted, and on the 4th or 5th day, when I got up to use the bathroom in the middle of the night, I literally fell to the floor, sobbing uncontrollably in what felt like endless waves of grief. Carl heard me, got out of bed, and provided the only thing that could have possibly soothed me in that moment: He got on the floor with me and held me as I sobbed.

The stress of years and years of "holding it all together," and managing the details of my mother's life felt as if it were flooding through every pore, seeking any available outlet to be released. The most remarkable thing of all is that Carl didn't say a word. He just held me. It was a moment when I was truly incapable of answering the question, "What can I do for you?" or, "What do you need?" The pain was so extraordinary that I couldn't do anything but be with it – and Carl was right there with me as I did.

Most of us have been conditioned to offer pleasantries to people in times of need, but this level of communication is *not* connection; it's a token of connection. It's something we offer to make *ourselves* feel better. True empathy is having the willingness to step into another's pain with them; to love them enough to be where they are, and to offer the silent knowledge in your heart that everything is going to be alright. To practice this degree of compassion, we have to relinquish altogether any expectation of how long our partner's grieving process will last, and communicate to them whether silently or aloud that we're going to be with them, shoulder to shoulder, as they move through this process, whatever the timeframe.

When at last my sobbing subsided, Carl was tuned in enough with me to sense a shift, and gently posed a question we've discussed at length in this section, asking me quietly, "What do you need?" When I didn't respond right away, he again comforted me, telling me that he loves me and is here for me and asking me again, "What do you need?" And, in the presence of his genuine compassion and incredible attentiveness, I was actually able to hear what I needed and express it to him. "I just need a place to share and your listening to me will mean a great deal." So, for several weeks he just listened. It was a healing salve.

While there is no panacea for healing wounds of loss, physical touch almost always provides the deepest comfort. When you're going through something of that magnitude, you don't want to be fixed, and you don't want to be managed. You just want to be *seen*. Physical contact is the tool of choice that we offer to couples seeking insight on how to support and console one another.

If you're the one grieving, lay with your back against your partner's chest, while your partner is doing nothing but holding you. In this exercise, you have permission to say whatever you need to say; you can express your fears or insecurities, and the only thing your partner needs to say in return is, "I hear you." "I love you." "I am here for you." and "What do you need from me?"

As we move through time in intimate partnership with another soul, we will inevitably encounter losses, including some that shake us to the core. Nobody can prepare us for aging, or for the unexpected loss of a job or of a physical capacity. It becomes easier to love the person through it when we realize that we don't need to become responsible for their experience. Just by being there with them, by "getting" them, we become a conduit for love, acceptance and ease to flow to our beloved.

## Practice #6: Creating Safety through Physical Intimacy

Touch is one of the most primal ways that human beings communicate trust and intimacy. And, because affectionate touch boosts the body's levels of oxytocin – the hormone associated with bonding and attachment – this form of communication can become a powerful force to draw you and your partner back together following a period of estrangement or a disagreement.

While all of the couples featured in this book acknowledged the value of making daily connection a high priority, Ron and Margo clearly took this commitment a level deeper. Through their "promise" to using physical intimacy as a means of listening to and honoring one another's needs, they brought their relationship back from the brink of divorce and discovered a dimension of love that neither one had ever before experienced.

The following exercise is a summary of their daily "promise" to one another, which can be practiced in its entirety, or tailored to meet the needs and comfort levels of both you and your partner:

*Begin by creating an environment that will support your intention to experience greater intimacy: take a shower or bath to relax your body; light candles, put on music, adjust the temperature of the room.*

*Before connecting with your partner, take a few minutes in silent meditation to center and settle yourself. Simply observe the flow of your breath as it moves in and out, allowing yourself to fall still and to give your attention completely to what is occurring in the present moment.*

*When the impulse arises to extend your attention to include your partner, slowly open your eyes, allowing your partner to join you in his or her own time.*

*As each of you becomes ready, find a comfortable, side-lying position that allows your bodies' energy centers to align. As you settle in, become aware of the rhythm of your partner's breath and heart rate.*

*Remind yourself that there is no right or wrong way to approach this exercise; simply notice the sensations that arise. As the energy builds, allow yourself to deepen your expression of love through the language of physical touch, taking turns providing for your partner the quality of touch that you most want to receive.*

*When giving, allow yourself to attend completely to your partner, noticing the effect your love is having on him or her. When receiving, practice letting in each and every sensation, while appreciating the intention behind the touch.*

*If uncomfortable feelings arise, use your breath to remind yourself that building greater trust and intimacy is a gradual process of opening and discovering. Allow the physical presence of your partner to be a source of comfort.*

*Stay with this process for as long as it feels natural, allowing the quality of touch to evolve from nurturing to playful to sexual. When you feel complete, acknowledge yourselves silently or aloud for having allowed another protective layer that stands between you and love to melt away.*

Human beings crave physical intimacy. Whether it's a squeeze of the hand while walking; a shoulder rub at the end of a long day, or a spontaneous, intimate kiss, physical intimacy breathes life-giving energy into a relationship. We all yearn for a trusted friend we can turn to – what my friend Arielle Ford calls "a soft place to land" – and when our partners stop providing this, a part of us disconnects and may instinctively begin to look elsewhere for this sustenance.

## Practice #7: The 'Honoring Your Partner' Ritual

This exercise is best reserved for special occasions – engagements, anniversaries, or at a time when you as a couple desire to release the old in order to make space for something new. It can also be used to facilitate healing – after a loss, or following the completion of a big project or to recover after an intense period of work or travel. Unlike the

other practices outlined in this section, in this ritual, one person is the 'giver,' while the other is focused solely on receiving. At another time, partners can switch roles.

Prior to offering this ritual, the partner who is in the role of 'giver' will need to gather:

- ♥ *A blanket*
- ♥ *One washcloth soaked in warm water*
- ♥ *Three towels*
- ♥ *Your partner's favorite massage oil*

To begin, create a healing environment by putting on some beautiful music. Adjust the lighting and the temperature of the room according to your partner's preferences. ***Put one towel on the ground and have your partner place their feet on it. Place the container of warm water with the wash cloth next to the towel.***

With the wash cloth, wash your partner's feet. Take your time so that your partner can relax into the feeling of the warm water soothing their feet. Dry them with second towel. Now, and as you apply oil to your partner's feet, tell them what they mean to you; and how much you love and appreciate them. Take your time; don't rush. Encourage your partner to breathe and receive the love you are offering. Use the third towel to dry off the excess oil, and then allow your partner as much time as they need to rest in the gift that they have been given.

## Process #8: Gratitude and Appreciation

If you take away from this book just one practice to begin incorporating into your relationship, I would recommend above all others the final process described here.

This exercise is incredibly simple to do, and takes no more than five minutes a day, and yet the cumulative effect of this investment, over time, is priceless. Despite busy lives and daunting travelling schedules that can cause us to be apart for up to several weeks at a time, Carl and I have devoted ourselves to the following practice that was shared with us in a couple's workshop every single day for the past eighteen years:

*First, you and your partner can make written lists of 10 things that each of you is grateful for — that transpired during that day, or in your lives in general. Now, each partner shares, out loud, their lists. The partner just listens.*

*Next, take turns expressing three rounds of acknowledgement, first acknowledging something about yourself, and then acknowledging something about your partner.*

The interesting thing about both parts of this exercise is how often you're likely to be surprised by the things your partner is grateful for and the things he or she finds worthy of acknowledging. This exercise is by far the fastest, easiest way to keep the currents of emotional intimacy flowing strong – even when you are not in physical proximity.

Carl and I have done this exercise together over Skype; we've done it via our individual journals when he was in the Grand Canyon and without phone reception. We've done it when we're mad at each other; when we've felt madly in love with each other, and when we've been in the midst of a life transition or another emotional challenge. It always has the same effect: emotional intimacy is the glue that forges lasting and resilient romantic bonds.

# Conclusion

## LOVE AS AN ART FORM

*T*HROUGHOUT THE EXISTENCE OF HUMANKIND, from the earliest cave petroglyphs to the present day's boundless expressions of art, the theme of love weaves its grand message and journey through the ethos not only of all humans, but throughout all living creatures. After all, if love is the key, foundational element that gives rise to all of creation, it would make sense that its essence would be encoded throughout all forms of expression.

When we explore, as we have throughout this book, how love evolves in the context of an intimate relationship, we discover greater dimensions of love's essence, akin to finer brush strokes on a vivid, masterpiece painting. When you view a Rembrandt from a distance, the entire image is clear and pronounced. The subtleties of shadowing, lighting and color are so realistic that you feel as if you could walk into the scene. You are transported back to a slower time where all is lit by candles and kerosene lamps. Only when you step closer do you see all of the fine and intricate brushstrokes that, together as a unit, create the entire vividly detailed image.

This same principle applies as we explore the depths and intricacies that form the fabric of all conscious, devoted and intimate partnerships. It's common in our culture to project onto positive role models who inspire us to live our most brilliant life imaginable. When we see a couple that appears to have a growing, honoring and loving relationship, we immediately identify with the sense of wholeness or *home* that they symbolically represent. Yet, only if we were to live with this couple day in and day out would we see all of the intricate brush strokes that build the strength, pliability and expansion necessary to sustain a *masterpiece* relationship!

Love *is* perfection. As we give way to love's most genuine guidance, we are innately directed. We are the artist, we're the brush strokes, the canvas, the vision, the devotion and the surrender. Mastery builds as we strengthen our daily practice of high level listening, softening and honoring of love's design and direction of our lives. Our brush stokes become more refined, our depth and dimension expand, and we begin to shape and take brilliant form as living, breathing ambassadors of love. We greet and recognize others from this clear perspective and honor love's truth at the core of every experience on our journey through this precious life.

My life will forever be touched to its very core by the tremendous courage, wisdom, trust and faith brought forth through the unique journey that each of the eight couples featured throughout this book have traveled into the infinite realms of evolving love. Each has inspired within me a greater willingness to trust what is possible when we lead with love before and beyond all else. My deepest wish is that you take each of these fruitful sojourns into your heart and allow them to cultivate a most flourishing garden where love's ever-expanding light leads your path and nourishes your soul.

*"In your light I learn how to love. In your beauty, how to make poems. You dance inside my chest where no-one sees you, but sometimes I do, and that sight becomes this art."*

— **Rumi**

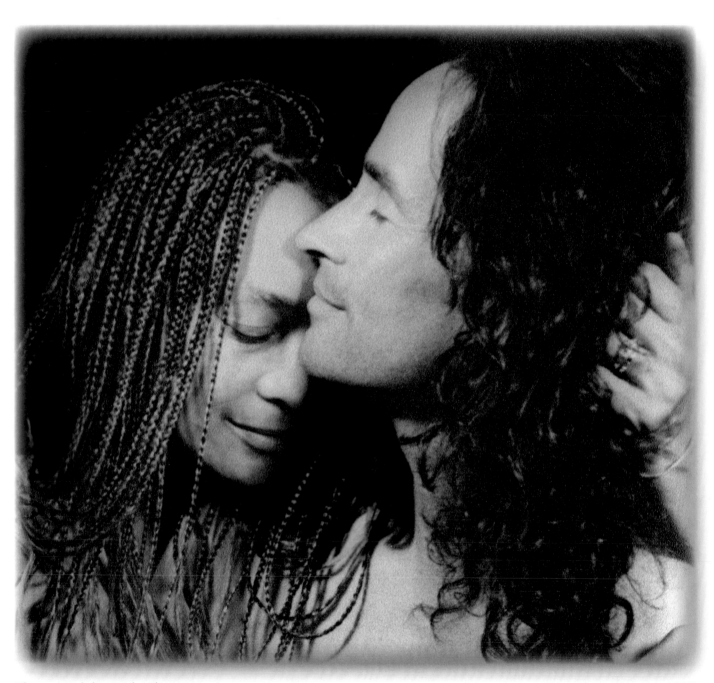

Photograph by Carla Chotzen

August, 1997